D1471343

Hayward Gallery, London, 3 April to 15 June 1969

FRESCOES FROM FLORENCE

An exhibition organized by
the Soprintendenza alle Gallerie per le provincie
di Firenze e Pistoia

The Arts Council of Great Britain

Under the Gracious Patronage of
Her Majesty the Queen
and His Excellency Giuseppe Saragat,
President of the Italian Republic

The Arts Council of Great Britain
gratefully acknowledges the financial assistance of
BRITISH OLIVETTI LIMITED

Italian Committee of Honour

NATIONAL

On. Mariano Rumor
Presidente del Consiglio dei Ministri

On. Pietro Nenni
Ministro degli Affari Esteri

On. Fiorentino Sullo
Ministro della Pubblica Istruzione

Signor Raimondo Manzini
Ambasciatore d'Italia presso il Regno Unito

Prof. Mario Salmi
Vice Presidente del Consiglio Superiore delle Antichità e Belle Arti

S.E.R. Mons. Giovanni Fallani
Presidente della Pontificia Commissione Centrale per l'Arte Sacra in Italia

Dr Alessandro Tassoni Estense di Castelvecchio
Direttore Generale delle Relazioni Culturali con l'Estero. Ministero degli Affari Esteri

Prof. Bruno Molajoli
Direttore Generale delle Antichità e Belle Arte

Dr Ugo Rossi
Direttore Generale degli Scambi Culturali del Ministero della Pubblica Istruzione

Prof. Avv. Bruno Visentini
Presidente, Ing. C. Olivetti & C.S.p.A., Ivrea

Dott. Roberto Olivetti
Amministratore Delegato, Ing. C. Olivetti & C.S.p.A., Ivrea

Ing. Bruno Jarach
Amministratore Delegato, Ing. C. Olivetti & C.S.p.A., Ivrea

FLORENCE AND TUSCANY

Em. Rev. Ma Card. Ermenegildo Florit
Arcivescovo di Firenze

Sen. Piero Bargellini
Senatore della Repubblica

On. Avv. Edoardo Speranza
Deputato al Parlamento, già Assessore alle Belle Arti del Comune di Firenze

S.E.R. Arc. Mons. Mario I. Castellano O.P.
Arcivescovo di Siena

S.E.R. Mons. Telesforo Giovanni Cioli
Vescovo di Arezzo

S.E.R. Mons. Mario Longo Dorni
Vescovo di Pistoia

S.E.R. Mons. Antonio Bagnoli
Vescovo di Fiesole

S.E.R. Mons. Giuseppe Franciolini
Vescovo di Cortona

S.E.R. Mons. Pietro Fiordelli
Vescovo di Prato

S.E.R. Mons. Giovanni Bianchi
Vescovo ausiliare di Firenze

Dr Manfredi de Bernart
Prefetto di Firenze

Dr Lorenzo Lorè
Prefetto di Siena

Dr Cristofero Tirrito
Prefetto di Arezzo

Dr Alceo Chiesi
Prefetto di Pistoia

Avv. Luciano Bausi
Sindaco di Firenze

Prof. Renato Gnocchi
Sindaco di Arezzo

Sig. Mario Assirelli
Sindaco di Empoli

Sig. Ottorino Goretti
Sindaco di Sansepolcro

Sig. Mario Cioni
Sindaco di Castelfiorentino

Prof. Ugo Procacci
Soprintendente alle Gallerie per le provincie di Firenze e Pistoia

Arch. Guido Morozzi
Soprintendente ai Monumenti per le provincie di Firenze e Pistoia

Prof. Enzo Carli
Soprintendente alle Gallerie per le provincie di Siena e Grosseto

Arch. Albino Secchi
Soprintendente ai Monumenti e alle Gallerie per la provincia di Arezzo

P. Giulio Barsottini
Ministro Provinciale dei Frati Minori Conventuali della Toscana

P. Lorenzo Pontani
Ministro Provinciale dei Frati Minori Osservanti della Toscana

P. Leonardo Magnini
Ministro Provinciale dei Padri Domenicani delle provincie di Fiesole e Sardegna

P. Alfonso Bottai
Ministro Provinciale dei Servi di Maria della Toscana

P. Raffaele Schiavoni
Provinciale dei Padri Carmelitani della Toscana

Mons. Giulio Lorini
Presidente della Commissione d'Arte Sacra di Firenze

Principe Giovanni Ginori Conti
Presidente dell'Opera di Sta. Croce di Firenze

Dr Renzo Chiarelli
Direttore della Galleria dell'Accademia di Firenze

Prof. Giovanni Colacicchi
Presidente dell'Accademia Fiorentina delle Arti e del Disegno

Don Ferradino Fiorini
Delegato Arcivescovile per l'Arte Sacra, Firenze

Mons. Sabatino Ferrali
Arciprete del Duomo di Pistoia

Can. Antonio Ortelli
Arciprete del Duomo di Prato

Mons. Gino Bonanni
Parroco della Badia di Firenze

P. Gustavo Cocci
Rettore della Basilica di Sta. Croce di Firenze

P. Giorgio Francini
Priore della Basilica della SS. Annunziata di Firenze

P. Vittorio Scoccimarro
Superiore del Convento di S. Marco di Firenze

P. Franco Frizzi
Superiore del Convento del Carmine di Firenze

P. Emo Costantino Noci
Superiore del Convento di Ognissanti di Firenze

P. Enrico Antoni O.P.
Superiore della Basilica di S. Domenico di Arezzo

P. Giuseppe Giacomelli O.P.
Superiore del Convento di S. Domenico di Pistoia

Mons. Elio Morozzi
Priore della Chiesa dei SS. Apostoli di Firenze

Don Mino Tagliaferri
Parroco della Chiesa di Sta. Felicita di Firenze

Don Giampietro Gamucci
Parroco della Chiesa di S. Niccolò Oltrarno di Firenze

Don Enzo Ugolini
Parroco della Chiesa di S. Francesco di Paola di Firenze

Don Desiderio Sozzi
Priore della Chiesa di S. Ambrogio di Firenze

Don Nicola Fruscoloni
Parroco della Chiesa di S. Domenico di Cortona

P. Cristoforo Testa
Priore della Chiesa di S. Domenico di Fiesole

Don Giuseppe Gilli
Rettore dell'Oratorio di S. Galgano di Montesiepi

United Kingdom Committee of Honour

The Archbishop of Canterbury

The Rt. Hon. Harold Wilson O.B.E., M.P.
Prime Minister and First Lord of the Treasury

The Rt. Hon. Michael Stewart C.H., M.P.
Secretary of State for Foreign and Commonwealth Affairs

The Rt. Hon. Edward Short M.P.
Secretary of State for Education and Science

The Rt. Hon. Jennie Lee M.P.
Minister for the Arts

Sir Evelyn Shuckburgh G.C.M.G., C.B.
H.M. Ambassador to Italy

John Cardinal Heenan
Archbishop of Westminster

Archbishop H. E. Cardinale
Apostolic Delegate to Great Britain

Sir Louis Gluckstein C.B.E.
Chairman of the Greater London Council

The Lord Goodman
Chairman of the Arts Council of Great Britain

Carlo Alhadeff
Managing Director, British Olivetti Ltd.

Exhibition Committee

Prof. Ugo Procacci
Superintendent of Fine Art, Florence

Dr Umberto Baldini
Director, Laboratories of Restoration, Florence

Dr Luciano Berti
Director, Bargello Museum, Florence

Dr Paolo Dal Poggetto
Inspector of the Soprintendenza, Florence

Dr A. F. E. van Schendel
Director, Rijksmuseum, Amsterdam

John Pope-Hennessy C.B.E.
Director, Victoria & Albert Museum, London

Gabriel White C.B.E.
Director of Art, Arts Council of Great Britain

Working Committee

Stefan Buzas
Architect

Stanley Cornwall
British Olivetti Ltd

Andrew Dempsey
Exhibitions Officer, Arts Council

Alan Irvine
Architect

Jack Nichol
British Olivetti Ltd

Duncan Robinson
Department of Fine Art, Cambridge University

Stanley Vigar B.E.M.
Exhibition Installation, Arts Council

Francis Ward
Administrator, Hayward Gallery

Jeffery Watson
Shipping Officer, Arts Council

Technical Committee

Alfio Del Serra
Restorer, Florence

Dino Dini
Restorer, Florence

Giuseppe Rosi
Restorer, Florence

Leonetto Tintori
Restorer, Florence

EXHIBITION DESIGN
Professor Carlo Scarpa, Venice

9

Foreword

A few years ago one would not have expected to see an exhibition of mural paintings. Copies, yes, these we have had, but the paintings themselves only became a possibility as a result of recent advances in the technique of detaching frescoes. These techniques have been developed particularly in Florence and Tuscany where many frescoes have had to be removed from their walls to prevent deterioration in their condition. Those who wished to see the monumental painting of Italy had to visit that country and in the last three centuries generations of British travellers have in increasing numbers made the journey. There are still, however, many who have never had this unique experience. True, here they will see the frescoes divorced from their context, the architecture of which they are an integral part, but they can console themselves that often *in situ* they are difficult to see, and it is some compensation that here they can be looked at and enjoyed with far greater ease. It is hoped, however, that many who have not yet made the Italian journey will now be induced to do so, for the greatest works are still there on their walls.

In 1961 Anglo-Dutch co-operation with the Italian authorities achieved a remarkable exhibition of Italian Bronze Statuettes which was shown at the Victoria & Albert Museum, the Rijksmuseum and lastly at the Palazzo Strozzi, Florence. In London shortly afterwards there was a meeting to discuss further exhibitions of Italian art and the suggestion was made, perhaps with no great expectation of success, to obtain some of the frescoes that had been recently exhibited in Florence. The first approaches were reassuring and it is due to Dr Ugo Procacci, Soprintendente alle Gallerie per le provincie di Firenze e Pistoia, who was responsible for the policy of removing frescoes, and to his continuous encouragement, co-operation and perseverance that this exhibition was finally realized. We began our plans before the tragic disaster of November 1966, which was to prove the wisdom of Dr Procacci's policy. In the final plan the exhibition also became a gesture of gratitude for the help which Florence had received from abroad and it was first sent to the Metropolitan Museum, New York, where it was shown with such outstanding success last autumn before going to the Rijksmuseum, Amsterdam.

To the City of Florence and its authorities, civil and religious, as well as those of the Province of Tuscany, London and the Arts Council will ever be indebted for this proof of their confidence in entrusting us with their treasures and of their recognition of the long traditional love of Italian life and art which so many of us in this country share. The exhibition received the ultimate authority of the Direzione Generale delle Antichità e Belle Arti and of the Pontificia Commissione di Arte Sacra to whom we are also deeply grateful. To Dr Procacci who can rightly be called the 'onlie begetter' of the exhibition we can only reiterate the thanks we have already given him personally. He has been ably supported in all the

detailed plans by Dr Umberto Baldini, who has been responsible for the delicate task of the removal, restoration and conservation of the frescoes. In the practical installation of the exhibition we have benefited from the skill of Signore Alfio Del Serra, Dino Dini, Giuseppe Rosi and Leonetto Tintori who have for years worked on the frescoes.

In all the arrangements for the exhibition in London, we have had the fullest co-operation of His Excellency Signor Manzini, Italian Ambassador to the United Kingdom, who arrived here recently at this auspicious moment of Anglo-Italian cultural co-operation. We have also enjoyed the continual help of Professor F. Donini, Director of the Italian Institute and of Signora A. Beghé, the Deputy Director.

The catalogue was prepared in Florence and includes the admirable introduction on fresco painting and its preservation by Dr Procacci, as well as critical notes on the frescoes and *sinopie* by Dr Procacci, Professor Millard Meiss and the Florentine specialists, Dr Umberto Baldini and Dr Paolo Dal Poggetto. To this Mr John Pope-Hennessy has added an introductory note which discusses some of the general problems raised by the exhibition. Mr D. Robinson has written the biographies of the artists and Mr N. Brommelle has given us much help on technical matters in connection with the catalogue. We have necessarily benefited from the catalogue of the Metropolitan Museum whose staff were the first to be faced with the formidable task of producing one. This is only one of many examples of happy collaboration between ourselves and the Museum. We must also record our gratitude to Mr Thomas P. F. Hoving, its Director, to Mr Theodore Rousseau, Vice-Director and Curator-in-Chief and Mr Claus Virch, Curator of European Paintings.

From its inception this exhibition has been a second chapter of happy co-operation between the Rijksmuseum and the Arts Council, and for this we are personally indebted to its Director, Dr A. F. E. van Schendel with whom we have been continuously associated throughout the planning of the exhibition. Dr P. J. J. van Thiel, the Keeper of Paintings, and many other members of the staff have helped us greatly, and the printers of the excellent Dutch catalogue, Messrs. Meijer Wormerveer N.V. have collaborated with our printers in the production of this catalogue.

Olivetti, to mark the centenary of the birth of its founder, has given generous financial assistance to the museums showing the exhibition, and British Olivetti were not slow in approaching the Arts Council with offers of practical assistance. They gladly agreed to our suggestion that they should take over the cost of the installation which is necessarily so important and integral a part of such an exhibition. It was right that an Italian designer should undertake the formidable task and we are unexpectedly fortunate in having as our designer Professor Carlo Scarpa who has made a

world-wide reputation for his brilliant achievements at the Municipal Museum of Castelvecchio, Verona, and the Museo Correr, Venice. He immediately accepted the invitation and visitors at the Hayward Gallery will see in the exhibition the first example of his work in London. For this generous response and other help we are largely indebted to Signor Carlo Alhadeff, the Managing Director. In our day-to-day planning Mr J. Nichol, Press and Advertising Manager, and Mr S. Cornwall, Public Relations Manager, have constantly advised and helped us.

Gabriel White
Director of Art
The Arts Council of Great Britain

Contents

page 13 Preface *by John Pope-Hennessy*

15 Introduction *by Ugo Procacci*

44 General bibliography

45 - 216 Catalogue

217 Glossary

220 Index of artists

221 Index of places

223 Map of Tuscany

Preface *by John Pope-Hennessy*

Those charged with the care of works of art have many onerous responsibilities, but one transcends all others, that of ensuring that the works entrusted to them are handed on in unimpaired condition to posterity. Sometimes this is best achieved by letting well alone, sometimes it presents a challenge which can be met only by new policies and by the use of new techniques. The preservation of Italian wall-paintings falls in this second class. For more than a generation it has been recognised that if no action were taken and the process of disintegration pursued its course, many of the greatest Italian frescoes would be irreparably impaired. Nowhere have the facts of this disastrous situation been accepted more realistically than in Tuscany, where, over the past twenty years, a large number of threatened or deteriorating frescoes have been removed from the walls for which they were painted as a precondition for ensuring that they are preserved. Exhibitions of the transferred frescoes were organised in Florence at the Fortezza di Belvedere in 1957, 1958, 1959 and 1966. By November 1966, when countless wall-paintings were damaged in the flood, the Superintendency in Florence had accumulated an unrivalled body of experience and had perfected a technique for the transfer of frescoes which could be put to immediate, large-scale use.

The present exhibition was conceived before the flood took place, and many of the frescoes shown in it were transferred prior to 1966, but some of them, notably the great St Jerome of Castagno from the church of the Annunziata, were stripped from their walls to save them from the consequences of the inundation. It would be difficult to exaggerate the debt which lovers of Italian art, in this country and throughout the world, owe to the energy and foresight of Professor Ugo Procacci, the Superintendent of Fine Art in Florence, and of his deputy, Professor Umberto Baldini, and to the skill of the restorers responsible for detaching the frescoes, Leonetto Tintori, Dino Dini, Giuseppe Rosi and Alfio Del Serra.

Not unnaturally frescoes are sparsely represented in public collections in this country. In the National Gallery there are two fresco fragments by Pietro Lorenzetti from S. Francesco in Siena, sections of a cycle by Spinello Aretino from the Carmine in Florence, two heads and a ruined Virgin and Child from the Carnesecchi tabernacle of Domenico Veneziano, and a large Nativity by Perugino; in the Wallace Collection there is a fresco of the Young Cicero by Foppa; and in the Victoria and Albert Museum there are frescoes by Luini and Perino del Vaga. From none of these should we gain a clear impression of the importance of the medium of fresco in the fourteenth and fifteenth centuries. It would none the less be generally admitted that any view of the great Italian painters based solely upon knowledge of their panel paintings was restricted and incomplete. No matter how closely we study the Madonna by Masaccio or the paintings by Piero della Francesca in the National

Gallery, we shall misjudge both artists unless account is taken of the work they executed in a more direct medium on a monumental scale. So it is with Orcagna, parts of whose huge Last Judgement from Santa Croce are shown in this display, Masolino, Fra Angelico, who is represented by a number of works, Benozzo Gozzoli, and Pontormo, whose Annunciation from the Capponi chapel in Santa Felicita in Florence offers one of the supreme aesthetic experiences of the exhibition. Similarly those who know Andrea del Sarto only through the far from inconsiderable paintings in this country will be surprised by the sensibility and vigour of the cycle of frescoes from the Chiostro dello Scalzo.

As is explained by Professor Procacci in his introduction, the removal of these frescoes often laid bare the underdrawing, or *sinopia*, beneath. Many of these *sinopie* are included in the exhibition. Some of them are great works of art in their own right, while others are of interest in that they enable us to reconstruct the processes by which the fresco was produced. One, the *sinopia* by Uccello for the gravely damaged Nativity from S. Martino alla Scala (no. 36), illustrates the practical application of linear perspective to pictorial composition; in this case the fresco (illustrated on p. 141) proved in too precarious a state to travel. Fra Angelico's famous fresco of St Peter Martyr from San Marco in Florence (no. 28) is shown with its *sinopia*, which is in certain respects markedly different from the completed work. In some cases the *sinopia* is elaborated in the fresco, as in Francesco d'Antonio's St Ansanus from S. Niccolò (nos. 23 and 24); in others, of which Castagno's Trinity with SS. Jerome, Paula and Eustochium (nos. 42 and 43) is perhaps the most remarkable example, the literary content is thought out afresh. In Parri Spinelli's Crucifixion from Arezzo (nos. 31 and 32), the eccentric lateral figures seem to have been reproduced in fresco, and then replaced on fresh *intonaco* by the figures we see now. If the present exhibition were simply a display of frescoes, that would be remarkable enough, but it is more than this. Its true subject is the creative processes of some of the greatest Italian artists.

The technique of mural paintings and their detachment
by Ugo Procacci

It is a common assumption that all mural paintings are frescoes. This is incorrect. If you paint on plaster (or *intonaco*) that is still fresh, the result is a painting in *affresco* or *a fresco*, as the term itself connotes. If, on the other hand you paint on *intonaco* which has already dried or hardened, what results is not a fresco in the strict sense.

It is essential to distinguish clearly between these two techniques. The first method is described by Cennino Cennini, a painter from Colle Valdelsa who studied art in Florence in the school of Agnolo Gaddi, and about the turn of the fifteenth century wrote the *Libro dell' Arte*, an invaluable treatise on technique to which we owe much of our knowledge in this field. Cennini explains that in true fresco the artist must apply his pigment on the damp or fresh (*fresco*) *intonaco* as soon as it has been laid on the wall. The pigment will penetrate the wet plaster, and when it dries and hardens, they will solidify and become one with it. What occurs is a chemical reaction in which calcium carbonate is formed through carbon dioxide from the air combining with the calcium hydroxide in the wet plaster. When, on the other hand, the artist paints on dry (*secco*) *intonaco*, glue or some other binding medium is needed to hold the pigments together and cause them to adhere to the surface of the wall. The adhesive is frequently egg white (for tempera paintings) or oil (for oil paintings). It can also be made with lime (calcium hydroxide) and the active component of the *intonaco*, which consists of lime and sand. The result resembles a painting executed *a fresco*, since the lime carbonises as plaster does, but it is in fact painted *a secco*, that is on dry plaster. Before the time of Cimabue wall-paintings were frequently painted *a secco*, but the great mural paintings of the golden age of Italian art from Cimabue to Michelangelo were true frescoes, as are practically all the works in the present exhibition. Later on *secco* technique was used more frequently, and, in addition, a technique called *mezzo fresco* (or half fresco) was employed. In *mezzo fresco* the painting is not done on freshly laid plaster, but on plaster that has partly dried, so that the colours penetrate it less deeply. *Mezzo fresco* technique was widely used from the middle of the sixteenth century. Padre Ignazio Pozzo, in an appendix to the second volume of his *Prospettiva dei pittori e architetti*, characterises *mezzo fresco* as the normal technique for fresco painting, since it was widely used in his own time. 'Be sure,' he writes, 'not to begin painting until the lime has reached a stage where it is hard to make a fingerprint in it'. By then the old and splendid technique of true fresco had been forgotten.

Padre Pozzo's words, like those of Vasari whose important pages on technique appear in the first (1550) edition of his Lives, show that a considerable change had taken place since Cennini wrote his instructions for painters. Then the plaster intended for frescoes was 'so well slaked that it has the appearance of an ointment'. It was spread 'thin, but not too thin,

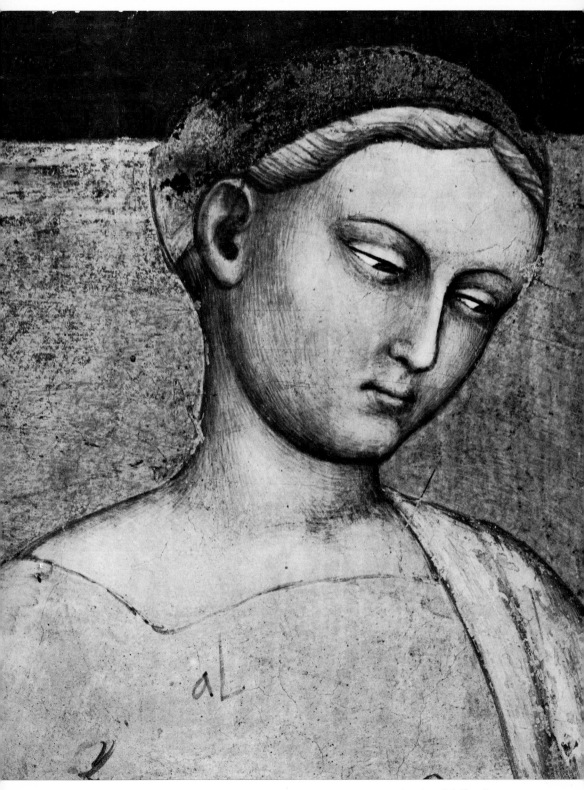

FIG I. An example of smooth *intonaco*. Detail from a fresco by Giovanni da Milano in the Rinuccini Chapel, Santa Croce, Florence.

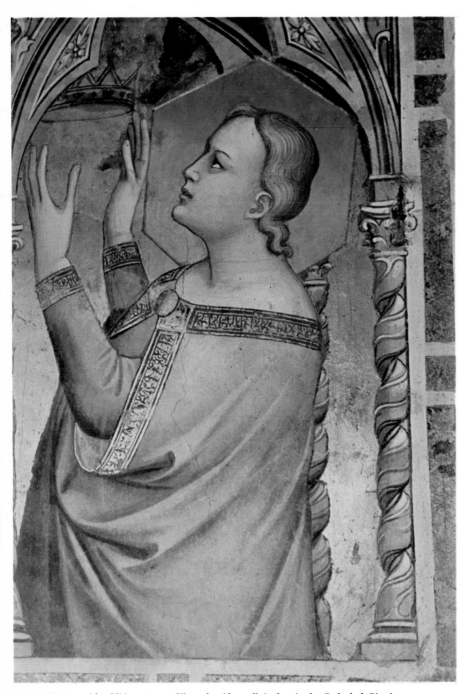

PLATE I. Fresco with additions *a secco*. Virtue by Alesso di Andrea in the Cathedral, Pistoia.

FIG 2. An example of rough *intonaco*. Detail from a fresco by Bernardino Poccetti in the Giglio Chapel, Santa Maria Maddalena dei Pazzi, Florence.

and perfectly flat', so that a smooth surface would result (fig. 1). Plaster laid in this way into which colour had penetrated had among other advantages a great resistance to the ravages of time and atmosphere. Rain, for example, runs rapidly off a smooth mirror-like surface, but not off a rough one. For *secco* painting on the other hand it is preferable that the plaster should not be perfectly smooth, since colours held together by a binding medium adhere better to a rough surface. This is the reason for Vasari's warning that when painting *a secco* on smooth pre-existing plaster, the plaster must first be roughened. Where fresh plaster is used, he continues, 'scratch it with the edge of the trowel, so that the resulting surface will be rough'. Nevertheless, Vasari himself developed a superb technique expressly for painting in oil on walls, and used it on very smooth surfaces in his decorations in the Palazzo Vecchio.

A century and a half later Padre Pozzo recommends granulating the *intonaco*, that is covering it with minute grains of sand so that the colours can adhere more easily. *Intonaco* roughened in this way should, he advises, be used for large works intended to be seen from a distance. It could also be used for works intended to be seen close to, but to ensure that the painting does not look too rough, a sheet of paper should be laid on it when it is finished and the excessive irregularities pressed lightly with a trowel through the paper to flatten them. This meant that the rougher the plaster was, the better suited was it for this type of painting, though for the sake of appearance large bumps had to be flattened out. Eighteenth century mural paintings, the great decorations of Tiepolo for example, illustrate how widely later artists followed Padre Pozzo's advice (fig. 2).

As mentioned above, the pigments used in *secco* painting adhere best when the painter works on a wall surface which is granular rather than smooth. This is why *secco* painting executed on a roughened surface has generally lasted, while additions *a secco* to the smooth surface of true frescoes have almost always disappeared.[1] In very many cases, for instance, the blues used for skies or robes have been lost, and all that remains is the red preparation beneath executed *a fresco*.[2] In order to paint *a fresco* it is necessary to use earth colours which are easily dispersed, and can sink into the wet plaster. But the only types of blue known to early painters, the very costly lapis lazuli (ultramarine) and Alemagna blue (azurite), were not completely soluble. For this reason they had to be put on the wall *a secco*, held together by glue, not by egg yolk which would have turned them green. Slight variations of tone were apt to occur in the same colour when it was applied on different days, as can be seen mostly in backgrounds. These variations were remedied by retouching in tempera.[3] Finally, after the fresco was finished, certain colouristic refinements were obtained by retouching *a secco*.

In almost every case these additions in tempera have disappeared. Only in

1. There are many examples of this in the exhibition. One is in the frame of the fifteenth century fresco with the Angel of the Annunciation (no. 25); another of special interest is the two lost portraits in the fresco by Alessandro Allori (no. 70). For these see the respective technical entries in the catalogue.

2. An example of the loss of blue can be found in the background of the Transfiguration by Taddeo Gaddi (no. 8). The green areas were originally Alemagna blue, transformed with the passing of time into malachite. A still more notable example of this metamorphosis is found in the Gozzoli tabernacle from Castelfiorentino (no. 46). In the figure of the dead woman at the base of the Orcagna Triumph of Death (no. 10) the *secco* retouching of the dress has disappeared, revealing the pink preparation beneath. Similarly the dress of the standing woman above is not fully finished.

3. The most obvious example of day-to-day colour variations is found in the Peruginesque fresco (no. 50).

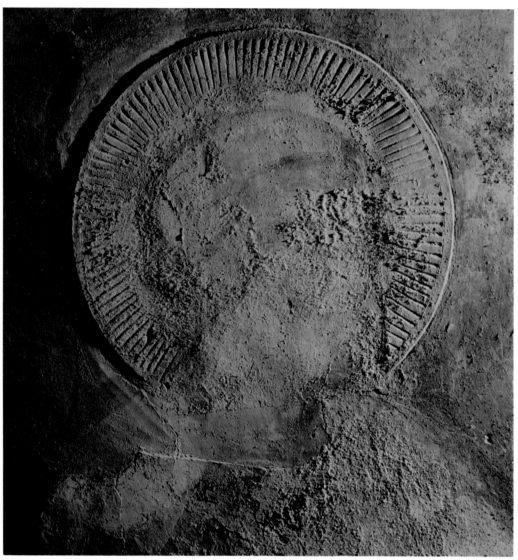

PLATE IIa. Salts on the surface of a fresco before detachment and restoration. Detail from the Last Supper by Taddeo Gaddi in Santa Croce, Florence.

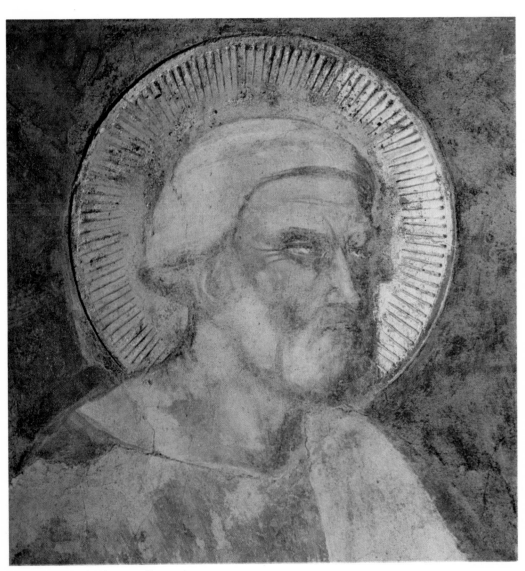

PLATE IIb. After detachment and restoration.

some small figures of the Virtues painted by Alesso di Andrea round a window in the Cathedral of Pistoia is tempera retouching preserved. This is due to the happy chance that the window was walled up soon after the frescoes were finished and was reopened only recently. By looking at these frescoes we can get a clear idea of how mural paintings were finished at this time (pl. I) and of the full meaning of the passage in which Cennini, after vehemently defending the practice of true fresco painting, adds what appears a contradiction in terms, that 'everything that is done in fresco must be completed and then retouched *a secco* in tempera'.

We have therefore to ask ourselves why artists abandoned the consummate technique of fresco—for Cennini it was 'the sweetest and subtlest technique that exists,' and for Vasari 'the strongest, surest, most decisive and durable method of all'—in favour of a technique that was not only aesthetically less satisfying, but also less resistant to time and atmospheric conditions. Painting *a fresco* was infinitely harder than painting *a secco*, and there were three main reasons why artists abandoned it. First, a painter working on damp *intonaco* could not see the exact tone of his colours; he was, as it were, working in the dark. 'When the wall is wet,' says Vasari, 'the colours on it do not look the same as they do when it is dry.' Secondly, changes and mistakes in drawing in true fresco can be corrected only at the beginning of the work and not subsequently, since the brushstroke is immediately absorbed by the *intonaco*. In other words, in fresco painting one cannot afford to make mistakes, whereas in painting *a secco* mistakes can easily be remedied. The third and principal reason for abandoning true fresco painting was the great saving of time in painting *a secco*. It must be remembered that times were changing and that the painter was no longer thought of as an artisan. About 1430 Leon Battista Alberti wrote in his Treatise on Painting: 'We may consider ourselves the first to have gained the prize of commending boldly to men of letters this most subtle and noble art.' Whereas an artisan could linger over the execution of his work, the painter who had risen on the social ladder and had assumed a new prestige, had to work fast in order to handle all the commissions he received. Painting *a secco* enabled him to meet these demands. In vain did the indignant Michelangelo declare: 'Oil painting is for women, and slow and slovenly people.' Though *intonaco* had already been spread on the altar wall of the Sistine Chapel, so that the Last Judgement could be painted *a secco* in oil, as had been planned, he insisted that it be removed, and decided, in spite of the much greater effort it entailed, to carry out the scene *a fresco*. But not even the fame that he enjoyed among his own contemporaries could check the trend away from fresco. The long apprenticeship that pupils had to serve before they were proficient in fresco painting could not be maintained when there was premium on speed. In words which read like a lament for the old order that was disappearing, Vasari writes: 'Of all the methods that painters employ, painting

on the wall is the most skilful and most beautiful, because it consists of doing in a single day what, with other methods, can be reworked over many days. Fresco was much used among the ancients, and the old masters among painters of the present day have continued to employ it.' But of young artists this was no longer true. 'Many of our artists excel in other kinds of work, that is in oil or tempera, but in this they are not proficient.' And even Vasari had recourse to oil painting in order to complete the vast mural decorations of the Palazzo Vecchio.

Let us now describe the stages by which frescoes were executed. Since artists in the fourteenth and fifteenth centuries did not feel humiliated by the task of preparing personally every detail of their work, they themselves spread on the wall the *arriccio*, a rough layer of coarse plaster whose surface was uneven so that the upper layer of plaster (or *intonaco*) could adhere to it. It was on this second layer that the painting was executed. When *intonaco* already existed, it was customary to use this as the *arriccio*, scratching the surface in many places so that the new *intonaco* would adhere.[4] A fine cord, soaked in red paint, fastened at each end and pulled taut, was pressed or 'beaten' against the wall, so that it left a mark on the *arriccio*. This established the centre of the space to be painted.[5] When the space was large, the cord was used more than once to make a number of vertical and horizontal divisions in it. The artist then drew in charcoal, directly on to the *arriccio*, the design of the painting he was to make, correcting it if necessary until he was completely satisfied. With a small pointed brush dipped in a thin solution of ochre which left only a light imprint, he went over the charcoal drawing, which was then erased with a bunch of feathers ('un mazzo di penne'). The faint ochre was then retraced and reinforced with *sinopia* red, and when this was done the preparatory drawing for the painting was complete. These large mural drawings (which are now called *sinopie* after the special red earth in which they were carried out) disappeared from sight under the wet *intonaco*, and only come to light again when the paint surface of a fresco is detached. No matter whether they are finished with great precision or show traces of rapid, summary execution—this varies from artist to artist according to the importance each attached to this preparatory work[6] —*sinopie* are always of the greatest interest, not only because they are often very beautiful (they were always executed by the master himself, unlike the fresco where pupils and assistants intervened) but also because they are almost the only drawings that survive from early times, when save in exceptional cases it was not a common practice to draw on paper or parchment. *Sinopie* could also serve to give the donor who commissioned the work a clear idea of how it would look when it was finished, and there are numerous cases in which one can infer that the patron insisted upon changes in the composition. They were not, however, intended to be permanently visible or to be exposed to public view. Consequently the *sinopia* consti-

4. There are various examples of this in the exhibition: see the *sinopia* by Lapo da Firenze (no. 2) St Onophrius (no. 14), and the Pistoia Crucifixion (no. 1). For other cases see fig. 3 and no. 3 in the exhibition.

5. A fine example is the *sinopia* by Paolo Schiavo (no. 33). Other cases are the Pistoia Crucifixion (no. 1), the Parri Spinelli Crucifixion (no. 32), the *sinopia* by Castagno (no. 41), the *sinopia* of the Castelfiorentino tabernacle by Gozzoli (no. 46), the Uccello *sinopia* from San Martino alla Scala (no. 36), and the Peruginesque fresco from Sta. Maria Maddalena dei Pazzi (no. 51).

6. The *sinopia* of Castagno from S. Apollonia (no. 41) illustrates most of the alternative procedures practised in *sinopie*. Thus, the angel is not only complete in all its details, but is also shaded. The three soldiers at the base are represented in essential features, while in the figure of Christ in the centre only the outline is recorded.

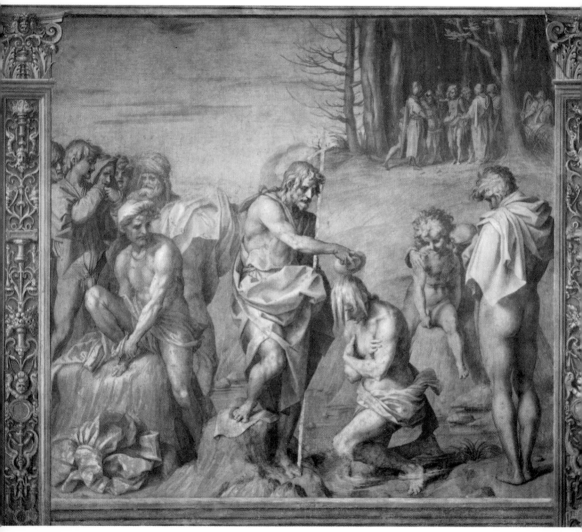

ANDREA DEL SARTO, the Baptism of the Multitudes, from the fresco cycle in the Chiostro allo Scalzo, Florence (cat. nos. 56-64).

tutes the purest expression of the artist's personality, one in which he is not compelled to follow the conventions of his period. Because they are a free expression of the painter's consciousness, *sinopie* sometimes seem altogether alien to the time in which they were produced (fig. 3).

When the *sinopia* was complete, the artist began his fresco by spreading the smooth *intonaco* on the *arriccio*. In true fresco technique he applied only as much *intonaco* as he could paint and finish between the morning and evening of one day. One can readily see on the paint surface of frescoes the extent of each day's work.[7] Close examination can even establish the chronological sequence in which the various parts of the fresco were carried out. The artist always began at the top of the fresco and worked down, the edges of the newly applied *intonaco* slightly overlapping the *intonaco* of the previous day's work.

Although the *sinopia* disappeared under the new plaster, the essential lines of the hidden drawing were rapidly retraced on the *intonaco*. So the fresco came into being. The separate sections (called *giornate* since each corresponded to a day's work) varied in size according to the difficulty they presented, to the part painted and to the speed of the artist's hand. In *mezzo fresco* the individual sections are much larger, and in painting *a secco* they are not visible at all. In this last technique the *intonaco* was laid at one time and left to dry and harden. When a large surface was to be painted, the walls of a chapel for example, one finds a division *a pontate*, determined by the level of the scaffolding. The *intonaco* extended as far down the wall as the artist could comfortably work. Later the scaffolding was lowered, and the artist laid new *intonaco* below his previous work, continuing in this way until he reached the bottom of the wall. Consequently the joins in the areas of *intonaco* on the paint surface are horizontal, and run parallel to each other at uniform intervals (fig. 4).

The *sinopia* was in constant use until the fourteen thirties unless a single figure only was to be painted or the work was to be carried out in *mezzo fresco* or *a secco*, when the drawing could be traced directly on to the *intonaco*. Thereafter the use of *sinopie* declined, though it never altogether disappeared. In Florence it was taken up again at the end of the sixteenth and the beginning of the seventeenth century. In general, however, it was replaced by other methods, first by *spolvero* (pouncing or dusting) and then, especially in the Cinquecento, by the use of a cartoon. Drawings of the same dimensions as the fresco were executed on large sheets of paper, their outlines were pricked with a needle, and they were then cut into sections corresponding with the various days of work. When the *intonaco* for the day had been laid, the corresponding section of the drawing was placed over it and 'dusted' with a cloth bag filled with finely ground charcoal powder. Passing through the perforations in the drawing, the charcoal dust adhered to the *intonaco*, leaving little dots which

7. The *giornate* are very noticeable in the frescoes by the Master of the Chiostro degli Aranci (nos. 37, 39) and in the Peruginesque fresco (no. 50).

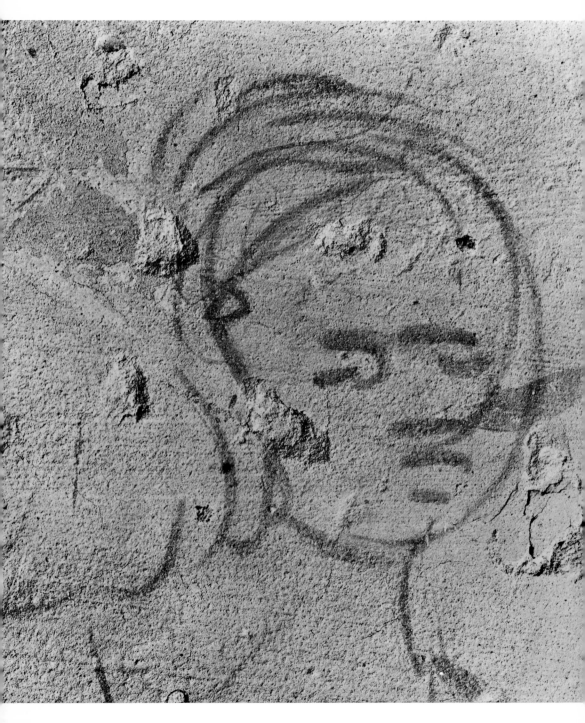

FIG 3. Detail of a *sinopia* by an unknown Florentine artist of the end of the fourteenth century, Sant' Agostino, Empoli.

are still visible on close inspection today.[8] At the beginning of the Cinquecento the *spolvero* technique was replaced by the cartoon, with whose aid the drawings could be more speedily transferred to the *intonaco*. In this technique the drawing was traced on paper of medium thickness, and as with the *spolvero* method was cut to conform to each day's work and attached to the fresh *intonaco*. The outlines were then gone over with a sharp stylus. According to Vasari, 'when . . . cartoons are used for fresco or wall painting, a piece of the cartoon is cut off and pressed on the wall, which must be freshly plastered and absolutely clean. The piece of the cartoon is placed on the exact spot where the figure is to be. A mark is made so that on the following day the next piece of cartoon will match. To transfer the outlines on to the wall, the artist uses a stylus to impress them in the fresh plaster, which yields to the pressure on the paper and is thus marked.'[9]

A complete change in the preparation of large designs for frescoes and mural paintings was brought about by the invention of the net (*rete*), which enabled artists to use large portable drawings on paper in place of *sinopie*. This net, or grid, or squaring as it was also called, was not unknown to earlier artists, though it was used by them for other purposes. It offered a practical means of expanding small drawings to large dimensions. The surface of the drawing was divided by horizontal and vertical lines into squares of uniform size (fig. 5). A corresponding grid, on a considerably larger scale, was traced on paper or light pasteboard, and the lines of the drawing could then be projected almost mechanically on each of the large squares.

A precedent for the net is the veil that Leon Battista Alberti claims to have invented. Squaring is, however, employed in Masaccio's fresco of the Trinity in Santa Maria Novella, where squares are incised in the *intonaco* of the face of the Virgin. This suggests that it was probably a product of the studies inspired by Masaccio's friend, the architect Brunelleschi. Alberti's veil was 'a very soft veil thinly woven and dyed whatever colour you wish, with thicker threads placed in parallel lines at as frequent intervals as you like'. These thick threads crossed one another to form a grid which was placed 'between the eye and what was viewed,' in such a way that the object to be painted was seen through squares which corresponded with those on the paper. By this means, square by square, the artist could copy what he perceived with his eyes. Alberti's words seem to imply that this new method was opposed by traditional artists, and to painters accustomed to draw their compositions freehand on large wall surfaces the technique may well have seemed degrading. 'I refuse to listen', he writes, 'to those who say that there is little need for the painter to use such things, even though they are a great aid to good painting. On the contrary they are so made that one day he will be able to do nothing without them. I do not expect

8. Above all, this can be seen in the head of St Jerome by Andrea del Castagno (no. 42) and in that of the Saint by Piero della Francesca (no. 45).

9. The exhibition includes a beautiful and old example (the earliest known) in the St Jerome from Pistoia (no. 44); other fine examples occur in the frescoes by Pontormo (nos. 66, 68) and by Allori (no. 70).

vast labour from an artist, but rather painting which appears recessive and which resembles what he sees. Without use of the veil I believe this to be unattainable.'

Quite apart from the controversies attendant on the introduction of a novel technique whereby old habits and practices were changed, it must be stressed that the practice of making preparatory drawings for mural paintings was also revolutionised. No longer were large compositions conceived and translated into drawing on scaffolds set against church and cloister walls. Instead, projects were planned in workshops in small drawings which could later, with the assistance of the grid, be enlarged to the desired dimensions. As the artist ceased to have immediate contact with the surface to be decorated, the whole concept of composition underwent a change. Sometimes the sense of synthetic vision seems as a result to be compromised by analytical detail—the frescoes by Benozzo Gozzoli in the Medici-Riccardi Palace are a case in point. It seems that when studies which originated as small drawings were enlarged, the practice encouraged a search for picturesque detail to the detriment of the dominant theme.

Insufficient weight is normally attached by art historians to these technical considerations but they enable us to understand how mural paintings were conceived, how they developed and how they came alive under the artist's brush. In some cases, moreover, they can help to resolve questions of attribution through study of the similarities and differences in the way in which mural paintings were carried out. The facture and constitution of the *intonaco* may vary from painter to painter. Each artist employed his own formula for the lime and sand mixture he required, and from slight differences in this amalgam we can sometimes infer the presence of a different painter.

The precarious state of preservation of many mural paintings is due mainly to two factors, the passage of time and inexpert restoration which in many cases has only served to aggravate the condition it was designed to rectify. Damp, seeping upwards from the ground or downwards from the roof, is the great enemy of mural paintings, especially those in the open air, on the façades of buildings, in cloisters, porticos or tabernacles. It attacks the fabric of the *intonaco*, depriving it of its resistance and cohesiveness. It can, moreover, bring with it more fearful hazards, such as nitrates and other salts, which, as they reach the surface, destroy the colour and cause the paint to disintegrate and drop off in tiny flakes.

This was what occurred on a terrifying scale in Florence after the flood of November 1966. The nitrates, with which the ground under many churches is filled as a result of the decomposition of the bodies buried there, were dissolved in the water and were carried to the painted wall surfaces, where they were fed from below by capillary action (pl. IIa, b). It seemed that when, in early spring, the *intonaco* began to dry and the salts were brought

◁ FIG 4. An example of *pontate*, outlined in white. Fresco by Giotto in the Peruzzi Chapel, Santa Croce, Florence.

to the surface, a great number of the mural paintings for which Florence is renowned would inevitably suffer serious damage and might in many cases perish. Fortunately, it was possible to detach the frescoes that were in danger, even though most of them were still wet. This was the only means by which total ruin could be averted. It is impossible to describe here the complex rescue operation that was involved. Suffice it to say that after a year and a half of unremitting work, two thousand three hundred square metres of mural painting were detached. In two cases—the Nardo di Cione Inferno in Santa Maria Novella and the Crucifixion of Taddeo Gaddi in Santa Croce—the frescoes were removed in single pieces, respectively a hundred and ten and a hundred and twenty square metres in size.

In addition to corrosive salts, the presence of organic substances, such as egg or various types of adhesive, sometimes contributes to the need to remove frescoes from their walls. Though these substances were originally used to give consistency to the colour and prevent its falling off, with time they have the opposite effect. The reason for this is that the dry glue on the surface loses its elasticity and causes the pigment to become detached. This problem can usually be dealt with if the glue on the paint surface can be removed. When the wall is attacked by damp, the binding substance frequently develops mould. Moulds must be checked immediately, otherwise, like salts, they pulverize and destroy the layer of colour. Remedial action can sometimes be taken in such cases, but when it proves ineffective, the fresco has to be detached.

The transfer of frescoes was carried out even in Vasari's day. Indeed, Vasari explains how the difficult operation was performed. A whole block of masonry was sawn through and held together with chains. In his biography of Spinello Aretino he tells us that there was 'a figure of the Virgin handing a rose to the Child Christ, which on account of its beauty and its devotional quality was much venerated by the people of Arezzo. When the church of Santo Stefano was razed, the people of Arezzo cut through the wall surrounding the fresco and cleverly fastened it together. They brought it into the city and placed it in a small church where they honour it with the same devotion as before.' This transfer was carried out in October 1561, when the Duomo Vecchio and the oratory of Santo Stefano which stood near it were demolished. The fresco can still be seen in the place to which it was moved in the sixteenth century.

In two passages in the biographies of Domenico Ghirlandaio and Botticelli, Vasari relates what happened to two celebrated frescoes by these artists when the old choir of the church of Ognissanti in Florence was destroyed. Speaking of Ghirlandaio's St Jerome he writes: 'Since the friars were obliged to remove the choir from its old place, this painting, along with one by Sandro di Botticelli, was tied with iron and transported to the middle of the church, without any fissure, at the very time at which the second edi-

◁FIG 5. Drawing squared for transfer. The Angel of the Annunciation by Pontormo, Uffizi, Florence (see cat. 68).

tion of these lives is being printed.' Of Botticelli's St Augustine he writes, 'in this year of 1564 this painting, as was mentioned in the life of Ghirlandaio, has been moved from its place, and is safe and intact'.

Though the second edition of Vasari's Lives did not appear till 1568, it was finished some years earlier, and for this reason he does not mention another important transfer, that of the fresco of SS. John the Baptist and Francis in Santa Croce. Once ascribed to Andrea del Castagno and now unanimously given to Domenico Veneziano, it was moved from the site for which it had been painted because of the demolition of the old choir of the church. Bocchi records this move in his *Bellezze della Città di Firenze* (1591): 'The merit of this painting was the reason why, when the entire wall of the choir was demolished in 1566, the whole section containing these figures was preserved, and with great trouble and expense moved to the place where it is now.' These are the first recorded transfers of frescoes. It seems that they were carried out either because a much venerated image was involved, or because the works concerned were held to be of high artistic value.

Marcantonio Michiel, writing between 1510 and 1530, claimed to have seen in a private house at Padua a head believed to be by Cimabue, which had been removed from the church of the Carmine at Padua after a fire. Moreover, when the Palazzo Comunale at Sansepolcro was restored some years ago, it transpired beyond all possibility of doubt that, at the beginning of the sixteenth century or even at the end of the fifteenth, Piero della Francesca's famous fresco of the Resurrection was moved from its original site to its present location, along with the 'stola' of bricks on which, as we know from documents, it had been painted.

The practice of removing mural paintings (fig. 6) together with the section of wall on which they were painted continued intermittently, and is still sometimes resorted to today when there is no viable alternative. It was certainly used up to the beginning of the eighteenth century, as Giovanni Bottari mentions in his edition of Borghini's *Riposo* (1730). According to this source, the owners of what is now the Palazzo Ferroni in Florence transferred 'a lovely little cupola by Bernardino Poccetti to a site that suited them better'. The chapel still exists, and the frescoes in the cupola seem to be perfectly preserved. This is the more amazing in that the undertaking was, of course, carried out with far more limited means than those of which we dispose today.

Some decades later, the architect Nicolò Gasparo Paoletti successfully moved a large vault in the Villa of Poggio Imperiale, which was then ascribed to Matteo Rosselli but has recently proved to be the work of Ottavio Vannini. This achievement is described by a contemporary of Paoletti's, Domenico Moreni, who writes that, 'in order to enlarge the Villa, His Royal Highness Pietro Leopoldo ordered that the vault, which measured about a

FIG 6. Fresco detached with section of wall. Madonna and Child with Angels by Masolino, Sant' Agostino, Empoli.

hundred and forty square *braccie* [about forty-seven square metres], be moved. This risky undertaking was successfully carried out, with no damage at all to the frescoes, in the presence of the Royal Sovereigns and to their great satisfaction, on the thirteenth day of April 1773, through the skill and industry of our fellow Florentine Signor Nicolò Gasparo Paoletti, first architect of His Royal Highness.' A few years later, in 1788, Paoletti successfully effected the removal of a large painted tabernacle by Giovanni da San Giovanni. Moreni reports that this operation 'was admirably executed by the famous engineer Gasparo Paoletti. With the use of a well-devised apparatus, he transferred the entire tabernacle with the Rest on the Flight into Egypt by Giovanni da San Giovanni from the Giardino della Crocetta to the sculpture gallery in the Accademia delle Belle Arti.' The tabernacle can still be seen, perfectly preserved, at the Accademia today (fig. 7). In 1813, when the Villa of Poggio Imperiale was renovated, the vault by Ottavio Vannini was moved for a second time, on this occasion by the architect Giuseppe Cacialli. These achievements must arouse our wonder as they did that of contemporaries. On Gasparo Paoletti's tomb in Santa Croce his feats in moving the vault and chapel are singled out for special praise ('cuius sagacissimo ingenio testudo et sacellum pictoria insigna pristino loco cunctis admirantibus amota sunt').

Such technical tours-de-force could, however, only be effected in rare cases, and it was necessary to look for easier methods of transferring mural paintings. As we shall see, new methods, mainly perfected in the last few decades, now make it possible to proceed confidently with an operation that may seem (and did seem when it was first attempted) extremely difficult. There are two ways in which the operation can be carried out, the first by detaching all the *intonaco* (the *stacco* method) and the second by removing the paint-layer alone (the *strappo* method). *Stacco* is generally used for well-preserved frescoes where the colour and *intonaco* are still unified and are not easily divisible. *Strappo* is used for disintegrating surfaces where the colour has started to detach itself from the *intonaco*. Mural paintings preserved in cloisters and tabernacles or those which have been damaged by corrosive salts belong almost without exception to this second class. With both techniques it is necessary first to lay down loose particles of colour and free the paint surface from foreign substances. When this has been done, canvas, generally of double thickness, is fixed on to the paint surface, with different adhesives for each of the techniques, in order to prevent the paint surface and the *intonaco* from cracking and disintegrating at the moment of detachment. With the *stacco* technique the process of detachment is effected through the slow and cautious separation of the *intonaco* from the *arriccio*, which is achieved by using a knife and by pounding the *intonaco* with a wooden or rubber hammer to reduce the adhesion between the two (fig. 8). The fresco is then laid down on a flat surface

34

FIG 7. Tabernacle with the Rest on the Flight into Egypt by Giovanni da San Giovanni, Accademia, Florence. ▷

with the canvas still attached, and the *intonaco* is removed from the back until the thin layer of paint (that is the surface of the *intonaco* which has soaked up the pigment) is reached. When the layer of paint is clean and smooth, it is glued to a support and mounted. The support may be of masonite (which does not react to changes of humidity) or of a special type of resin. The latter is preferable, but is a good deal more costly. When this is completed, the canvas is removed from the front of the fresco.

With the *strappo* technique it is essential that the adhesion between the canvas and the layer of colour be greater than that between the layer of colour and the *intonaco* beneath. In cases where the *intonaco* is disintegrating because of the action of moisture or salts, the adhesion of the colour to the *intonaco* is generally extremely weak. When the canvas on the surface has dried and the adhesion between it and the layer of pigment is consequently at its strongest, the canvas is gradually pulled off the wall, bringing with it the layer of colour (fig. 9). The fresco is then laid flat and every trace of the *intonaco* is removed from the back, until, as in the *stacco* technique, the surface is absolutely smooth.

Experiments with the *stacco* technique are known to have been made in early times. In 1374, when the old cathedral of Santa Reparata in Florence was demolished, an attempt was made first to remove the upper half of the figure of the Baptist, the protector of the city, and then to detach the head. In 1627, when the church of the Badia was under restoration, an attempt was made to detach the heads of the Virgin and Annunciatory Angel from a fresco of the Annunciation by Giotto. Amateur experiments like these were not infrequent but were almost always unsuccessful (fig. 10). Sometimes sections of mural paintings came away accidentally. Baldinucci records that in 1626 a mason labouring on the loggia outside the church of the Annunziata broke through the wall, detaching a piece of Andrea del Sarto's fresco of St Philip Benizzi raising a dead girl, in the forecourt of the church. Andrea del Sarto's frescoes enjoyed great celebrity, and the resulting scandal is described by Baldinucci: 'Two of the most beautiful heads fell to the ground. As news of the disaster spread, there was general criticism both of the negligent workman and of the overseer who could have prevented the damage. Hearing this, the painter Passignano hurried to the spot, and with great pains sought out the pieces which had fallen from the fresco and put them back in place, and the heads took on almost all their former beauty save for the fine hair-like joins that can still be seen in them. Thanks to Passignano's proficiency, what was looked on with sorrow by amateurs when it occurred is now regarded as a prodigy.' As can still be seen, the results of Passignano's work were very satisfactory. A short time later the same thing happened to Francesco Salviati's large fresco of Scenes from the Life of Camillus in the Salone dell'Udienza of the Palazzo Vecchio, when *intonaco* on the right side of the fresco was

damaged. This time it was the painter Volterrano who came to the rescue, gathering the pieces together and putting them back with very good results. From cases like these, in which the detachment of the paint surface was accidental, we must pass to the rather different category of detachments which were deliberate. Girolamo Baruffaldi tells us in his *Vite dei pittori e scultori ferraresi* (which were written at the very end of the seventeenth and the beginning of the eighteenth century), that in 1690 his father, Niccolò Baruffaldi, suggested to Giulio Panizza, the mason in charge of the demolition of a chapel in San Giorgio at Ferrara, that he might be able to recover intact some life-size heads from the frescoes by Domenico Panetti which it contained. 'The valiant mason,' writes Baruffaldi, 'promised that he would use all possible diligence, and succeeded in rescuing fourteen sections, which he reinforced with plaster and offered to my father as a gift'. This was a case of detachment by *force majeure*, since the chapel was scheduled to be destroyed. But a few decades later optional transfers began to be carried out. Our source is once more Baruffaldi, who writes of the Ferrarese painter Antonio Contri that: 'About 1725, he heard that in the city of Naples some miraculous Madonna painted on a wall had been removed without cutting into the wall and transferred from an old church to a new one, and that the restorer possessed the secret of removing only the paint film and the plaster on which it was painted, reinforcing it from behind to hold it together in such a way as to avoid all risk of breakage. Contri determined to try a similar experiment, and notwithstanding the scepticism of his friends, after a year of unsuccessful experiments, one day, with indescribable joy, he began to understand how it could be done. The first case in which he succeeded, involved a piece of architectural decoration of the size of a large sheet of paper, which he removed complete and intact with only a very thin layer of plaster. He did not know how to reinforce it, and for this reason, he almost gave up the whole undertaking. However, he was reluctant to abandon his experiments, and moving from one discovery to another, he finally was able to attain the perfection he desired.' The account by Baruffaldi which follows is of great interest, and some sentences from it must be quoted here: 'The method that Contri used was this. He covered the paint surface with a piece of canvas well varnished with a special bitumen or glue which adhered firmly to the wall. When the painting was covered, he tapped the canvas with a wooden mallet, and then cut the *intonaco* round the canvas [as is still done today]. With his knuckles he sounded the wall to see if it was solid or showed traces of blistering. Then after it had been left to dry for several days, he little by little peeled off the canvas, which brought the paint-layer with it from the wall. This was immediately placed on a flat smooth table. He then applied to the back another canvas which was varnished and impregnated with an even stronger adhesive than the first. On this he placed sand

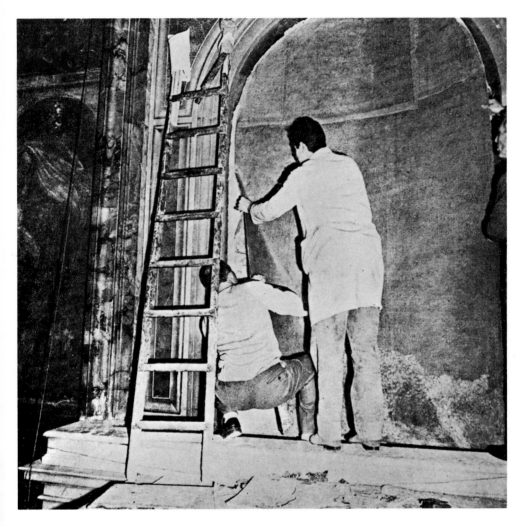

FIG 9. Detachment of a fresco by the *strappo* method.

◁FIG 8. Detachment of a fresco by the *stacco* method.

FIG 10. An incomplete and unsuccessful attempt at detachment by the *stacco* method. Head of a saint by Spinello Aretino in Santa Trinità, Florence. The fresco was chipped for the *intonaco* of a new fresco by Lorenzo Monaco.

and weights, in order to compress the painting uniformly. The work was left in this condition for a week, and the weights and sand were then removed. After this was done it was reversed and replaced on the table, and the first canvas was washed with hot water to remove the glue. When the canvas was lifted off, the painting reappeared as beautiful and fresh as it had been on the wall, indeed cleaner than before since the glue brought away with it the dust which, with the passage of time, had accumulated on the surface. If there were any traces of scratching or signs of incisions made by the painter, these too were preserved just as they had been on the wall.' This minute description of Contri's experiments shows that the method he used was not very different from the method that is used today. After more than two centuries of experience, the detachment of frescoes still seems almost inconceivable to many people, and one can well imagine the impression that it made when the operation was carried out for the first time. Baruffaldi's words are a lively echo of this amazement. After telling us that Contri's first detachments were undertaken in Cremona, he adds that in 1728 the artist returned to Ferrara, where he successfully overcame public scepticism of his new technique. A year later, in 1729, Baruffaldi himself took an example of fresco detached by the *stacco* method to Bologna, where, through the interest of Giampietro Zanotti of the Accademia Clementina, 'many painters and dilettanti came to see this new discovery. I saw them all contemplate it with astonishment. After examining and discussing it, they concluded that the claim was true. They touched the transferred fresco with their hands, but did not understand the method nor the skill with which it was accomplished, since they could not understand how the layer of colour alone could be removed without the *intonaco* and laid on canvas.' Baruffaldi's words are complemented by the even more enthusiastic comments of Zanotti, who in 1739 speaks of 'the inestimable secret of removing paintings from walls and placing them on canvas, a remarkable thing and scarcely to be believed. At first I thought that the secret lay in the removal from the wall of the thin layer of painted *intonaco*. What makes it stupendous and almost unbelievable is that only the colour is removed, some traces being left on the *intonaco* in those parts where the colour was denser and darker.' What was involved, therefore, was a true *strappo*; even today traces of colour, the extent of which varies from case to case, are sometimes left on the *intonaco*. In May 1730, however, at the very time at which he was summoned to Bologna to detach some frescoes there, Contri had an attack of apoplexy, and he died in November 1732 without doing further work. He left two sons, Giuseppe and Francesco, but it is not known whether they inherited the secret from their father or if he took it with him to his grave. The words of Baruffaldi: 'May God grant that rumour is true, and that one of his sons possesses his father's secret,' shows that this issue was in doubt. Zanotti likewise writes: 'If this

beautiful art dies with its creator, this will be a grievous loss. But if it lives and can be propagated, every city which has beautiful mural paintings will bless Ferrara, where there was discovered a means of saving from destruction the notable works of art for which this country more than any other is renowned.'

Whether or not Contri's method was lost, knowledge of how frescoes could be transferred did not disappear, for Lanzi, writing at the end of the century, tells us that in the years that followed the technique 'was perfected by others, and the rediscovered method was widely disseminated,' so that 'nowadays in Italy this secret or its equivalent is well known'.

Notwithstanding inevitable failures, like the disastrous result of a *strappo* undertaken in Florence in 1787 by the painter Sante Pacini on a fresco wrongly ascribed to Cennino Cennini, which is still preserved today though reduced to a shadow of what it once was, many frescoes were detached in the eighteenth century in Italy. Giacomo Succi, for example, was responsible for detaching the frescoes by Bartolommeo Cesi in the town of Imola, and worked for many years at the end of the eighteenth and beginning of the nineteenth centuries at Imola, Ferrara, Bologna, Mantua and Rome. Mural paintings at Modena, Scandiano, Cento and Ferrara were detached by Antonio Boccolari, whose son Pellegrino, like Girolamo Contoli from Imola, was a pupil of Succi.

In the Veneto, Filippo Balbi removed all the frescoes, a hundred in number, from the Palazzo Morosini at Castelfranco; some of these are now in the Museum at Castelfranco and others are in the Seminario in Venice. The frescoes in the Palazzo Foscari at Malcontenta on the Brenta, which were painted by Zelotti, Battista Franco and members of the workshop of Paolo Veronese, were also detached, and are now preserved in the Museo di Castelvecchio at Verona. In 1818, through the generosity of the rector (or *sindaco*) of Padua, a medal was presented to Giuseppe Zeni, a chemist, in recognition of his skill in removing frescoes from the wall. Finally, in Florence in 1809, under Principessa Elisa Bonaparte Baciocchi, permission was given to a Frenchwoman, Madame Barret, to give a public demonstration of her technical ability. The operation was carried out successfully, but, according to Cicognara, after some years 'the painting was found to be shrivelled and covered with minute cracks: owing to scaling the colour no longer adhered to the canvas, and fell off.' The same thing happened to a fresco by Guido Reni which Madame Barret detached not long afterwards in Rome. It can be concluded therefore that by the turn of the nineteenth century the technique of *strappo* was well mastered, though many works were ruined by the treatment accorded them after the *strappo* was complete. Some of the detached frescoes were mounted on canvas, an unsuitable support since it slackens with time and causes the colour to flake off. Whenever adhesive substances were spread on the surface of frescoes,

the results were bad. Finally, if the *intonaco* was not completely removed from the back, in cases where the technique of *stacco* was employed, the moisture present in the *intonaco* continued its destructive action, albeit slowly.

Notwithstanding this, Cicognara, in an article published in 1825 in the Florentine review *Antologia*, began a crusade against the detachment of frescoes, basing himself partly on the poor results that had been obtained, and partly on the fear that mural paintings (as had happened not long before at the time of the Napoleonic invasion with portable works of art) might be removed from Italy. The fact, however, was that the techniques of *stacco* and *strappo* were pursued with far from unsatisfactory results. In the same year in which Cicognara wrote his bitter invective, the frescoes by Melozzo da Forlì, now in the Pinacoteca Vaticana, were detached on the instructions of Pope Leo XII. The famous frescoes of Sir John Hawkwood and Niccolò da Tolentino by Uccello and Castagno were removed from the wall of the Duomo in Florence in 1842, and a few years later the frescoes of famous men and women by Castagno in the Villa Carducci at Legnaia were likewise detached. By this time such operations were being undertaken all over Italy, so that by 1866 Secco Suardo could write, in a text book on restoration, that 'at the time at which we live the need to save from certain ruin a quantity of frescoes by great artists, by detaching them, advances by giant steps from day to day'. In the same year Cavalcaselle asserted that 'whenever a wall is attacked by damp, it is essential to detach the fresco if one does not want to see it disappear'.

The present exhibition is a unique occasion which will never be repeated. It is a tribute of gratitude from the Italian people, and especially from Florence and other cities in Tuscany, to all those who, from every country all over the world, with moving warmth and solidarity, despatched material help on an imposing scale after the tragic flood of the River Arno in November 1966. It is a tribute also to all those who came in large numbers to work side by side with the people of Florence on their difficult and as yet unfinished task, and who contributed, and are still contributing so greatly, to the saving of a cultural and artistic patrimony, of which Florence is the custodian but which belongs to the whole civilised world.

General Bibliography

ORIGINAL SOURCES

Cennino Cennini, *Il libro dell'arte*, translated as *The Craftsman's Handbook* by D. V. Thompson, Jr., New Haven, 1933; New York, 1954.
Giorgio Vasari, edited by G. Baldwin Brown, *Vasari on Technique*, London, 1907; reprint London & New York, 1960.

MODERN STUDIES

E. Borsook, *The Mural Painters of Tuscany*, London, 1960.
R. Oertel, 'Wandmalerei und Zeichnung in Italien', in *Mitteilungen des Kunsthistorischen Instituts in Florenz* V, 1940, pp. 217–314.
U. Procacci, *La tecnica degli antichi affreschi e il loro distacco e restauro*, Florence, 1958; and *Sinopie e Affreschi*, Milan, 1961.
L. Tintori & M. Meiss, *The Painting of the Life of St. Francis in Assisi*, New York, 1962; 1967.
L. Tintori & E. Borsook, *Giotto: The Peruzzi Chapel*, New York, 1965.
D. V. Thompson, *The Materials of Medieval Painting*, London, 1936.

Catalogue

Each catalogue entry has four sections: biographical notes on the artist prepared by Duncan Robinson; critical discussion of the works contributed by various authors whose names are given after each entry; technical information on the condition of the work and the method and date of detachment compiled by Dr Umberto Baldini; and finally, bibliographical references prepared by Sherwood A. Fehm, Jr. The technical and bibliographical sections are set as marginal notes.

The bibliographies refer only to the most recent publications specifically concerned with the works exhibited. Where a large body of literature exists, a selection has been made with emphasis on publications in English. Wherever possible a work which contains previous bibliography has been included. The general survey of Florentine churches by Walter and Elizabeth Paatz, *Die Kirchen von Florenz*, published in 5 volumes between 1940 and 1953, contains much material regarding frescoes which came to light before 1953, but it has not always been cited.

The glossary at the end of the catalogue has been compiled by Dr Umberto Baldini.

When the fresco was discovered it was not in good condition, and was damaged further during the last war, especially near the edges where certain parts were completely destroyed. In addition to this, the wall on which it was painted suffered seriously from the infiltration of damp. This in turn caused the paint surface to deteriorate. An unsuccessful attempt was made to isolate it from rising damp by cutting into the wall beneath it. To avoid further damage it had to to be removed completely and without delay. However, this proved to be more difficult than usual; gelatine is normally used in the operation, but in this case the presence of salts prevented it from drying. After the necessary tests, a method was devised in which advantage was taken of the experience gained in Florence after the floods. The removal of the fresco, which was carried out by the restorer Alfio Del Serra, revealed an interesting technical point about the way in which the artist had prepared the *intonaco* and *arriccio*. In the *intonaco*, a high proportion of tow had been added to the normal mixture of lime and sand, and the *arriccio* contained straw. The technique he used was not, as far as we know, employed in Florence, where the method described by Cennini was predominant. It might be explained as the work of an artist with a foreign background or training, perhaps in some way connected with the 'Greek [Byzantine] Masters' who are supposed to have arrived at Pisa as early as the twelfth century. The *sinopia* was drawn first in ochre and then gone over in red; in conformity with the technique laid down by Cennini. The *arriccio* was scored with the point of a hammer to improve adhesion between its surface and the *intonaco*.

The *strappo* method of removal was used and new supports of the *sinopia* consist of two layers of polyester and fibreglass, separated by a layer of polyurethane.

U. Procacci, *Atti del I Convegno Internazionale di Studi Medievali di Storia e d'Arte* (1964), p. 363.
U. Baldini, in *La Nazione*, Florence, Feb. 13, 1968.

I

CRUCIFIXION
Sinopia, 10ft 4in x 14ft 10in (315 x 452cm)
Church of San Domenico, Pistoia

The *sinopia* was discovered as recently as January 1968, when the Crucifixion fresco on top of it was removed from a wall of the chapter house in the church of San Domenico in Pistoia. The fresco itself was found some thirty years ago beneath a coat of whitewash which completely concealed it. It can be attributed to a painter active around 1250, perhaps a follower of Giunta Pisano, but is also influenced by the art of Florence in the era before Cimabue. This impression is confirmed more strongly by the *sinopia*, which displays a number of interesting variations when compared to the finished version of the fresco. We can tell from the *sinopia* that the artist conceived the scene as an isolated episode in the narrative of the Passion, making St John and the Virgin into a grief-stricken group on the left side of the cross, counterbalanced by the harsh and arrogant figure of an armed soldier on the right. Perhaps it was the Dominican commissioners who asked for and later insisted upon a Crucifixion representing only the three essential characters (excluding the soldier and placing St John on the right), a Crucifixion more strictly devotional and appropriate to the chapter house of the Convent, in which theological and administrative assemblies took place. The artist then made several notes of the changes he was obliged to adopt, on top of the design he had already prepared. These corrections can be identified in paler additions to the *sinopia* drawing; the horizontal line marking the top of the wall beyond which the city of Jerusalem will rise, the buildings shown in foreshortened perspective on the left above the Virgin and St John, and the new halo above St John, enlarged to become that of the Virgin. On both sides of the double border, which must have remained uncovered after the first application of the *intonaco*, we can see small patches—green, cinnabar red, brown-red and azurite blue—where the artist clearly tested his colours. Furthermore, the *sinopia* is important for the assistance it gives us in reading those parts of the fresco which are almost completely lost, above all on the face and body of Christ. Fresco and *sinopia* together represent a fundamental addition to our understanding of artistic practice in Pistoia at this time; on the basis of a documentary analysis due largely to Procacci, this is the subject of current study.

UMBERTO BALDINI

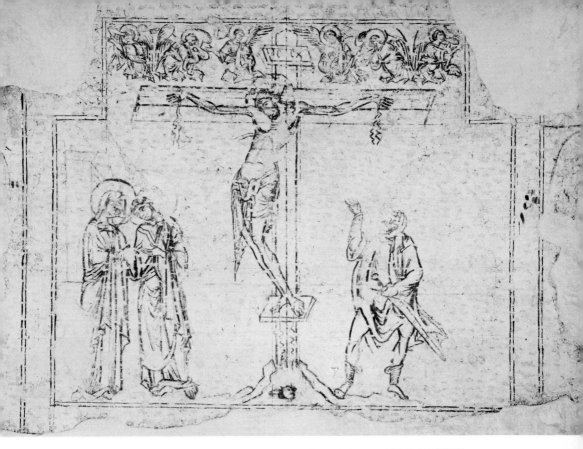

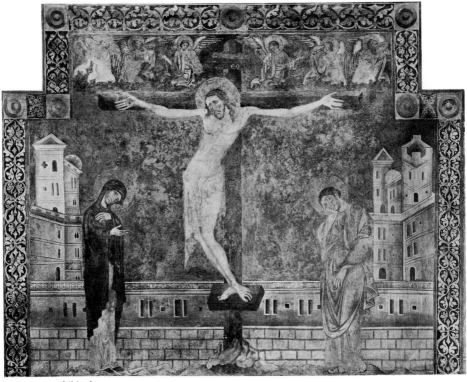

Fresco not exhibited

47

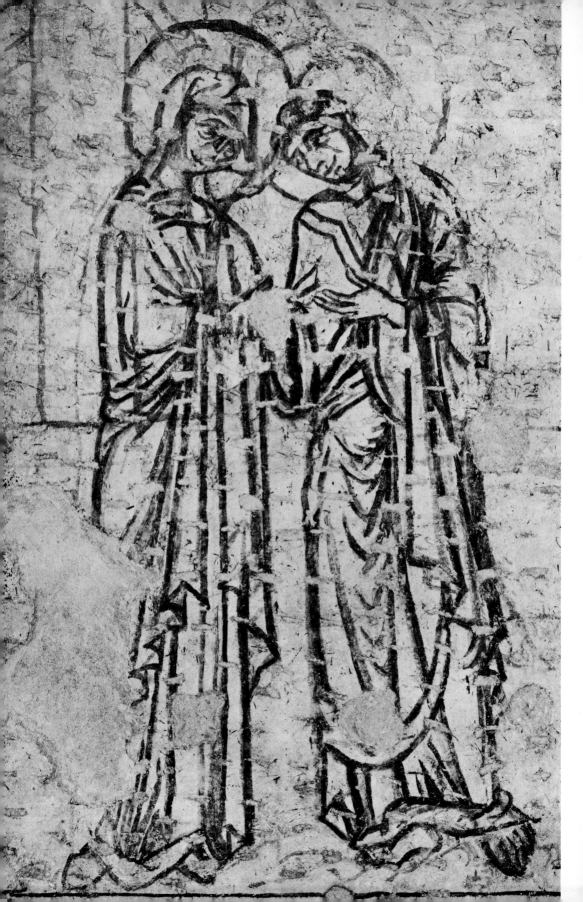

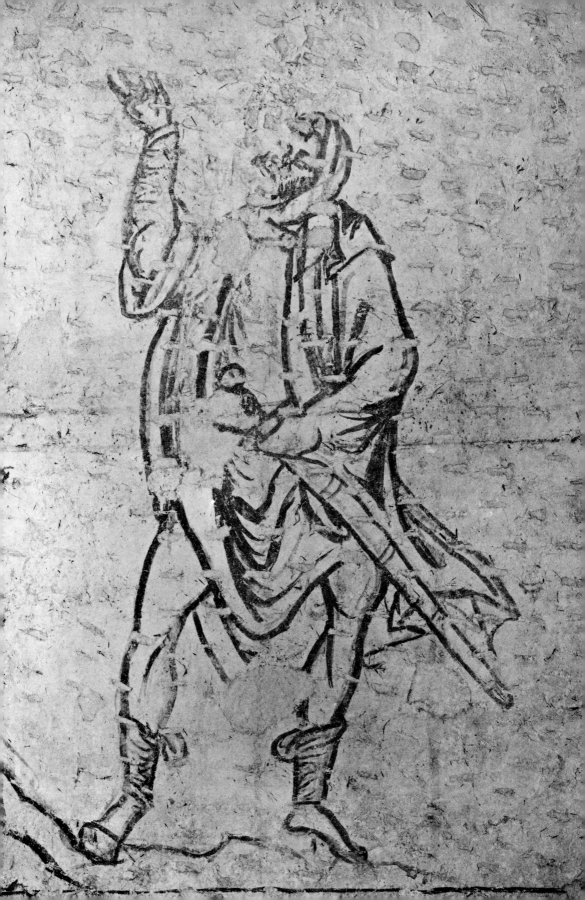

LAPO DA FIRENZE
active c. 1260–80

Our knowledge of Dugento painting in Pistoia is still incomplete. We know that Coppo di Marcovaldo worked there in 1275 and that this local school was influenced by the later Florentine works of Cimabue. However, the activity of an artist like Lapo da Firenze, documented in 1260, suggests that a native tradition flourished much earlier. Other frescoes have been attributed to Lapo da Firenze in the Cathedral of Pistoia and in the church of S. Bartolommeo in Pantano.

2

MADONNA AND CHILD WITH SAINTS JACOB AND ZENO
Sinopia, 4ft 11⅞in x 6ft 11½in (152 x 212cm)
Cathedral, Pistoia

Although constant exposure to the weather had destroyed the fresco, its *sinopia* was discovered in perfect condition beneath the *intonaco* which protected it. The *sinopia* was painted in yellow Siena clay, then finished in red, on a pre-existing plaster surface which was roughened by the artist with a hammer to make the *intonaco* adhere; this explains the damage visible in the *sinopia*, apart from which its condition is good. It was detached in 1959 by Alfio Del Serra, using the *strappo* technique, and was transferred to a masonite support.

U. Procacci, *Sinopie e Affreschi* (1961), p. 49; and *Atti del I Convegno Internazionale di Studi Medievali di Storia e d'Arte* (1964), pp. 364 ff.

A few traces of colour and a large halo in relief suggested that at one time there had been a painting in the lunette above the side door leading into the right nave of the Cathedral at Pistoia. The fresco itself had completely disappeared, but beneath the crumbling plaster this handsome *sinopia* was still intact. It is one of the oldest surviving Tuscan *sinopie*, painted in 1260 by Lapo da Firenze. The attribution rests on documents published in the last century by Ciampi, corrected and reprinted by Bacci, and finally confirmed by Procacci. The *sinopia* was discovered in 1959, through the agency of Procacci, who published it and subsequently related it to another fresco attributed to Lapo: a Christ in Glory among Angels, with Saints Bartholomew and John the Evangelist, in the vault of the apse of the Pistoiese church of S. Bartolommeo in Pantano.

UMBERTO BALDINI

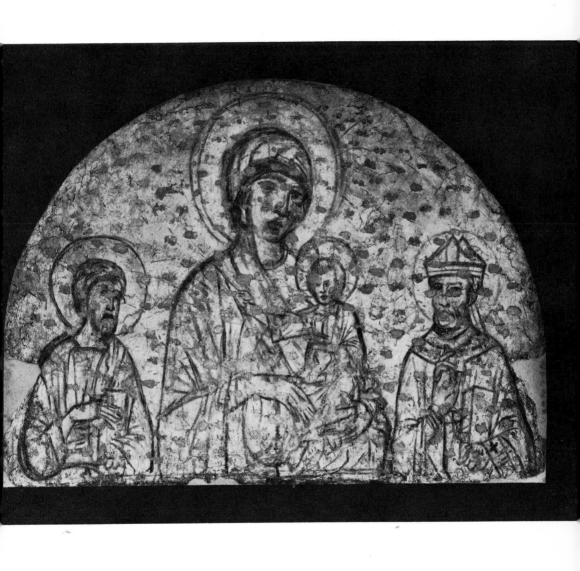

3

The existence of preparatory drawings under the mosaics in the Florentine Baptistery is reported by Vasari. He writes, 'that at the time when Alesso Baldovinetti . . . restored these mosaics [between 1481 and 1499] it was seen that it had been in the past painted with designs in red, and all worked on stucco.' Records made by workmen who carried out restorations in the Baptistery between 1898 and 1910 confirm what Vasari wrote. For some unknown reason, only this small fragment was removed at that time, and is now the sole example of a vast group of *sinopie* which, if recovered, would have contributed immeasurably to our knowledge of early Florentine painting.

G. Castelfranco, *Bollettino d'Arte* XVIII (1934-35), p. 331.
E. Borsook, *The Mural Painters of Tuscany* (1960), pp. 12 f.
U. Procacci, *Sinopie e Affreschi* (1961), pp. 49 f., 299 (with bibliography); in *Catalogo della Mostra di Firenze ai tempi di Dante* (1966), no. 39, p. 102.

TWO HEADS
Sinopia, $16\frac{1}{8}$in x $18\frac{1}{2}$in (41 x 47cm)
Baptistery, Florence

The *sinopia* was first published by Castelfranco in 1935. It comes from the Annunciation to Zacharias, the first scene in the cycle of mosaics of the life of St John the Baptist, and shows the heads of two boys who kneel in prayer at one side. Although the drawing is damaged in parts by chipping, it reveals a freedom of brush-stroke and movement of line which seem incredibly modern and free from the formulas of the period, especially when compared with the related mosaic. The mosaics of the life of St John the Baptist are among the finest in the cupola of the Baptistery, and most critics now recognise the participation of Cimabue in the cycle, as well as of other artists in his following.

UGO PROCACCI

The Annunciation to Zacharias, mosaic, Baptistery, Florence (see no. 3).

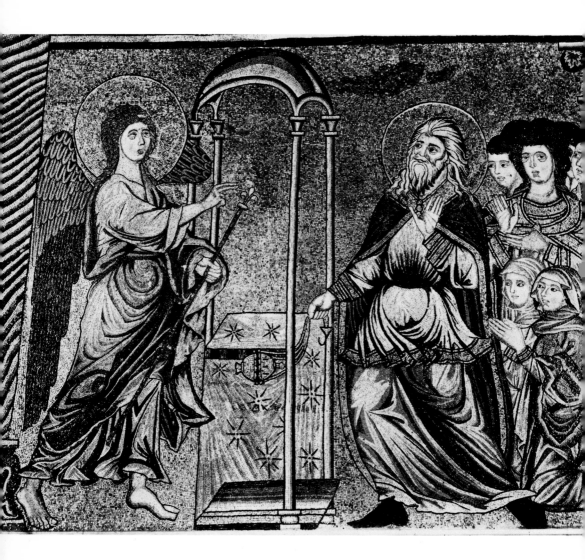

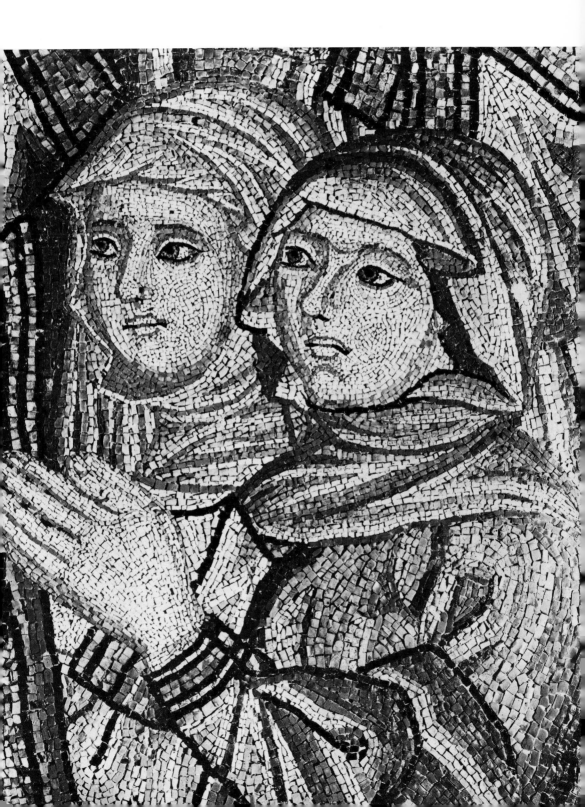

GIOTTO DI BONDONE
1266/67–1337

When Vasari wrote of Giotto as 'the true restorer of the art of painting' who 'put an end to the crude Greek [Byzantine] manner,' he was echoing a tradition which goes back to the lifetime of Giotto himself. His reputation as the leading Florentine artist of the day was clearly established; Dante (died 1321) refers to it in the *Purgatorio* (Canto XI, line 95), and his responsibility for 'the rise of the art of painting' was unequivocally affirmed by Ghiberti in the fifteenth century.

Controversy surrounds the activity of Giotto at Assisi during the first decade of the Trecento, when the frescoes in the upper church of San Francesco were probably painted. His first certain works are the frescoes in the Arena chapel in Padua. This was built by Enrico Scrovegni, consecrated in 1305, and therefore probably decorated between 1304 and 1312–13. Of his work for the church of Santa Croce in Florence, the Bardi (?1315–20) and Peruzzi (?1320–26) chapels survive, clearly demonstrating the existence of a large and competent workshop. Between 1329 and 1333 Giotto is known to have worked in Naples under royal patronage, but returned to Florence in 1334 as 'Capomaestro' or Supervisor of Works for the Duomo in Florence.

4

HEAD OF A SHEPHERD (a fragment from the scene of Joachim among the Shepherds)
Fresco, 8ft 3⅝in x 4ft 4in (253 x 132cm)
Badia, Florence

The probable existence of the Badia fresco fragments was established in 1940, although they were recovered only in 1958. All three have been removed by the restorer Dino Dini using the *strappo* method. The support of the Joachim fragment, which carefully reproduces the curve of the ribbed vault, is made from duraluminium.

C. Gnudi, *Giotto* (1958), p. 241 (with bibliography).
U. Procacci, 'La tavola di Giotto dell' altar maggiore della Chiesa della Badia Florentina. *Scritti de storia dell' arte in onore di Mario Salmi*, vol. II, Rome 1962, pp. 27–35; and in *Omaggio a Giotto* (Exhib. cat. Orsanmichele, Florence 1967), no. 3a, pp. 12–14. L. Bellosi, *Paragone* (1966), no. 201, pp. 76 f. G. Previtali, *Giotto* (1967), p. 318.

In his Commentaries, the sculptor Lorenzo Ghiberti records that Giotto painted the Cappella Maggiore and the altarpiece in the Badia. It seems unreasonable to doubt such a precise assertion, since Ghiberti himself started as a painter, and emerges from his writings as an unreserved admirer of Giotto and of early Trecento painting, which he rated above that of his Renaissance contemporaries. In his youth, Ghiberti must have visited the workshops of Giottesque artists, like Agnolo Gaddi, the son of Giotto's favourite pupil Taddeo Gaddi, and these late followers, whose respect for Giotto bordered on idolatry, would certainly have told him which were the authentic works of the great master.

The Badia frescoes illustrated scenes from the Life of the Virgin. Only three fragments survive. The fragment exhibited here comes from the scene of Joachim among the Shepherds, and was found in the right corner of the upper lunette. A second fragment, of the Presentation of the Virgin in the Temple, identified by the inscription '. . . [c]lara ex stirpe Davit . . .', comes from the lower zone of the same wall.

Detail▷

Part of an Annunciation was discovered on the right adjoining wall, in the same band as the Presentation.

While it is difficult to doubt Ghiberti's assurance of Giotto's responsibility for the Badia frescoes, it is equally impossible to claim that the few small fragments which survive are necessarily attributable to his own hand. In fact, in an undertaking of such a size, he would certainly enlist the support of assistants, a practice which was common in a period in which artistic personality was understood not in a narrowly individual sense, but in the wider context of a workshop. This point is confirmed by the three surviving works signed by Giotto, all of which clearly show the intervention of his pupils. The master was always responsible for the conception and design of a work, but its execution might be left in part or entirely to assistants.

After Ghiberti, all other early sources (Antonio Billi, the Anonimo. Magliabechiano, Gelli) give the Badia frescoes to Giotto, and Vasari writes in his Life of Giotto that (in the Badia) 'he carried out many works considered beautiful, but in particular a Madonna receiving the Annunciation for the reason that in her he expressed vividly the fear and the terror that the salutation of Gabriel inspired in the Virgin, who appears, to be filled with the greatest alarm, wishing to turn in flight'. Perhaps it was Vasari's enthusiastic praise which prompted the attempt to remove the heads of the Virgin and the Angel in 1627, when the frescoes were almost completely destroyed in the course of drastic architectural reconstruction of the Badia. The outcome of this effort is unknown, although a wide gap in the *intonaco* around the figure of the Virgin clearly suggests that it was made. Since no technique for removing frescoes was known at the time, we can only fear the worst. There is no subsequent reference to the heads.

The dating of the frescoes presents certain difficulties. There are, however, strong arguments for placing them, with the altarpiece for the same chapel, in the first years of the fourteenth century between the cycles of Assisi and Padua. For instance, the architecture in the background of the Badia Presentation of the Virgin in the Temple, which today is reduced to little more than a shadow, appears to be firmly related to compositions at Assisi. The impressive remains of the Annunciation clearly belong to the same point in Giotto's career, and seem to have been not only conceived but also executed entirely by him. In dating the frescoes we should not be misled by the figure of the shepherd in the scene of Joachim among the Shepherds which, if considered alone, might appear to be later in date. In favour of the view that the polyptych and the frescoes were produced at the same time, it may be noted that it was customary in important churches like the Badia to order both the altarpiece and the wall decoration concurrently from a single artist.

AMBROGIO LORENZETTI (active 1319–47), PIETRO LOREN-
ZETTI (active 1320–45), AND ASSISTANTS

The Lorenzetti brothers emerge from Sienese painting in the tradition of
Duccio, and with Simone Martini, represent the next stage of its
development. They both worked outside Siena; Pietro Lorenzetti
in 1320 at Arezzo, and Ambrogio Lorenzetti in 1319 near Florence.
Already these works show a much wider field of reference than those of
their Sienese contemporaries. Pietro Lorenzetti's figures owe something to
the sculpture of Giovanni Pisano, and Ambrogio Lorenzetti, in a panel
dated 1319, reflects the influence of Florentine artists. During the
1320s Pietro Lorenzetti was probably active in Assisi, and Ambrogio
matriculated in a Florentine guild in 1327. Separately they were also
responsible for a large number of Siena's important public works, and the
one joint commission of which records exist dates from 1335, when they
were both employed to paint frescoes now lost, on the façade of the hospital
of Santa Maria della Scala in Siena. The inscription, still visible in the
seventeenth century, read HOC OPUS FECIT PETRUS LAURENTII
ET AMBROSIUS EJUS FRATER. MCCCXXXV. Though Ambrogio
Lorenzetti has always been regarded as the younger of the two, he
received what must have been the most important fresco commission
of that decade in Siena, and in 1337 began the frescoes of Good and
Bad Government, on the walls of the Council Chamber in the Palazzo
Pubblico. It is from these that the Montesiepi frescoes are derived. After
1340, the style of both brothers becomes heavier, to judge from the
few panels which survive. Among these are the Presentation by Am-
brogio Lorenzetti (Uffizi) and the Birth of the Virgin by Pietro (Opera
dell' Duomo, Siena).

5, 6

THE ANNUNCIATION
Fresco, two parts, each 7ft 10½in x 5ft 7¾in (240 x 172cm)

Sinopia, two parts, each 7ft 10½in x 5ft 7¾in (240 x 172cm)

Oratory of San Galgano, Montesiepi

The fresco and the *sinopia* were
detached in 1966 by Leonetto
Tintori and were mounted on
frameworks of polyester resin
and fibreglass.

This fresco forms part of an important cycle in a small chapel attached to an
exquisite russet brick church of the twelfth century in the country south-
west of Siena. The Angel was painted on one side of a window, the
Virgin on the other.
Intervention by the conservators in 1966—desperately needed—disclosed a
marvellous drawing below the Annunciation. This drawing, first shown in
1967 in the Giotto exhibition in Florence and just recently in the exhibition
of the Council of Europe in the Louvre, attracted thousands of visitors, who

G. Rowley, *Ambrogio Lorenzetti* (1958), I, p. 10 ff., 62 ff. (with bibliography).
E. Borsook, in *Omaggio a Giotto* (Exhib. cat., Orsanmichele, Florence 1967), p. 25.
C. Gnudi, in *L'Europe Gothique XIIe XIVe siècles* (Exhib. cat., Louvre, Paris 1968), pp. 191 f.

were captivated by its beauty and by its astonishing iconography as well as by its puzzling relationship with the painting that for centuries covered it. The Gospel of St Luke says that at the time of the Annunciation the first words the Angel Gabriel spoke to Mary troubled her, and beginning in the late thirteenth century Sienese painters expressed this first, very human response of the Virgin to the Angel by depicting a kind of defensive withdrawal. Sometimes, too, in the second quarter of the fourteenth century—the period of our drawing—they represented her humility at this moment (as at many others) by seating her upon the floor. No artist, however, before the author of the drawing, and perhaps none later, portrayed the Virgin so overcome by the apparition that she shrinks to the floor and hugs a column for support. The diverse movements of her head, arm and body are realised by a cluster of bold, sure strokes. The less meaningful Gabriel is evoked with equal assurance by even fewer lines. The *sinopia* shows the qualities of the art of Ambrogio Lorenzetti, and though we possess no drawings by him for comparison it seems improbable that any assistant could approximate the mastery of this superb, unforgettable work.

The original fresco followed the lines of the *sinopia* rather closely, showing however, such changes as the substitution of one door in the left wall for the two in the *sinopia* and the elimination of the beam in the ceiling over the wall between these two. The fresco was probably executed at least in part by Ambrogio's workshop, though it is difficult to be certain whether its lesser brilliance should be ascribed to the hand of an assistant or to subsequent alteration and damage.

Shortly after the completion of the fresco, in any event, the unorthodox figure was transformed into a conventional Virgin who, standing and facing the Angel, humbly accepts the message by bowing toward him while crossing her hands on her breast. To effect this change the painter, very close (it seems to the writer) to Pietro Lorenzetti, Ambrogio's brother, cut out a patch of the original *intonaco* above the crouching Virgin, replaced it, and then painted the new head and hands in true fresco, according to normal practice. He painted out much of the original figure, but since he employed for this a *secco* technique the paint has as usual flaked off, disclosing once again the original Virgin Mary, especially the telling head and eyes, which were executed in true fresco. The tonsured man kneeling in prayer behind the angel, now rather faint, was likewise added in *secco* to the original composition, no doubt within a century of the painting of the original fresco.

Ambrogio Lorenzetti was one of the greatest of the group of Sienese and Florentine painters in the first half of the fourteenth century who transformed European painting, especially by endowing the sacred figures with a novel humanity. The Annunciation is one of the most striking manifestations of this new culture, and we may therefore seek to discover more pre-

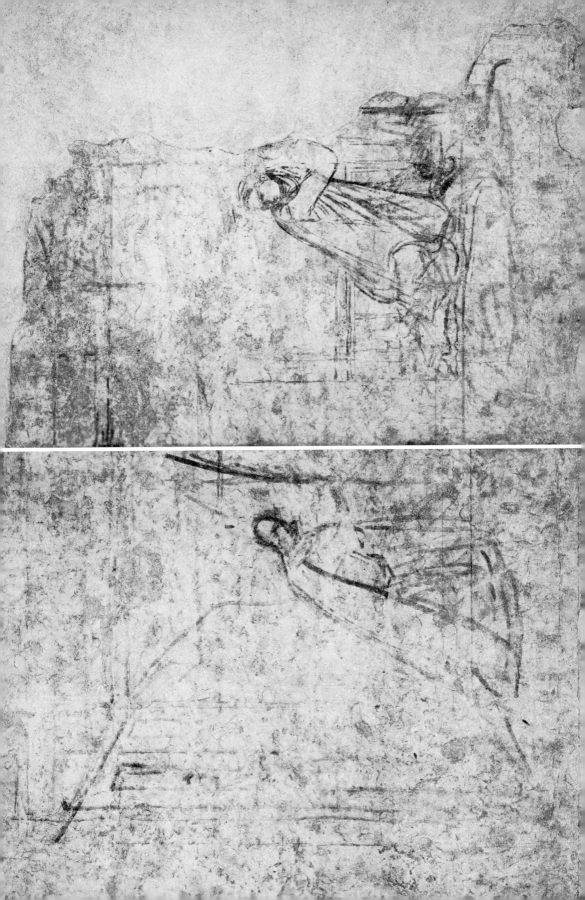

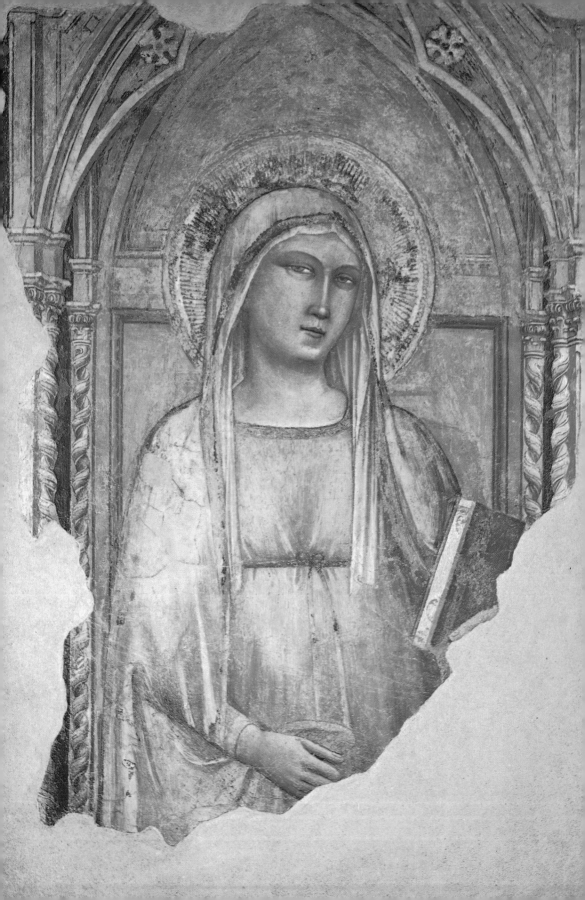

cisely what the master sought to communicate by his innovation and why he chose to do so in this painting. Though the branch carried by the Angel in the *sinopia* cannot be definitely identified, in the fresco it is clearly a green palm, which apparently bears a stem of fruit. Now the palm, symbol of martyrdom, is normally borne by the Angel when he announces the impending death of the Virgin, in accordance particularly with the story in the Golden Legend. This interpretation might seem a clue to the exceptional behaviour of the Virgin, and the figure in the doorway would then be the rapidly approaching St John. This scene, however, would scarcely be appropriate to a chapel dedicated to S. Galgano and to a prominent place on a wall just below a fresco of the Virgin in Majesty accompanied by angels and saints. In the *sinopia*, furthermore, just to the left of the Virgin a vase, probably for lilies, seems to be indicated and in the fresco the traces of a dove are probably original. Moreover, in thirteenth century painting, particularly English, Gabriel occasionally presents a palm when announcing the Incarnation to the Virgin, and, more relevant, he bears the same symbol in several Sienese paintings of the fourteenth century, the earliest being the famous altarpiece in Siena, dated 1344, by Ambrogio himself. The fresco of the Majesty above the Annunciation likewise shows novel or exceptional iconography. The sinner Eve reclining below the enthroned Madonna is apparently the earliest in a long series of similar representations in Italian art. Now, Eve appears at the feet of Mary in canto XXXII of Dante's Paradise, in an account given by St Bernard, the greatest saint of the Cistercian order to which the chapel belonged. Bernard indeed may be one of the two Cistercian saints below the enthroned Virgin in the fresco. In this canto, furthermore, Mary is described as Empress, and in the original fresco she wore a crown and held a sceptre, an extraordinary attribute at this period that was shortly painted out by the same assistant of Pietro who altered the Virgin Annunciate.

There is very good reason, then, to suppose that the same canto of Dante's poem was the source of two exceptional aspects of the Annunciation, one hitherto unnoticed and the other hitherto unexplained. The wings of Gabriel, normally represented folded as he alights, are extended, and Dante says that as Gabriel approached Mary he 'spread his wings before her'. The poet also says that when Christ resolved to take on himself the redemption of mankind the angel appeared before the Virgin bearing a palm. In the *sinopia*, then, Mary trembles with the knowledge not only of Christ's coming but his going, with the awareness of life giving way early to death. Rarely did the great poem have so deep and beautiful an effect upon art. MILLARD MEISS

◁ Madonna del Parto by Taddeo Gaddi (7).

TADDEO GADDI
c. 1300–66

'Taddeo Gaddi was a pupil of Giotto and a man of great invention who painted very many chapels and murals' (Ghiberti). He was also the most outstanding member of a family of Florentine artists active for the greater part of the fourteenth century, and unlike many of the 'giotteschi', has always enjoyed a reputation independent of his master. His hand can be traced in works from the studio of Giotto, although the first of his signed and dated works known today is a triptych of 1334 in the Kaiser Friedrich Museum, Berlin. He must have been established earlier, however; in 1327 he was admitted to the guild of Medici e Speziali, only slightly later than Giotto and his own father, Gaddo di Zanobi. In 1332 he received an important commission to paint frescoes showing scenes from the life of the Virgin in the Baroncelli chapel of Sta. Croce, and completed these by 1338. Soon afterwards he worked in the churches of S. Miniato al Monte, Florence, and San Francesco, Pisa, and 1347–53 painted a polyptych for the church of S. Giovanni Fuorcivitas in Pistoia. A Madonna and Child from the church of S. Lucchese, Poggibonsi, signed and dated 1355, is now in the Uffizi, and a series of panels from the doors of a sacristy cupboard in Sta. Croce are distributed between Florence (Accademia), Berlin and Munich. In 1363 Gaddi painted a fresco, now lost, in the Mercanzia Vecchia, and is last mentioned in 1366.

7

MADONNA DEL PARTO
Fresco, 4 ft 7⅛in x 2ft 9½in (140 x 85cm)
Church of S. Francesco di Paola, Florence

The fresco was removed *a strappo* by Giuseppe Rosi in 1964, and transferred to a support of tempered masonite.

U. Procacci, in *Catalogo della Mostra di Firenze ai tempi di Dante* (Exhib. cat., Certosa, Florence 1966), no. 38, p. 102.
L. Bellosi, *Paragone* (1966), no. 201, p. 78.
P. Dal Poggetto, in *Omaggio a Giotto* (Exhib. cat., Orsanmichele, Florence 1967), no. 16, p. 37.
C. Gnudi, in *L'Europe Gothique XIIe XIVe siècles* (Exhib. cat., Louvre, Paris 1968), no. 312, p. 194.

In the church of S. Francesco di Paola, the condition of this handsome Madonna del Parto appeared to be extremely poor. It was obscured by dirt and other thick deposits so that only the head remained visible. Its removal and restoration in 1964 revealed both the quality of the fresco and the remarkable state of preservation of its upper part. It has since been exhibited several times; in 1965 in the exhibition *Firenze ai tempi di Dante*, attributed on that occasion to Taddeo Gaddi by Procacci; in the 1966 exhibition of *Affreschi Staccati* at the Forte di Belvedere; in *Omaggio a Giotto* at Orsanmichele in 1967; and in the Council of Europe exhibition *L'Europe Gothique XIIe-XIVe siècles* held in Paris last year. Clearly by Taddeo Gaddi, it is a fairly late work. Certain features might suggest an earlier date, closer to the Baroncelli chapel in Sta. Croce, which can be dated 1332–8, or 1327 as Borsook has recently suggested. On the other hand, the softer features of the Madonna show signs of Gaddi's final development away from the

influence of Giotto towards a more pictorial style. The affinities of this fresco are with the Madonna in the Uffizi altarpiece, dated 1355, and with the Madonna of S. Lorenzo alle Rose which just precedes it.

PAOLO DAL POGGETTO

8, 9

THE TRANSFIGURATION

Fresco, 7ft x 2ft 10¼in (214 x 87cm)

Sinopia, 6ft 2in x 2ft 5½in (188 x 75cm)
Badia, Florence

Both the fresco and its *sinopia* were discovered accidentally in November 1967, a year after the flood, during restoration work on a part of the old convent of the Badia. The room in which they were found had served, in the sixteenth century, as a refectory, and when the whitewash was removed a huge Crucifixion by Giovanni Antonio Sogliani was also exposed, which, though it had been recorded and described by Vasari, was later assumed to have been lost. The attribution of the Transfiguration to Taddeo Gaddi was made by Umberto Baldini (in *La Nazione*, Florence, December 6, 1967). Although no record of the fresco, ancient or modern, exists, it must still have been visible till recent times, since several sheets of a 1924 newspaper were found in place against the paint surface and under the brick wall which filled the entire recess. Gaddi must have painted the fresco around 1345, considerably later than the same scene on the Sta. Croce cupboards. It is closer to, perhaps slightly later than, the Last Supper in the Refectory of Sta. Croce, with which the *sinopia* is closely comparable. Although its dimensions are small, and in spite of losses at the base, it was clearly a masterpiece of great compositional originality. The *sinopia* shows the artist determined to reconcile his monumental forms with the long narrow space of the recess. His figures are blocked out in profile, one against another, to achieve a calculated equilibrium.

UMBERTO BALDINI

When the fresco was discovered its upper part was well preserved, although the lower section was seriously damaged and, because of the flood, had suffered badly from dampness. The fresco had to be removed as quickly as possible, to save it from complete deterioration, but before the operation could be carried out the wall had to be dried. A strong source of heat was provided behind the wall, to draw the water and the salts dissolved in it away from the paint surface. This drying took nearly three weeks, and the fresco was then removed *a strappo*, revealing the *sinopia* beneath. The fresco emphasises a number of interesting technical details: among them, the particular type of yellow used to paint the halo of the dove of the Holy Spirit, and the transition in some areas from an azurite background to malachite. The restoration was undertaken by Giuseppe Rosi. Both fresco and *sinopia* were transferred to supports of tempered masonite.

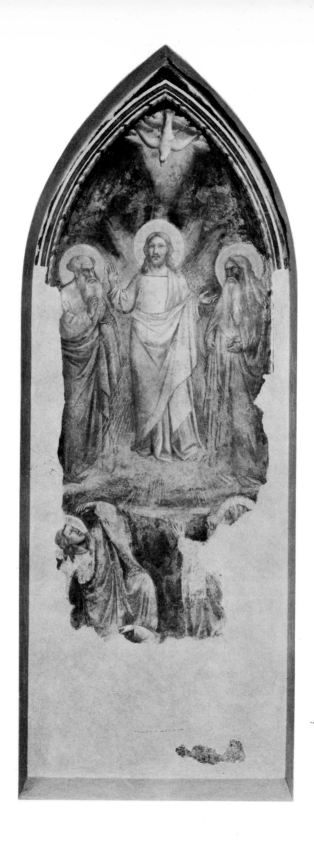

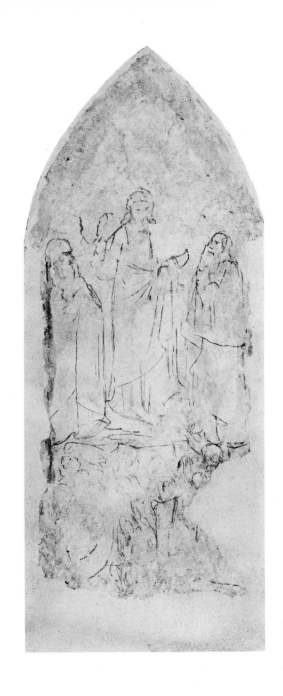

ORCAGNA (ANDREA DI CIONE)
c. 1308–c. 1368

Orcagna, the son of a goldsmith, was to become the most prominent Florentine painter, sculptor and architect of the mid-fourteenth century. He matriculated in the guild of the Medici e Speziali in 1343–4, and joined the stonemason's guild in 1352. In 1354 he was commissioned to paint an altarpiece for the Strozzi chapel in Sta. Maria Novella, which is signed and dated 1357. In September 1367 he received a commission for an altarpiece for the guild of St Matthew; the following August work on it was taken over by his younger brother Jacopo. This is now in the Uffizi. In 1355 he was the superintending architect of Orsanmichele and with another brother, Matteo, was responsible for the sculpture of the tabernacle in the guild oratory. In 1357 he was appointed architect for the Duomo in Florence, and in 1358 went to Orvieto where he supervised the mosaic decoration of the façade of the cathedral, again with his brother Matteo, between 1359 and 1360. Returning to Florence, he resumed his post at the Duomo from 1364–6. As a painter, his work is often cited as typical of Florence in the third quarter of the fourteenth century, reacting under the pressure of the Black Death against the optimism and innovation of the previous generation.

10

THE LAST JUDGEMENT: THE TRIUMPH OF DEATH
Fresco, 22ft 11⅜in x 7 ft 1½in (700 x 217cm)

11

THE LAST JUDGEMENT: THE INFERNO
Fresco, 22ft 11⅜in x 10ft 11½in (700 x 334cm)

Museo dell' Opera di Santa Croce, Florence

In 1958 the restorer Dino Dini detached all the fragments of the Last Judgement fresco which had been uncovered by the removal of the Vasari altars. They were beginning to deteriorate and so were removed *a strappo* and fastened to tempered masonite, supported by a wooden framework. After restoration, all six of the fragments were exhibited together in the Museo dell'Opera di Santa Croce, where they were completely submerged in the floods on November 4th, 1966. Stained by deposits of mud and naphtha, they were rapidly cleaned with the appropriate

Most of the colossal fresco which used to decorate the right wall of the church of Sta. Croce was destroyed either in the sixteenth century when the present altars were built, or in the eighteenth century when the monument to Machiavelli was erected between them. In 1911 parts of the Triumph of Death were found behind the fifth altar, and in 1942 fragments of the Inferno were recovered behind the fourth altar. The surviving pieces have been mounted in two vertical strips, which indicate the space once occupied by the missing sections.

Umberto Baldini made a reconstruction of the whole fresco for the exhibition of *Affreschi Staccati* in 1958. He suggests that it measured about 7 metres in height, including the decorated borders, and 18½ metres in length (23ft x 59ft approx.). To the left, the Triumph of Death occupied

about $4\frac{1}{2}$ metres ($14\frac{1}{2}$ft) of the total length; in the centre the Last Judgement took up $7\frac{1}{4}$ metres (24ft), and to the right, the Inferno also measured $4\frac{1}{2}$ metres ($14\frac{1}{2}$ft), with the head of Judas, part of which survives, marking the centre. A decorated border surrounded the scene on all four sides and contained medallions, three of which have been recovered. They show the Eclipse of the Sun (top left), the Fall of the Idols (left of centre) and an episode involving three fish (top right, above the twisted column). The lower left corner of the Triumph of Death has been recovered in two sections. It contains a group of crippled beggars who advance groaning and trampling on a pile of corpses. A broken inscription carries their invocation of death, which can be completed from the similar text on the Camposanto frescoes in Pisa. 'Since prosperity has left us/ Death, the medicine of all pains/come now to give us our Last Supper.' Above, the caption reads: 'Neither learning, riches, high birth nor bravery count for anything against the blows of Death. Nor can any argument avail. So beware, o reader, and stand always ready so that you are not taken in mortal sin.'

The Last Judgement fresco is undoubtedly the most important undertaking of Florentine painting in the mid-fourteenth century. With a deep sense of moral earnestness, Orcagna shows a dramatic awareness of the frailty of human life. He transposes the events of a plague-stricken city into visual experience. From this, Baldini infers a dating in the years immediately following the Black Death of 1348. The choice for subject matter of such a gigantic and terrifying tragedy would not have been characteristic of the confidence and prosperity which Florence enjoyed in the first half of the fourteenth century. This date is also convincing stylistically. In Orcagna's work, the frescoes have features in common with the Santa Maria Novella prophets of 1340–8, and are significantly different from his Strozzi altarpiece of 1357. The Sta. Croce frescoes show Orcagna still indebted to the dynamic vision of Giotto and his contemporaries. The influence of Taddeo Gaddi is particularly noticeable in his incisive drawing, and the sense of volume in his figures is derived from Maso di Banco. Such links are decisively broken by the time of the Strozzi altarpiece. Finally, these arguments for the early dating of the frescoes raise the possibility that they were executed before the Triumph of Death in the Camposanto in Pisa. This remains a controversial subject; Baldini argues that Orcagna's frescoes precede those at Pisa, while Meiss favours the opposite view.

PAOLO DAL POGGETTO

solvents; a process greatly facilitated by the high standard of their earlier restoration. In June 1967 the Last Judgement was reassembled for the *Omaggio a Giotto* exhibition in Orsanmichele. It may also be pointed out that Orcagna's work suffered flood damage while it was still in place on the walls of Sta. Croce. In 1557 the lower parts of the fresco were covered by water, as can be seen near the base in both the Triumph of Death and the Inferno fragments, where a strip of colour has been repainted in tempera.

U. Baldini, in *Il Mostra di Affreschi Staccati* (Exhib. cat., Forte di Belvedere, Florence 1958), nos. 16, 17, 18 (Triumph of Death), 19, 20, 21 (Inferno), pp. 131 ff. (with bibliography).
M. Meiss, *Painting in Florence and Siena after the Black Death*, 2nd ed. (1964), pp. 14, 74, 83 f.; and, *Atti del Congresso Giottesco*, 1967 (in press).
R. Oertel, *Die Frühzeit der Italienischen Malerei*, 2nd ed. (1966), pp. 174 f.
P. Dal Poggetto, in *Omaggio a Giotto* (Exhib. cat., Orsanmichele, Florence 1967), no. 29, pp. 56 ff.
C. Gnudi, in *L'Europe Gothique XIIe XIVe siècles* (Exhib. cat., Louvre, Paris 1968), no. 319 (Inferno), p. 199.

ORCAGNA, 10.

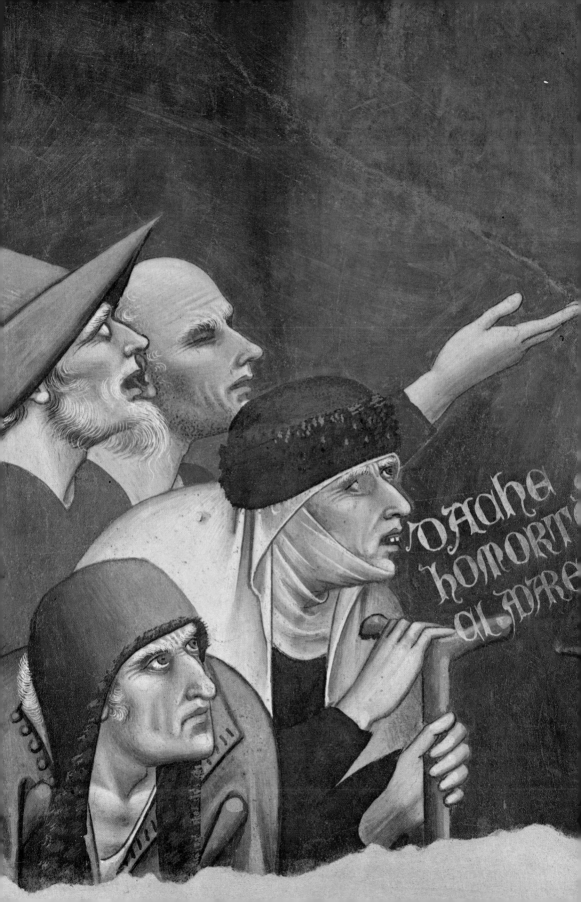

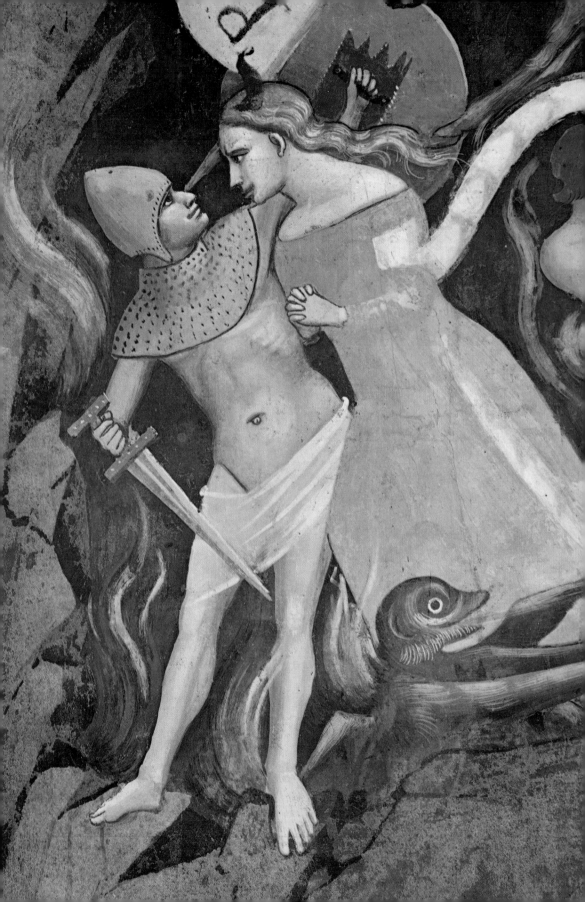

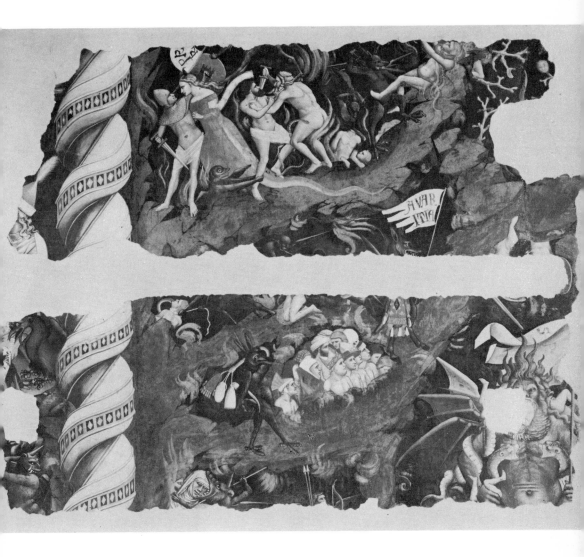

ORCAGNA, 10 and 11.

reconstruction by Dr Brigitte Klesse, 1958 (Offner IV, vol. 1, pl. III).

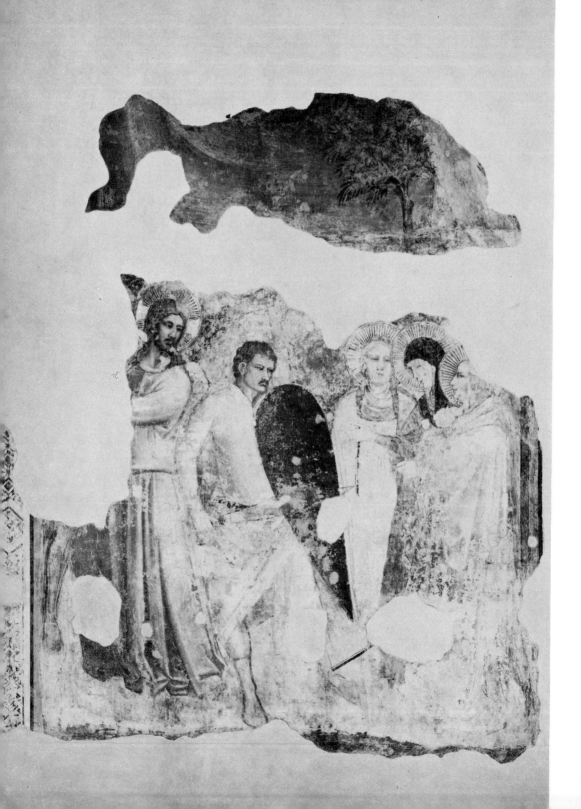

NARDO DI CIONE
active c. 1343, d. 1365–6

The date of his birth is unknown, but according to Milanesi and Frey, Nardo di Cione was the oldest brother of Andrea di Cione, called Orcagna. In 1343 he matriculated in the guild of Medici e Speziali, and in 1347 his name appeared on the list of artists who competed for the commission to paint an altarpiece for the Church of S. Giovanni Fuorcivitas at Pistoia. In October 1363 he was employed to decorate the vault of an oratory for the Compagnia del Bigallo and in 1364 joined the guild of St Luke. On May 21, 1365, Nardo di Cione made his will, and is referred to a year later as dead. According to Ghiberti he painted the frescoes in the Strozzi Chapel of Sta. Maria Novella, although Vasari attributes them to Orcagna 'in conjunction with his brother'. Scholars have tended to agree with Ghiberti, and it is by comparison with these frescoes that attributions to Nardo are usually made. These include frescoes in the Chiostro de' Morti of Sta. Maria Novella and in the Giochi–Bastari chapel in the Badia. Although Nardo di Cione probably worked within the framework of the family workshop, his own style seems to have remained more Giottesque than that of his younger brother.

12

THE WAY TO CALVARY: CHRIST AND THE THREE MARIES
Fresco, 13ft 5½in x 8ft 2½in (410 x 250cm)
Badia, Florence

In the 1568 edition of his Lives, Vasari attributed the frescoes in the Giochi-Bastari chapel to Bonamico Buffalmacco. Early in the seventeenth century they were covered with whitewash, but in 1911 they were rediscovered by Bacci who published them as a lost masterpiece of Buffalmacco. A year later, Schlosser rejected the attribution, and it was Sirèn in 1920 who first attached to the frescoes the name of Nardo di Cione, and dated them around 1350. His attribution has been accepted almost unanimously, though an earlier date is usually considered more appropriate. Offner at first agreed with the attribution to Nardo, but later gave them to one of his followers on account of their allegedly inferior quality. On the contrary, their quality is extremely high, in spite of deterioration and loss. Unfortunately only fragments have survived, of which Christ taking leave of the Maries is the most complete. It reveals both the deeply poetic nature of the cycle and the artistic sources of Nardo di Cione. His composition and clear impasto derive from Maso di Banco, and his rich chiaroscuro may come from the hypothetical 'Stefano', reconstructed by Longhi. Finally, his colouring, his subtle treatment of the surface and his elegant and elongated figures recall Giovanni da Milano's activity in Florence around 1350.

The fresco was removed in 1959-60 by Dino Dini. The *strappo* method was used, and the fragments were placed on to a reinforced support of tempered masonite.

R. Offner, *Corpus of Florentine Painting*, sec. IV, vol. II (1960), pp. 98 ff. (with bibliography).
P. Dal Poggetto, in *Omaggio a Giotto* (Exhib. cat., Orsanmichele, Florence 1967), pp. 54 ff.

PAOLO DAL POGGETTO

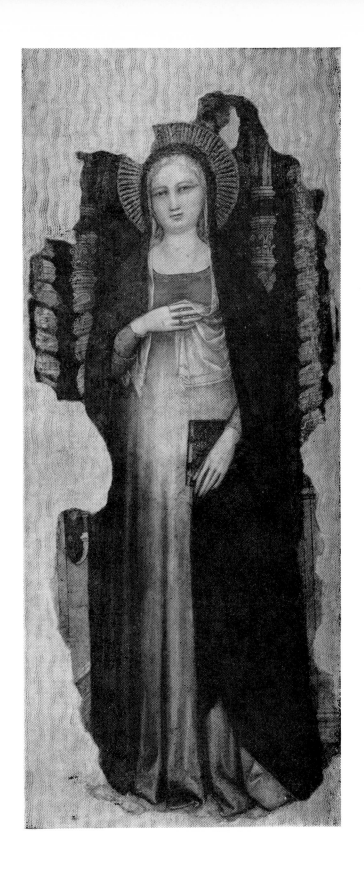

BONACCORSO DI CINO
active 1347

A Florentine painter about whom little is known, Bonaccorso di Cino was working in 1347 on the chapel of S. Jacopo in the Cathedral of Pistoia. These frescoes illustrate scenes from the life of St James, with God the Father surrounded by apostles on the vaulting. The documentary background of his activity has been investigated by Procacci, who credits him with a major part in the fresco cycle in the Convento del T., given by Offner to Niccolò di Tommaso.

13

MADONNA DEL PARTO (*not exhibited*)
Fresco, 6ft 9$\frac{7}{8}$in x 2ft 10$\frac{5}{8}$in (208 x 88cm)
Church of San Lorenzo, Florence

Since its restoration in 1952, the attribution of this fresco has caused some difficulty. Offner originally gave it to Niccolò di Tommaso, while Baldini proposed Nardo di Cione, whose name it bore when it was shown in 1952, in the third *Mostra di opere d'arte restaurate* in Florence. Baldini restated his attribution to Nardo in 1955, when he emphasised that the quality of the painting precluded its attribution to a mere follower, and compared it to figures in the Paradise fresco in Sta. Maria Novella. In spite of this and other arguments put forward by Baldini, Offner in 1956 reaffirmed his attribution to Niccolò di Tommaso citing for comparison a painting of St Catherine in a roadside shrine in Florence. The fresco was shown in the Council of Europe exhibition *L'Europe Gothique* (Paris, 1968) as a work by Nardo di Cione, and in the catalogue of this exhibition prepared for the Metropolitan Museum in New York (1968, p. 86), Poggetto rejected Offner's suggestion on the grounds that the St Catherine was greatly inferior to the Madonna from San Lorenzo. He did, however, point out that works by the two artists would necessarily present certain analogies, since Niccolò di Tommaso had been a follower of Nardo di Cione. However, an addendum to that catalogue (p. 47) explains that after recent research by Procacci on the activity of Bonaccorso di Cino, both he and Baldini attribute the Madonna del Parto to this artist.

The fresco had been moved with the entire wall at some earlier date, and had also been completely repainted. It was hidden, apart from the head, by an eighteenth century canvas behind the first altar on the right in the church of San Lorenzo. It was restored and removed *a strappo* in 1952 by Leonetto Tintori.

MASTER OF THE FOGG PIETA (MAESTRO DI FIGLINE)
active c. 1320–60

In 1926, Offner singled out a group of paintings which he attributed to the 'Master of the Fogg Pietà', named after a panel in the Fogg Art Museum, Cambridge (Mass.). He included a Madonna Enthroned in the church of S. Francesco in Figline Valdarno, which provides the second name, 'Maestro di Figline', normally used by Italian critics. His other attributions consisted of a Crucifix in Sta. Croce, two panels (St Philip and St Francis) in Worcester (Mass.), a King David in Rennes Museum and a fragment from a Crucifix in the Mason Perkins Collection, now normally rejected. Offner regarded this artist as a Florentine follower of Giotto, active after 1320. Later critics have endorsed and amplified Offner's original suggestions. The most substantial contribution was made by Graziani, who added to the œuvre a fresco of the Madonna with Saints Francis and Clare in the basilica of S. Francesco at Assisi and an Assumption in Sta. Croce, Florence, dating both as early works, around 1320.

14

ST ONOPHRIUS AND SCENES FROM HIS LIFE
Tinted mural drawing and painting, 11ft 1½in x 6ft 4¾in (339 x 195cm)
Church of Sant'Ambrogio, Florence

This painting was discovered in March 1965, when a fresco of the Madonna and Child by a different artist was removed from the wall. The marks are visible where its surface was pitted to make the new *intonaco* adhere. It is a rare example of mural design, parts of which were evidently done in colour, applied to the dry plaster. It was removed using the *stacco* method by Dino Dini, and fastened to a support of polyester reinforced with fibreglass.

R. Offner, *Corpus of Florentine Painting*, sec. III, vol. VI (1956), pp. 65 ff.
L. Bellosi, *Paragone*, 201 (1966), p. 77.
P. Dal Poggetto, in *Omaggio a Giotto* (Exhib. cat., Orsanmichele, Florence 1967), no. 24, pp. 48 ff.
M. Meiss, *Bollettino d'Arte* (in press, spring 1967).

When this fragmentary but still very impressive figure came to light, it reminded everyone at first glance of Castagno. The hermit saint has the weight and imposing physical presence of Castagno's figures as well as their great vibrant manes of hair.

The true author of the painting, however, is a much earlier master, one of Giotto's greatest followers, named years ago by Richard Offner after a beautiful panel in the Fogg Museum. This dramatic master unerringly controlled a line that at once defines the structure of a form (cheekbone, eyebrows, or foot) and gives it intense emotional life. Indeed, for powerful feeling this head is unmatched in fourteenth-century Florence. The St Onophrius is a late work by the Fogg Master, close to the middle of the century, when he painted one of the two murals by him that has survived, the Assumption in Sta. Croce.

A pigment bluer in colour than the usual *sinopia* was employed for the lines of the figure and the swirling branches of the tree, and the drawing appears on the smooth uppermost plaster or *intonaco*. The forms were probably originally tinted *a secco*, but none of this colour remains. The technique is very unusual, especially for an image over an altar.

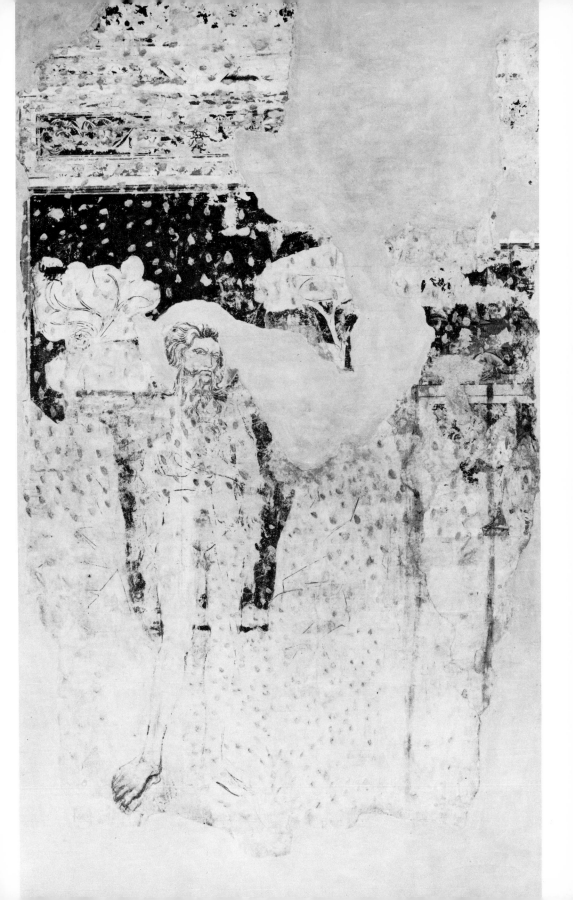

The paint in the small scene in the upper right, probably painted in a different way, has adhered better. The scene represents the long-haired St Onophrius meeting Paphnutius in the wilderness. Originally there were four scenes of the legend of the saint at the right, and no doubt another four at the left. The whole therefore resembled those contemporary altarpieces that show a saint standing between two tiers of scenes from his life.

MILLARD MEISS

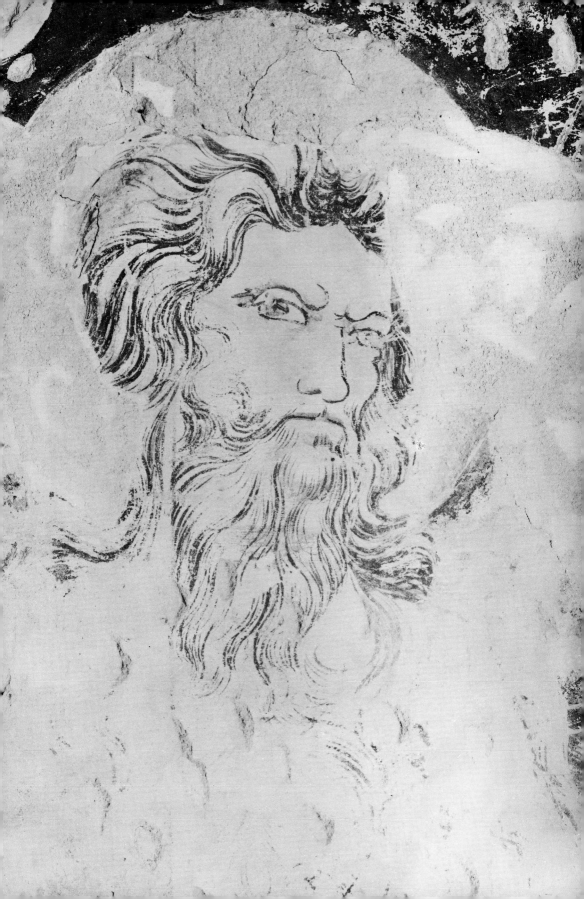

I 5

ST MARY MAGDALEN
Fresco, 14ft 4⅝in x 4ft 5½in (441 x 135cm)
Church of San Domenico, Pistoia

The Magdalen was painted on the interior wall of the façade of San Domenico to the right of the entrance, where late eighteenth century additions to the church sealed it off and left it invisible. Near to the Magdalen, on the wall adjacent to the nave, a Madonna and Child with a praying donor at her feet was discovered underneath a fresco of St Jerome. The painter of the St Jerome unfortunately made holes in the Trecento fresco to attach his *intonaco* to its surface, thus damaging it considerably. However, enough can be seen to indicate a work by the same artist as the Magdalen. The Madonna also carries a fragmentary inscription ('hoc opus fecit fieri . . .') with a date which can be interpreted as 1373.

U. Baldini, in *II Mostra di Affreschi Staccati* (Exhib. cat., Forte di Belvedere, Florence 1958), no. 25, pp. 22 f.

The Magdalen fresco can be dated around 1375. Although fourteenth century painting in Pistoia is a subject which remains to be studied, the dominant personality appears to have been that of the painter Giovanni di Bartolommeo Cristiani. This fresco is an important piece of evidence for that study. It has the decorative qualities and refined colour sense characteristic of Pistoiese art during the period. Influenced by the style of Nardo di Cione, which was transmitted to Pistoia by the work of Bonaccorso di Cino, it is closely related to a Madonna and Child with Saints in the same church, probably dated 1373.

UMBERTO BALDINI

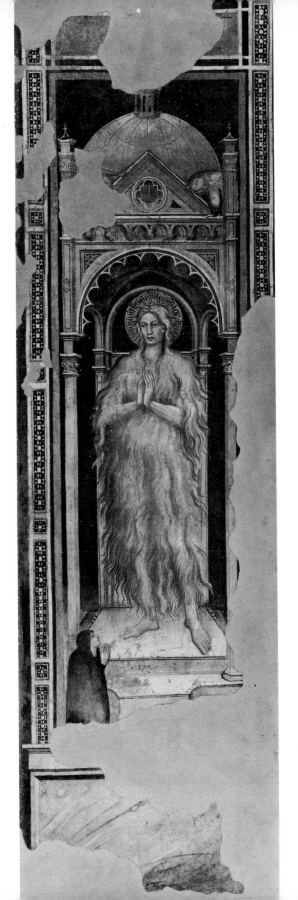

SPINELLO ARETINO (SPINELLO DI LUCA SPINELLI)
c. 1346–1410

Spinello Aretino was born in Arezzo around 1346, where he may have received a local workshop training, although at an early stage in his work the Florentine influences of Orcagna and Nardo di Cione can be detected. During the years 1384–5 he painted a polyptych for the church of Monte-oliveto Maggiore, parts of which are preserved in the Pinacoteca in Siena, the Fogg Art Museum and Budapest. Two fresco cycles, one in a small church at Antella near Florence and the other, illustrating the life of St Benedict, in S. Miniato al Monte, Florence, both date from around 1387. In 1391 Spinello painted a triptych for the church of S. Andrea, Lucca, in co-operation with Lorenzo di Niccolò, and towards the end of his life worked in Pisa (the Camposanto), Arezzo, and Siena where he frescoed scenes from the life of Pope Alexander III in the Sala di Balia of the Palazzo Pubblico. An accurate assessment of Spinello Aretino has often been hampered by the readiness of scholars to attach his name to anonymous fragments of late Gothic fresco. His authentic work, while representative of the late Trecento, is in fact more vigorous than many of the rather insipid attributions from which he suffers. Particularly in his later frescoes, the Giottesque element is one of advance towards a style which has more in common with Masaccio than with Agnolo Gaddi.

16. ▷

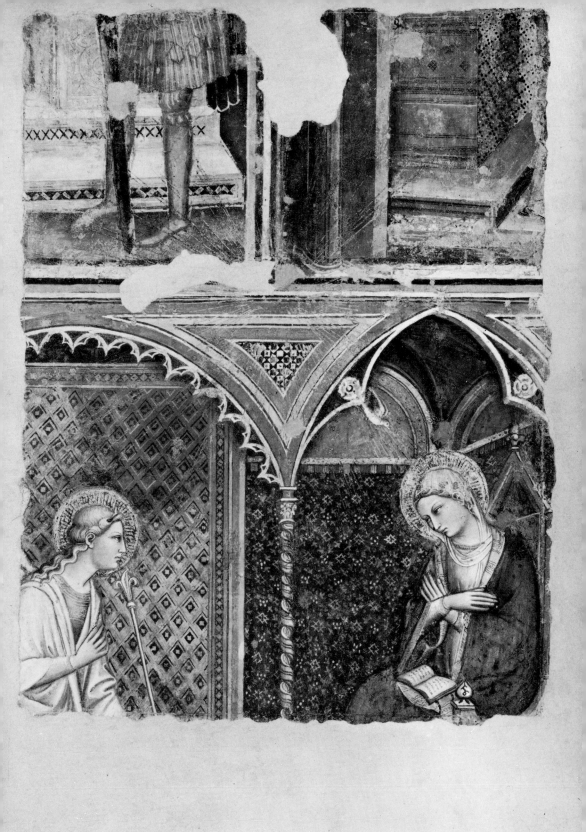

16

THE ANNUNCIATION
Fresco, 8ft 1¼in x 5ft 8⅛in (247 x 173cm)
Church of San Lorenzo, Arezzo

The fresco was detached using the *strappo* method by Giuseppe Rosi in 1965, and transferred to masonite. Its condition was critical, since it had suffered in the past from inappropriate treatment. During the operation, several pieces of another scene were discovered behind a false frame which had covered them.

Although it was discovered some thirty years ago, the Annunciation was only recently attributed to Spinello Aretino by Donati (*Antichità Viva*, vol. III, 1964, no. 4, p. 16). Vasari mentions the existence of frescoes by Spinello in the church of San Lorenzo, though he wrongly identifies them as four scenes from the Life of the Virgin on the right wall. On the other hand, the date of 1385 which Vasari gave to Spinello's activity in San Lorenzo is appropriate for this fragment. Donati himself accepts this dating. The Annunciation presents stylistic affinities with the Monteoliveto polyptych of 1385, and the dispersed polyptych of which the predella is in the Gallery at Parma. As in these works, the severity of the composition in the San Lorenzo Annunciation, itself derived from Florentine artists like Orcagna, is softened by a decorative use of colour and shadow which seems to be due to the influence of Giovanni da Milano. This fresco was painted below a scene including soldiers, of which only the lower part survives. Its scheme occurs again, only slightly modified, in the more archaic Annunciation in the church of San Domenico at Arezzo. In the present scene, the painter uses two types of architectural setting. The Angel is placed beneath a wide, rounded arch and the Virgin sits under a pointed arch. The contrast underlines a psychological distinction between the two figures. The Angel has just appeared, and is spread out in a shallower but wider space than that occupied by the Virgin, who withdraws slightly upon her throne.

PAOLO DAL POGGETTO

Detail ▷

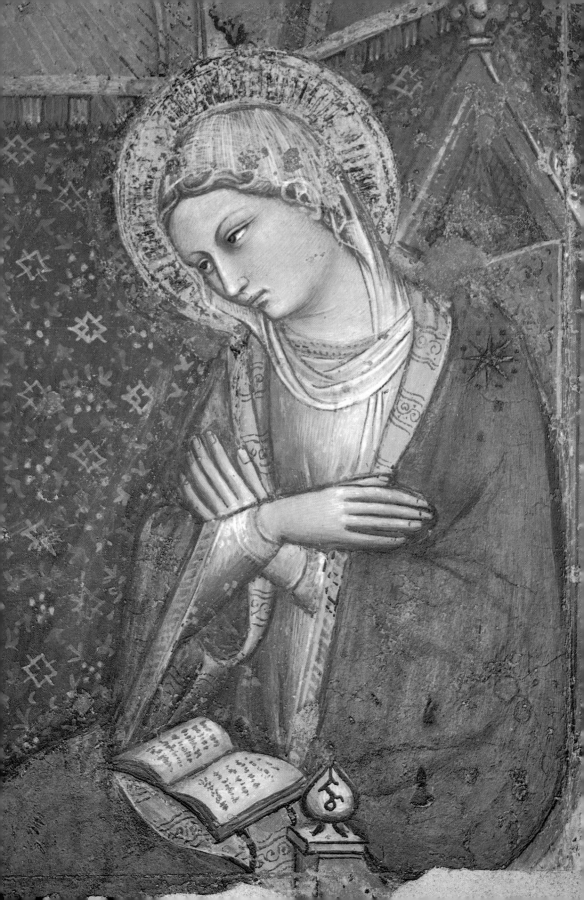

GHERARDO DI JACOPO STARNINA
1354—*c.* 1409

Vasari writes that Starnina was born in Florence and became a pupil of Antonio Veneziano, that his early work in Sta. Croce earned him the admiration of visiting Spaniards, and that as a result he was persuaded to go to Spain as a royal protégé. It has since been suggested that he was a member of the Gaddi workshop, but he appears to have been active in Toledo and Valencia in 1398–1401. In October 1404 he was back in Florence, employed in painting the St Jerome chapel in Sta. Maria del Carmine, and in 1409 worked on another cycle of frescoes, this time in the church of S. Stefano at Empoli. A document dated October 18th, 1413 refers to him as dead, 'cut off at the height of his powers' according to Vasari. The problem since has been to make reliable attributions to Starnina. His importance for the Quattrocento is clear; the absence of authenticated works has deprived him of the reputation he should perhaps enjoy.

17

ST BENEDICT
Fresco, 16ft 14⅞in x 4ft 3⅛in (500 x 130cm)
Church of Sta. Maria del Carmine, Florence

The fresco was removed in 1965 by Giuseppe Rosi using the *strappo* method, and was fastened to a panel of tempered masonite.

U. Procacci, *Rivista d'Arte*, ser. II, V (1933), pp. 151 f.; and in *Bolletino d'Arte*, XXVII (1934), pp. 327 ff.

The chapel of St Jerome, with its frescoes by Starnina, was destroyed during the reconstruction of the church of Sta. Maria del Carmine after a fire in 1771. The St Benedict is the best preserved of the fragments which have been found, and is actually the only figure with the head intact. Along with other scraps of the original decoration, it was discovered by Procacci through archival research, followed by a series of tests made on walls which corresponded to those of the chapel. These findings, however fragmentary, are extremely valuable because of the knowledge they provide about Starnina. Well regarded by his contemporaries, Starnina fell into obscurity until the 1930s because all his documented works were lost, including a large fresco on the façade of the Palazzo di Parte Guelfa as well as the Carmine cycle. On the basis of the fragments recovered, Procacci has been able to attribute to Starnina the delightful Thebaid in the Uffizi. These shreds of evidence, among which the figure of St Benedict is quite the most substantial, reveal a powerful artist with strong Gothic elements in his style, manifest particularly in the elegant placing of his figures, the long curves of their draperies and their penetrating gaze, yet capable of the noble archaising compositions of the Death and Funeral of St Jerome, known to us from the engravings made by D'Agincourt. Procacci's research enables the Carmine frescoes to be dated firmly, between 1393 and 1410. This early dating establishes Starnina as the forerunner of the last great generation of Florentine Gothic artists, of Lorenzo Monaco, the Maestro del Bambino Vispo, and Masolino.

PAOLO DAL POGGETTO

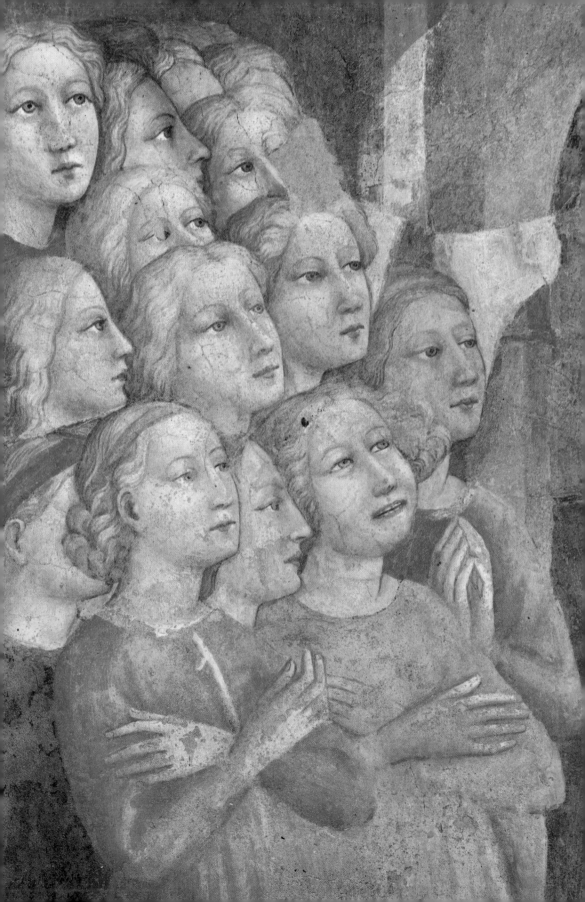

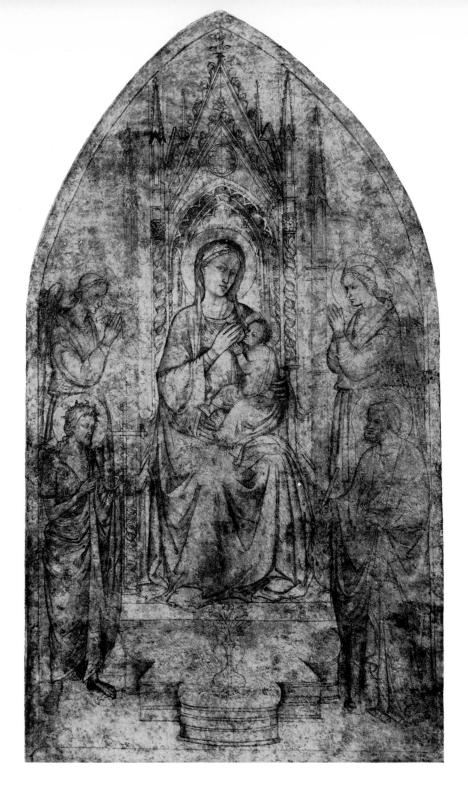

Detail from LORENZO DI BICCI tabernacle, 18.

◁ Detail of heads by MASOLINO DA PANICALE, 19.

LORENZO DI BICCI

c. 1350–1427

Documents show that Lorenzo di Bicci was active as a painter in Florence by 1370, and references to him continue into the fifteenth century. In 1385 he was working with other artists on the Loggia dei Lanzi in Florence, and was paid 90 gold florins in 1386 for paintings in Sta. Maria del Fiore. In 1389 he appears to have painted a Crucifixion for the Compagnia della Croce, in the church of S. Stefano at Empoli, and in 1412 a St Nicholas for the hospital of S. Matteo in Florence. Between 1386 and 1408 Lorenzo di Bicci joined the guild of Medici e Speziali and in 1409 his name appears on the register of the guild of St Luke. Not many of his works can now be identified, and it is generally accepted that the frescoes in Sta. Maria del Carmine in Florence and S. Francesco in Arezzo which Vasari attributed to him were in fact the work of his son Bicci di Lorenzo (1373–1452).

18

THE TABERNACLE OF THE MADONNONE

a Madonna and Child enthroned with Saints and Angels (*centre*)
 Sinopia 19ft 4¾in x 9ft 3¾in x 5½in (591 x 284 x 14 cm)

b God the Father (*centre of the under-arch*)
 Sinopia 6ft 6¾in x 5ft 3⅜in x 14⅛in (200 x 161 x 36cm)

c Two Prophets (*left under-arch*)
 Sinopia 8ft 10¼in x 6ft 4¾in x 18⅞in (270 x 195 x 48cm)

d Two Prophets (*right under-arch*)
 Sinopia 8ft 11⅞in x 6ft 3½in x 17¾in (274 x 192 x 45cm)

e Two Saints (*left reveal*)
 Sinopia 11ft 7⅜in x 4ft 4¾in x 2in (354 x 134 x 5cm)

f Two Saints (*right reveal*)
 Sinopia 11ft 7⅜in x 4ft 4¾in x 2in (354 x 134 x 5cm)

g Angel of the Annunciation (*left spandrel*)
 Sinopia 9ft 3⅜in x 8ft 3⅝in x 6¾in (283 x 253 x 17cm)

h Virgin of the Annunciation (*right spandrel*)
 Sinopia 9ft 3⅜in x 8ft 3⅝in x 6¾in (283 x 253 x 17cm)

i Four Saints (*upper left exterior*)
 Sinopia 10ft 11⅛in x 5ft 7¾in x 2in (333 x 172 x 5 cm)

j Fragment (*lower left exterior*)
 Sinopia 10ft 4⅜in x 5ft 7¼in x 2in (316 x 171 x 5cm)

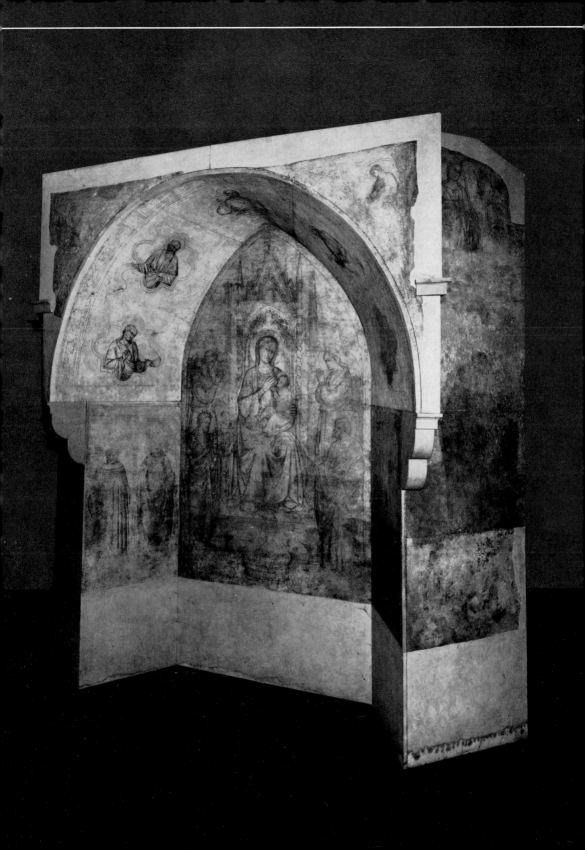

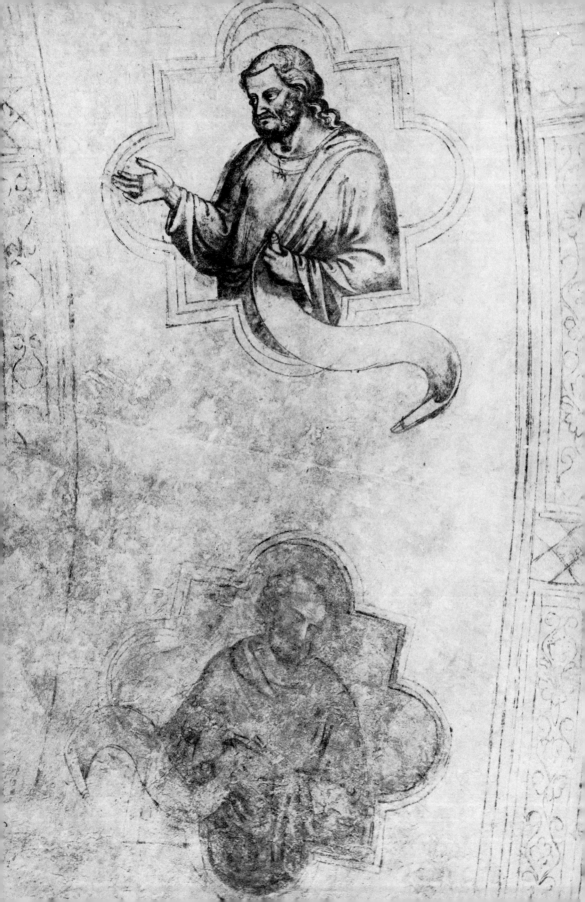

k Four Saints (*upper right exterior*)
 Sinopia 13ft 9¾in x 5ft 1¾in x 2in (421 x 157 x 5cm)

l Fragment (*lower right exterior*)
 Sinopia 7ft 5in x 5ft 1in x 2in (226 x 155 x 5cm)
Soprintendenza alle Gallerie, Florence (from the Via Aretina)

On the Via Aretina, beyond the old city walls of Florence there stands an impressive tabernacle which has long been called 'del Madonnone' or the 'shrine of the Madonna'. In fact the suburb which now surrounds it is also known as Madonnone. The name derives from the proportions of the Madonna, much larger than life-size, which used to decorate the shrine. Together with the other frescoes and their *sinopie*, these have recently been removed, unfortunately too late to save most of the paint surface. Having withstood corrosion for five centuries, the disintegration of the frescoes took place rapidly, in the course of a few decades, so that what remains does so only in a poor state of preservation. The consolation for such a loss is the handsome collection of *sinopie*, most of which are intact and which together form a unique ensemble. The central group of the Madonna and Child is surrounded by saints and angels, all over life-size. In the archivolts of the shrine, medallions contain God the Father and prophets, on the outside there are more saints, and in the spandrels, two roundels contain the Angel of the Annunciation and the Virgin. The *sinopie* are the work either of Lorenzo di Bicci towards the end of his activity, or of his son Bicci di Lorenzo. If by the latter they would be among the first of a long series of high quality preparatory drawings which he was to produce. All the *sinopie* are impressive works, shaded and carried to a high degree of finish, as though the artist intended them to be appreciated as works of art instead of mere sketches to be buried beneath a layer of *intonaco*. They recall the advice of Cennini on the subject of preparatory drawings; '. . . make sure that these figures are well worked out, because they enable you to understand and prepare the figures that you have to paint [on top]'.

UGO PROCACCI

The *sinopie* were discovered when Dino Dini began the removal of the damaged frescoes. Most of them were extremely well preserved, although some had suffered from exposure to the atmosphere. The rapidity of their deterioration can be seen from old photographs. Among those of which little remains, the enormous figure of St Christopher and what was probably the stigmatisation of St Francis must be included. The *sinopie* have been mounted on panels of reinforced masonite and reassembled as a shrine. The dark marking which can still be seen faintly on the *arriccio* is what remains of the charcoal used in the first outline of the *sinopie*.

G. Sinibaldi, *Bollettino d'Arte*, XXXVII (1952), pp. 57 ff. (with bibliography).
U. Baldini and L. Berti, in *III Mostra di Affreschi Staccati* (Exhib. cat., Forte di Belvedere, Florence 1959), p. 5.
U. Procacci, *Sinopie e Affreschi* (1961), pp. 55, 235.

MASOLINO DA PANICALE (TOMMASO DI CRISTOFORO FINI)
1383–after 1435

Masolino was born in Panicale near S. Giovanni Valdarno, in the same district as Masaccio, with whom his name is often linked. One of the major Florentine painters of the early Quattrocento, his art began with, and later reverted to, a style which was more Gothic than that of his associate. Masolino probably trained in Florence, perhaps in the workshop of Gherardo Starnina. He had certainly joined the Ghiberti shop before 1407, and in 1423 he enrolled in the guild of Medici e Speziali. In 1424 he received a payment for frescoes in the church of S. Stefano at Empoli and his association with Masaccio appears to have begun soon afterwards. The Virgin and Child with St Anne now in the Uffizi is their first joint work. Together they executed the fresco cycle in the Brancacci chapel of Sta. Maria del Carmine. Both artists went to Rome in 1428; Masaccio died there and Masolino carried out a cycle of frescoes in the Branda chapel of S. Clemente. After the death of Masaccio, Masolino returned to a more Gothic style which presents affinities to that of the sculptor Ghiberti. His last recorded works are the frescoes in the Baptistery and Collegiata at Castiglione d'Olona, completed by 1435.

19

HEADS
Fresco, 6ft 2¾in x 2ft 6in (190 x 76cm)
Church of Sant'Agostino, Empoli

The fresco was removed in 1957 by Dino Dini, using the *strappo* method. It was transferred to a masonite panel.

Documents published by Poggi and Giglioli prompted Procacci to search for work known to have been carried out by Masolino in 1424 in the chapel of Sant'Elena in the church of Sant' Agostino at Empoli. His discoveries made in 1943 include nos. 19–22 of this exhibition.

The fragment was found on the right wall of the church, and Salmi (1947) promptly linked it with the documented frescoes of the Legend of the True Cross in the Sant' Elena chapel. Salmi also argued, on the basis of a fragment showing an ermine cloak, that the subject was St Ivo and his pupils. Apart from the Bremen Madonna (1423) it is the earliest known work by Masolino. It shows his descent from the elegant and courtly world of Gothic forms, to which he returned in his later works in spite of the impact of Masaccio. The luminous and poetic vision makes this one of Masolino's most delightful works. The figures in the fresco are seen from below; a treatment which occurs in other paintings by Masolino, such as the Annunciation in the National Gallery in Washington, and in the works of other artists, Francesco d'Antonio for instance, around 1425.

PAOLO DAL POGGETTO

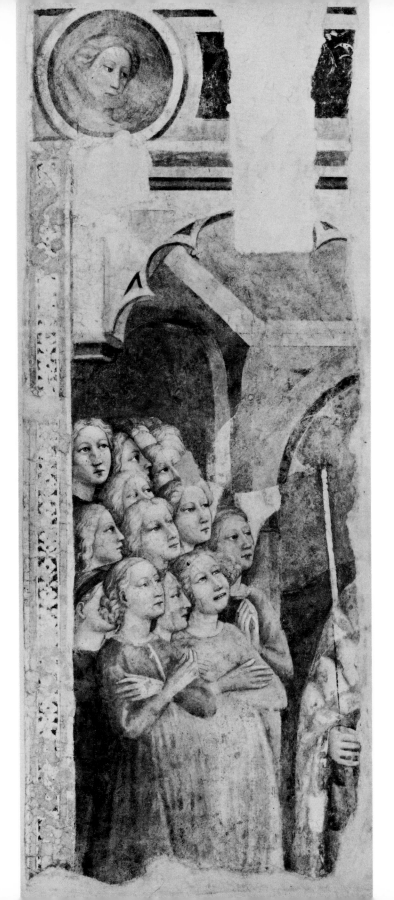

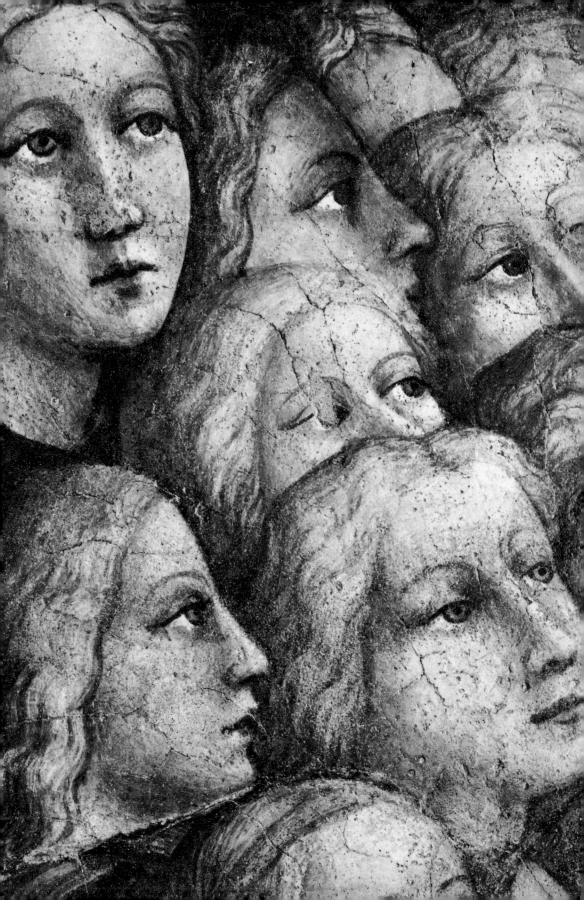

20

MEDALLIONS OF SAINTS
Fresco (in two strips) 10ft 4in x 1ft 6⅛in x 1ft 11⅝in
(315 x 46 x 60cm)
Church of Sant'Agostino, Empoli

Documents discovered by Poggi and Giglioli enable these busts to be dated in 1424. They were frescoed on the archivolts over the entrance to the Chapel of Sant'Elena. When he published them, Salmi pointed out that they are the work of assistants, with only two exceptions; the second from the bottom on both sides. Paolo Schiavo may have painted the two saints at the top, nearest to the point of the arch. In spite of their characteristic elegance, all of them display, in the opinion of this author, a knowledge of Masaccio, with whom Masolino must have made contact even at this early date.

UMBERTO BALDINI

The medallions were removed in strips from the archivolts using the *stacco* method. The operation was carried out in 1958 by Dino Dini.

21

THE PROOF OF THE TRUE CROSS
Sinopia and fresco fragment 11ft 7in x 8 ft5⅝in (353 x 258cm)
Church of Sant'Agostino, Empoli

22

FIGURE OF A SAINT
Sinopia, 7ft 10½in x 1ft 6½in (240 x 47cm)
Church of Sant'Agostino, Empoli

Documents showed that Masolino was paid 74 gold florins to decorate a chapel in the church of Sant'Agostino, and that his work was probably completed by November 2, 1424. The first task was to locate the chapel. Unfortunately very little of the frescoes remained, because in August 1792 the friars of the adjacent convent decided by 6 votes to 1, 'to strip down and replaster [the walls] . . . as it cannot be considered either harmful or unpopular to demolish the coarse and worthless paintings now there, in order to give the walls a more attractive colour'. It is some compensation that the *sinopie* of the destroyed frescoes have been recovered. They are not only an important contribution to our knowledge of Masolino, but can also rank among the finest early Quattrocento *sinopie* preserved. The drawings are mostly in clear, firm outline, with rarely a hint of shading, and no retouching. The compositions are masterly in their organisation of space. The *sinopie* possess, in fact, the delicacy and elegance for which Masolino's paintings are admired.

UGO PROCACCI

The *sinopie* were removed by Dino Dini in 1959–60, using the *stacco* method, and attached to a rigid framework of reinforced masonite. Part of the original fresco can still be seen in no. 21; its display with the *sinopie* helps to demonstrate the relationship between them. The white area in no. 21, the shape of a small window, corresponds to a niche in the wall which Masolino painted in *trompe l'oeil*. Containing a still-life, this is still in its original place in the church of Sant'Agostino, although it will soon be detached to join the rest.

M. Salmi, *Masaccio* (1947), p. 84 (with bibliography).
U. Baldini, in *II Mostra di Affreschi Staccati* (Exhib. cat., Forte di Belvedere, Florence 1958), no. 48, p. 36 [St Ivo].
E. Micheletti, *Masolino da Panicale* (1959), pp. 22 f., 49 f. (with bibliography).
U. Procacci, *Sinopie e Affreschi* (1961), pp. 61, 227.
P. Dal Poggetto, in *Arte in Valdelsa* (Exhib. cat., Palazzo Pretorio, Certaldo 1963), no. 32, pp. 40 f. [St Ivo].
L. Berti, *Masaccio* (1964), pp. 67 f.

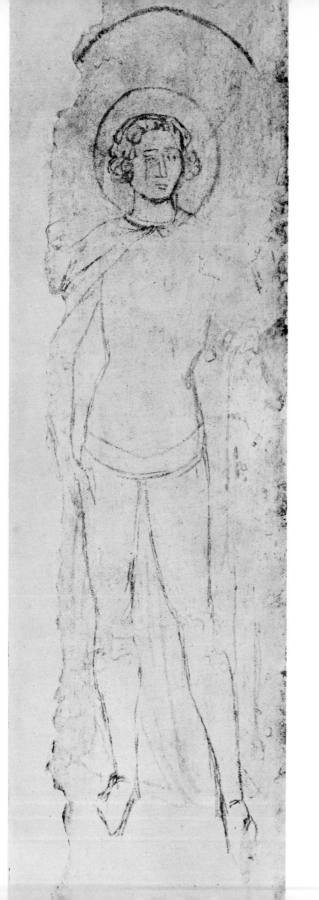

FRANCESCO D'ANTONIO DI BARTOLOMMEO
1393–c. 1433

A minor Florentine painter of the early Quattrocento, Francesco d'Antonio's style reacted to a series of contemporary influences. He began, perhaps as a follower of Lorenzo Monaco, but was then influenced by Gentile da Fabriano who worked in Florence between 1422 and 1425. A polyptych in the church of S. Niccolò in Florence for which Gentile painted his Quaratesi altarpiece (1424–5) has been attributed to Francesco d'Antonio, because of its obvious debt to Gentile. Like the fresco exhibited here it was probably painted soon after 1425, because by 1429, when Francesco d'Antonio was paid for decorating the organ of Orsanmichele, his style had once more shifted, under the influence of Masolino and Masaccio. His Madonna della Cintola in S. Vito a Loppiano in Valdarno can probably be placed slightly earlier. The head of a Virgin which he painted in a shrine in the Piazza Santa Maria Novella recalls Masolino's Madonna at Todi of 1432, and frescoes at Montemarciano first attributed to Francesco d'Antonio by Lindberg are dependant upon Masaccio.

23, 24

ST ANSANUS
Fresco, 7ft 5⅜in x 4ft 7⅞in (227 x 142cm)
Sinopia, 7ft 5⅜in x 4ft 7⅞in (227 x 142cm)
Church of San Niccolò, Florence

The St Ansanus was attributed to Francesco d'Antonio by Longhi, who pointed out the strong influence of Gentile da Fabriano. Such an influence was perhaps inevitable in a fresco from the church of S. Niccolò for which Gentile had, in 1425, painted his Quaratesi altarpiece. Longhi accordingly dated the saint 1425–6. A convincing comparison may be made between this and the shutters of the organ in Orsanmichele (now in the Accademia, Florence) which Francesco d'Antonio decorated in 1429, by which time his style had begun to move in the direction of Masolino. Longhi's attribution has been contested only by Salmi, who assigns this fresco to Boccati. It is accepted by Zeri and by Berti (1952), who emphasizes the popular accent given by Francesco d'Antonio to his borrowings from the more aristocratic Gentile. The saint fills the space which the frame provides, standing out against the white back-cloth. The frame is an interesting one; a simple rectangular construction, punctuated by circles evidently due to the influence of Masolino, and decorated with panels of two-toned intaglio. The *sinopia* shows only the figure of the saint which in spite of its courtly trappings is even more popular in style than the fresco version.

The fresco had to be removed when dampness in the wall on which it was painted began to damage the surface. The operation was carried out in 1965 by Giuseppe Rosi, using the *strappo* method. This also exposed the *sinopia* which is drawn in red, with signs of charcoal still apparent. It differs from the fresco only where the mantle falls from the right shoulder of the saint, a more dramatic movement in the final version, and in the position of the saint's left foot which has been changed slightly. Both fresco and *sinopia* have been transferred to masonite supports.

R. Longhi, *Critica d'Arte*, V (1940), pp. 186 f. (note 24).
M. Salmi, *Masaccio* (1947), pp. 218 f. (with bibliography).
L. Berti, *Bollettino d'Arte*, XXXVII (1952), p. 178.

PAOLO DAL POGGETTO

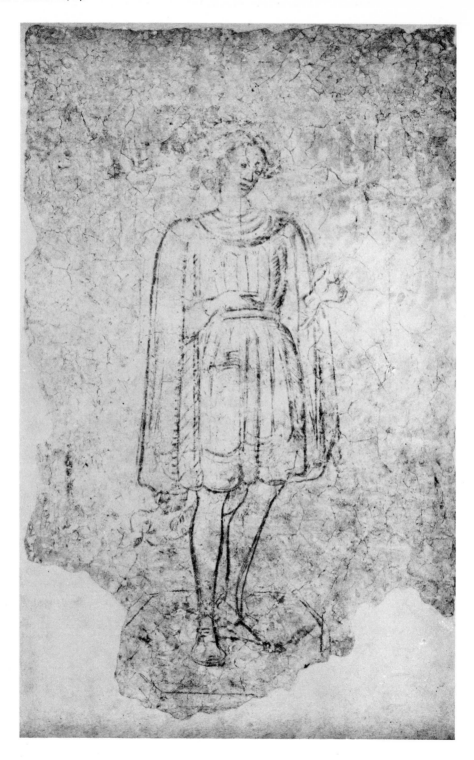

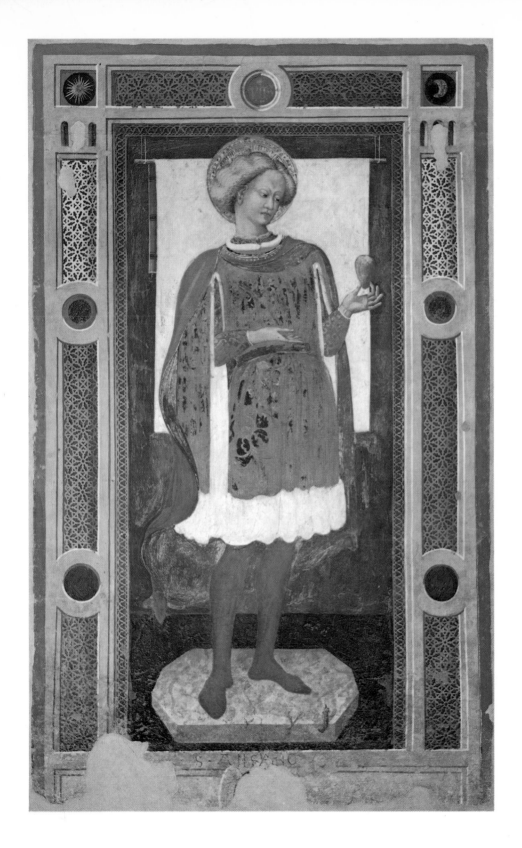

113

FLORENTINE MASTER OF THE FIRST HALF OF THE FIFTEENTH CENTURY

25

THE ANGEL OF THE ANNUNCIATION
Fresco, 2ft 8¼in x 2ft 7½in (82 x 80 cm)
Castel di Poggio, Fiesole (formerly in the Cappella del Romito)

The two figures of the Annunciation are almost complete and their refined style is close to but not identical with that of Francesco d'Antonio. They are the work of a minor Florentine painter of the first half of the fifteenth century to whom no other works have been attributed. If the new artistic personality is to be defined, then he might conveniently be called 'the Master of Castel di Poggio' after these frescoes. The marked influence of Masolino suggests that they belong in the fourth decade of the century.

LUCIANO BERTI

The fresco presents an interesting technical detail. The frame around the lunette was painted *a secco* and partly in fresco; the *secco* part has disappeared. The tabernacle from which the present figure comes was removed by Giuseppe Rosi in 1957 by the *stacco* technique.

L. Berti, in *II Mostra di Affreschi Staccati* (Exhib. cat., Forte di Belvedere, Florence 1958), no. 5, p. 3.

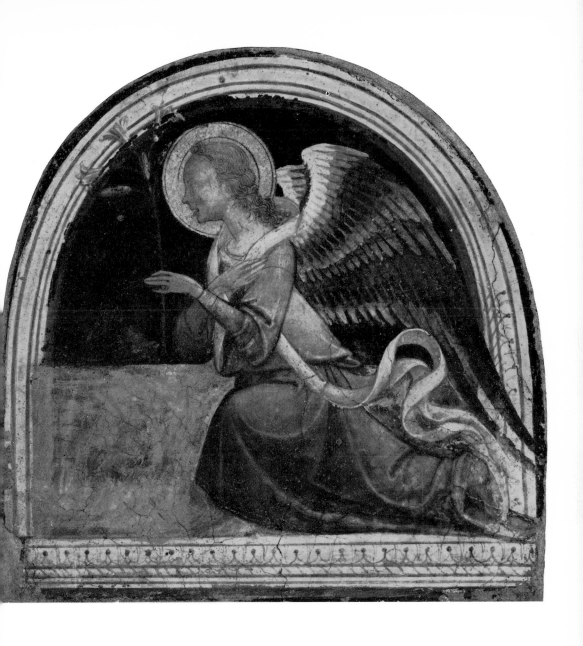

FRA ANGELICO (GUIDO DI PIETRO)
c. 1400–1455

Born in the Mugello around 1400, Guido di Pietro entered the Dominican convent at Fiesole about 1421. He was ordained in or before 1423, and more than any other Quattrocento artist, his work constantly reflected his own deeply-held religious views. A polyptych painted for the church of S. Domenico at Fiesole can be dated around 1428. It is a late Gothic work, which suggests affinities with Lorenzo Monaco, and is comparable to a fresco of the Crucifixion in the same church. In 1433 Fra Angelico was commissioned to paint the Linaiuoli Madonna (Museo di San Marco, Florence) which is redolent of the influence of Ghiberti. Around 1436 he worked for the Dominican foundation in Cortona, and in 1437 painted a polyptych for the church of S. Domenico in Perugia. Soon afterwards he abandoned the form of the polytych in favour of single panel altarpieces, the one he painted for the high altar of S. Marco in Florence was probably complete in 1440. In 1436 the Dominicans took over the church and convent of S. Marco, and Fra Angelico undertook his best known work, the fresco decoration of their quarters. Most of the common rooms and cells were painted, many of them by his assistants, between 1443 and 1447. Fra Angelico then went to Rome, to decorate the chapel of Pope Nicholas V in the Vatican with scenes from the lives of St Lawrence and St Stephen. In 1449 he returned to Fiesole to hold office as Prior of S. Domenico, returning to Rome at the end of his term in 1452. The 'Beato Angelico' as he was later termed, died in Rome on March 18, 1455, and was buried in Sta. Maria sopra Minerva.

26

MADONNA AND CHILD
Sinopia, 3ft 9⅝in x 2ft 5½in (116 x 75cm)
Church of San Domenico, Fiesole

The *sinopia* was detached *a strappo* in 1960 by the restorer Dino Dini, and fastened to a masonite support.

U. Procacci, *Affreschi e Sinopie* (1961), p. 243.

The fresco is a fragment of what was probably a larger composition, and was transferred from its original position, with the entire section of wall on which it was painted, to a place above a doorway on the ground-floor of the convent. The move probably occurred in 1587, during the construction of the new quarters for novices to which the doorway gave access. An elaborate border was then added, including the inscription 'B. Joannes Angelicus huius cenobii filius pinxit' (the Blessed Angelico, son of this convent painted [it]), and a separate inscription 'venite filii audite me' (Come, my sons, listen to me). In 1858 both the fresco and its surround were so crudely repainted that it was impossible to assess the quality of the Madonna, which as a result was never seriously considered as a work by Fra Angelico. However, apart from its location in S. Domenico where Fra Angelico had lived and worked, there were other grounds for hoping that beneath the repaint-

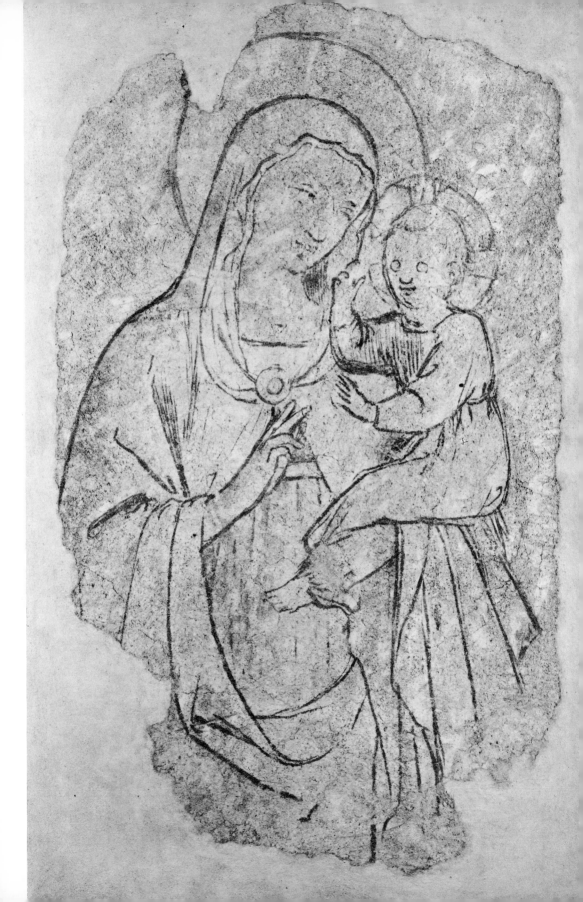

ing there might be an authentic work. This suspicion was confirmed when the fresco was restored (in its present state it is considerably damaged but free of later painting), and particularly when its magnificent *sinopia* was recovered in 1960. It was probably painted between 1435, the supposed date of the Annalena altarpiece (Museo di San Marco), and 1438–9, when work presumably began in Florence on the cells adjacent to the Via Lamarmora in the convent of S. Marco. The fresco was executed by a pupil.

UGO PROCACCI

27

MADONNA AND CHILD

Sinopia, 4ft 8⅝in x 7ft 9¾in (144 x 238cm)
Church of San Domenico, Cortona

The fresco was restored in 1955, when passages of peeling colour were fastened down and a considerable part of the lower section was salvaged. Unfortunately its condition later deteriorated, and in 1966 the fresco had to be detached from the wall. The removal of both fresco and *sinopia* was undertaken by Giuseppe Rosi, using the *strappo* method. The *sinopia is* supported by tempered masonite.

The *sinopia* was found beneath a fresco of the Madonna and Child with St Dominic and St Peter Martyr, painted by Fra Angelico between 1435 and 1438 in the lunette above the entrance to the church of San Domenico in Cortona. Mentioned by Vasari, the fresco has been related in all subsequent writings to the triptych which Fra Angelico painted for the same church. Unfortunately only the upper part of the fresco and *sinopia* survive, the former in very poor condition. Following its discovery, the *sinopia* was exhibited in 1966 at the Forte di Belvedere in Florence. It is one of the most remarkable *sinopie* that survive with its bold rhythms and subtle harmonies.

UMBERTO BALDINI

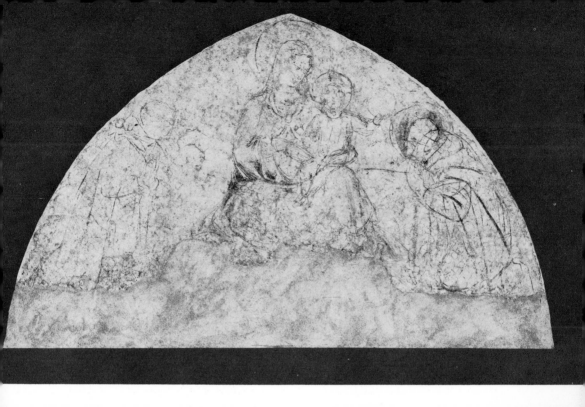

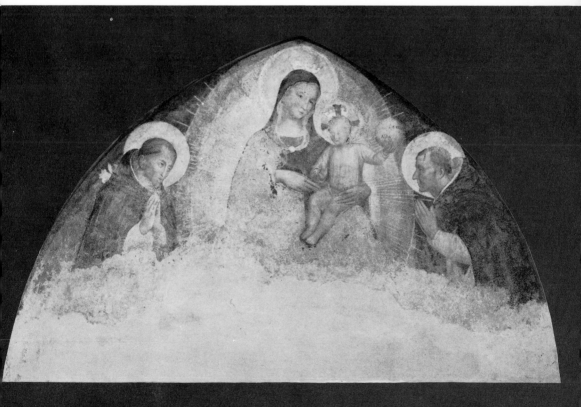

△ Fresco not exhibited.

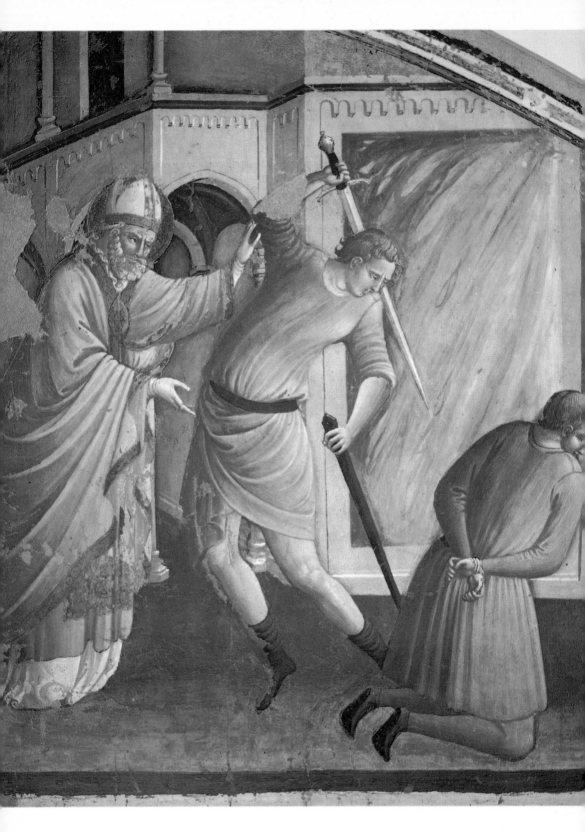

Detail from PARRI SPINELLI. 30.

FRA ANGELICO, 28 and 29.

28, 29

ST PETER MARTYR
Fresco, 3ft 6½in x 4 ft 9⅛in (108 x 145cm)
Sinopia, 3ft 6½in x 4ft 9⅛in (108 x 145cm)
Museo di San Marco, Florence

The fresco was painted by Fra Angelico around 1440 in the lunette of a doorway between the cloister of the convent and the church of San Marco. The saint is shown holding the forefinger of his right hand to his lips, admonishing the onlooker to silence since the door gave access to a holy place. Like other works painted by Fra Angelico in the cloister of San Marco, it fulfills a didactic purpose.

UMBERTO BALDINI

The condition of the fresco was extremely critical, because of unwise restorations in the past. It was removed in 1954 by Leonetto Tintori using the *strappo* method, and attached to a support of three-ply masonite. The *intonaco* remained in place until very recently, concealing the *sinopia* which appears for the first time in this exhibition. Although it is damaged, it illustrates the astonishing degree of freedom exercised by a major artist in the execution of his design.

U. Baldini, in *Mostra delle opere del Beato Angelico* (Exhib. cat., Museo di San Marco, Florence 1955), 2nd ed., no. III, p. **131**.
M. Salmi, *Il Beato Angelico* (1958), p. 117.
S. Orlandi, O.P., *Beato Angelico* (1964), p. 77.

PARRI SPINELLI (GASPARE DI SPINELLO)
1387–1453

Born in Arezzo in 1387, Parri Spinelli was the son and pupil of Spinello Aretino. In 1407 he helped his father to paint the frescoes in the Sala di Balia in the Palazzo Pubblico of Siena. He returned to Arezzo, where he continued to paint in the tradition which he derived from Spinello Aretino and from his contact with the Florentine followers of Lorenzo Monaco. His workshop must have been a prominent one in Arezzo. He worked for a number of local churches, among them S. Francesco and S. Domenico. He painted a Madonna della Misericordia in fresco for the Confraternità dei Laici around 1448 and the fresco of the Crucifixion (nos. 31–32) in the Palazzo Comunale. The museum in Arezzo has a number of panels attributed to him, and a group of drawings in the Uffizi appear to be his. He died in Arezzo on June 9, 1453.

30

SCENES FROM THE LIFE OF ST NICHOLAS
Fresco, 5ft 5¾in x 13ft 6⅝in (167 x 413cm)
Church of San Domenico, Arezzo

This fresco comes from the chapel of St Nicholas in the church of San Domenico in Arezzo, where, according to Vasari, Parri Spinelli painted a large Crucifixion on the upper part of the wall and above it a lunette containing scenes from the life of St Nicholas. Later scholars have accepted Vasari's attribution and his dating of the St Nicholas frescoes as late works by Parri Spinelli. The frescoes are normally placed around 1440, and are among his finest paintings. For many years, Parri Spinelli was underestimated by critics. Although the influence of Ghiberti can be detected in his late Gothic style, his work is highly personal and distinctive. Its characteristics are illustrated in these frescoes by the sharp silhouetting of the figures, by the exaggerated gestures, and by the elongated forms. Vasari notes that 'where others made [their figures] at most ten heads high, he made his eleven and even twelve'. The St Nicholas frescoes confirm the technical mastery of Parri Spinelli, which Vasari praised so highly, and show the subtlety with which he could control both his chiaroscuro and colours which Vasari regarded as incomparable. These scenes are also extremely well preserved.

PAOLO DAL POGGETTO

The fresco was removed, using the *strappo* method, by Giuseppe Rosi in 1965, and attached to masonite panels. A heavy layer of repainting was cleaned from the surface to reveal most of the original fresco in excellent condition.

P. P. Donati, *Antichità Viva* III (1964), no. 1, pp. 15 ff.

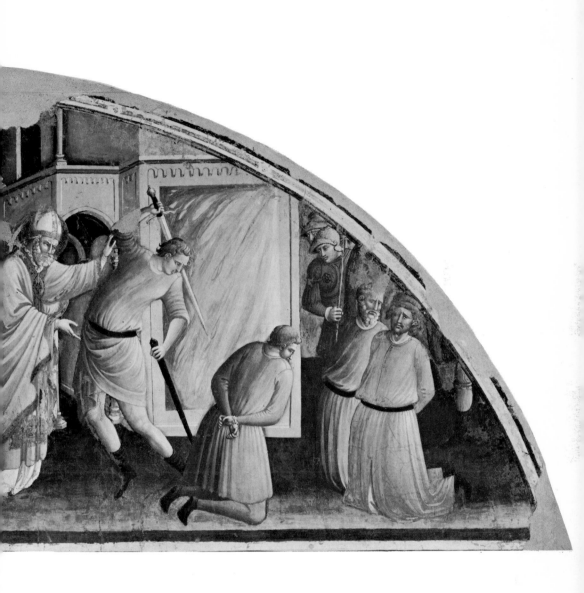

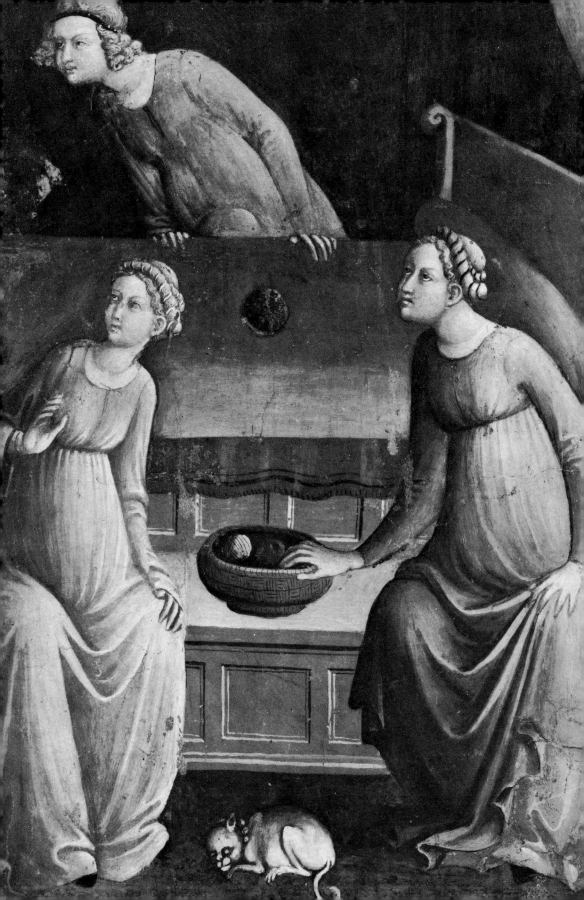

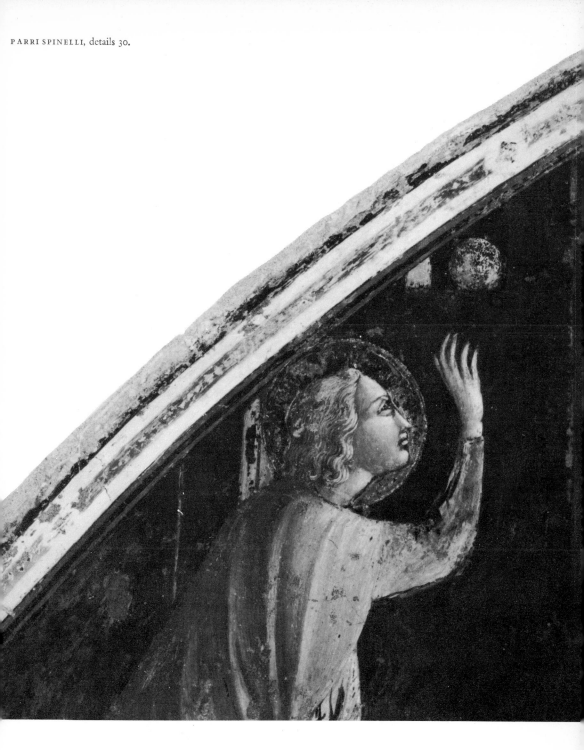

31, 32

CHRIST ON THE CROSS WITH THE VIRGIN AND ST JOHN THE EVANGELIST
Fresco, 3ft 11⅝in x 2ft 11½in (121 x 90cm)
Sinopia, 3ft 11⅝in x 2ft 11½in (121 x 90cm)
Palazzo Comunale, Arezzo

The *sinopia* is drawn in black, with a purity of line which places it among the most striking examples of preparatory drawing. A monogram of the type used by lawyers with the date 1461 has been scratched into the surface of the fresco. Both the fresco and the *sinopia* were removed *a strappo* by Giuseppe Rosi in 1958, and transferred to masonite supports.

L. Berti in *II Mostra di Affreschi Staccati* (Exhib. cat., Forte di Belvedere, Florence 1958), nos. 161, 162, p. 63.
E. Borsook, *The Mural Painters of Tuscany* (1960), p. 27.
U. Procacci, *Sinopie e Affreschi* (1961), pp. 60 ff.

The fresco shows Christ crucified, with the Virgin and St John mourning beside the cross. It was painted by Parri Spinelli in the Palazzo Comunale at Arezzo, probably in the fifth decade of the fifteenth century. It can be compared, for instance, with the Madonna della Misericordia of 1448. There is a marked contrast between the *sinopia* and the fresco. The first is drawn with a lively freedom while the final version is more mannered, with its heavy drapery folds and conventional late-Gothic forms. Changes have been made in the positions of the hands and heads of both the Virgin and St John, and in the form of the cross which in the fresco is made from a roughly-hewn tree. A drawing of a female saint in the Uffizi (37 E) offers a striking comparison with both the figure of St John in the *sinopia* and with that of the Virgin in the fresco.

LUCIANO BERTI

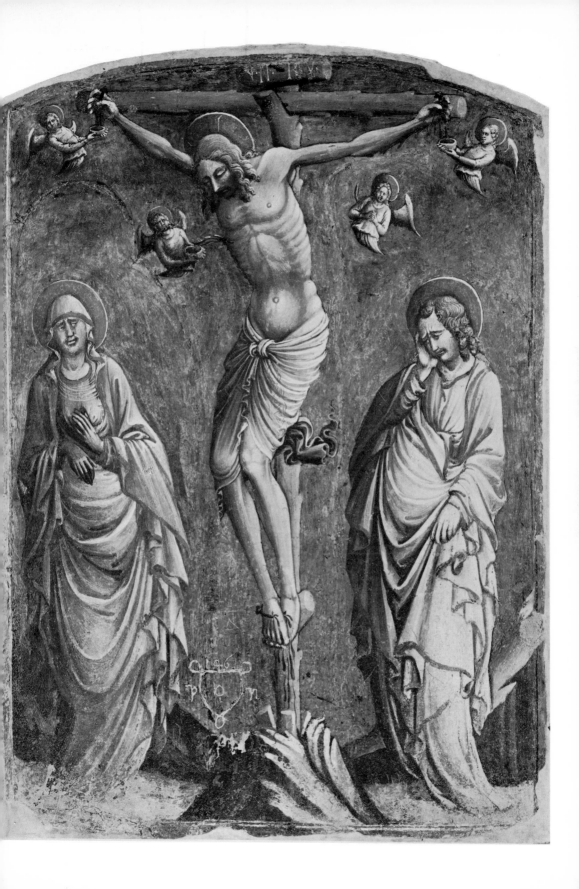

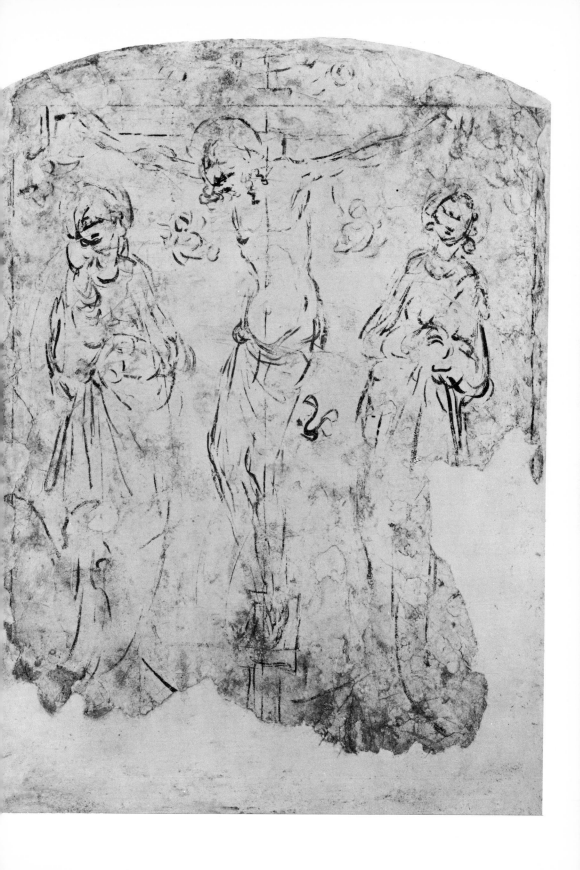

PAOLO SCHIAVO (PAOLO DI STEFANO BADALONI)
1397–1478

Paolo di Stefano was born in Florence in 1397. Vasari suggests that he was a pupil of Masolino. He enrolled in 1429 in the guild of Medici e Speziali, and probably painted his best-known work, the frescoes in the Collegiata at Castiglione d'Olona, between 1429 and 1436. A fresco of the Madonna with four Saints in the church of S. Miniato al Monte in Florence, appears to be later, and carries an incomplete date which is normally read as 1436. A small tabernacle of the Madonna and Child is in the Fitzwilliam Museum, Cambridge. In 1448 Schiavo worked in Pistoia on frescoes in the Cappella dell'Assunta and documents prove his activity in Pisa around 1462. He died there in 1478.

33

MADONNA AND CHILD ENTHRONED WITH ANGELS

Sinopia, 9ft 2in x 7ft 9¼in (280 x 237cm)
Church of Santi Apostoli, Florence.

The *sinopia* is drawn in black instead of the red colour traditionally used. It is in good condition, in spite of losses. The darker areas on the *arriccio* mark those parts which were exposed to the weather when the *intonaco* disintegrated with the fresco. The *sinopia* illustrates a common method of laying out a fresco. The vertical line which establishes its centre and those which mark the borders are made by snapping a cord against the *intonaco* (see Introduction).

The attribution of the Madonna and Child Enthroned to Paolo Schiavo was made by Offner. The fresco was painted on the façade of the church of SS. Apostoli, where in time it fell into almost total ruin. The fragments that remained were detached from the wall, and in the process this handsome *sinopia* was uncovered. It is an extremely accomplished drawing, made with great skill by the artist on the *arriccio*.

UMBERTO BALDINI

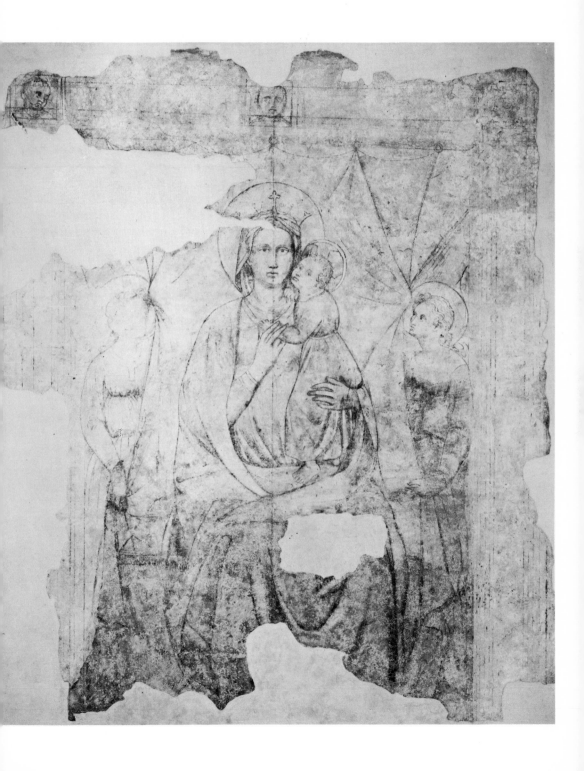

THE PRATO MASTER
active c. 1445

'An animated, mannered and deeply individual painter trained in Uccello's studio prior to 1443' (Pope-Hennessy, *Paolo Uccello*, 1950, pp. 157ff.). The unidentified artist takes his name from the frescoes in the Cappella dell'Assunta, to the right of the Cappella Maggiore, in the Cathedral of Prato. His work there comprises the representations of Faith, Hope, Charity and Fortitude on the roof, the single figures of saints on the arch above the entrance to the chapel, the Dispute of St Stephen in the top band of the left wall, and the Birth of the Virgin and the Presentation of the Virgin in the Temple in the top and centre bands of the right wall. The decoration of the chapel was completed with three frescoes by Andrea di Giusto who died in 1455. This provides the terminal date for their execution, and the debt which they reveal to Uccello's clock-face for the Duomo in Florence, painted in 1443, helps to establish the earlier limit. In isolating the work of the Prato Master, Pope-Hennessy attributed to him a Madonna and Child in the National Gallery, Dublin; a female saint with two children, in the Contini-Bonacossi collection in Florence; and three panels from a predella, showing St John on Patmos, the Adoration of the Magi, and two kneeling saints, from the church of S. Bartolommeo a Quarata, Bagno a Ripoli.

34, 35
BIRTH OF THE VIRGIN

Dampness in the Cappella dell' Assunta caused considerable damage to the frescoes, which were affected by fungus. Previous restorations, designed to strengthen the bond between the *arriccio* and the *intonaco* had merely weakened the mortar and contributed to their deterioration. They were detached from the walls in 1964–5, by Giuseppe Rosi, using the *strappo* method. The *sinopia* exhibited here was found beneath the *intonaco*, and contains a number of interesting variations from the fresco. In the *sinopia* the woman on the far right holds a small boy by the hand, later eliminated by the artist, who painted over that portion, as could be seen from the back of the paint surface during its removal. The figure of the child has been preserved and was removed independently from the wall. Both the fresco and the *sinopia* are fastened to masonite supports.

Fresco, 9ft 10⅞in x 11ft 10⅛in (302 x 361cm)
Sinopia, 9ft 10⅛in x 11ft 8½in (300 x 357cm)
Cathedral, Prato

This fresco forms part of the decorations in the Cappella dell'Assunta in Prato Cathedral, and as such is central to the controversial problem of the Prato Master. The group of frescoes has a long history of attributions. They were at one time given to Domenico Veneziano (Schmarzow, 'Domenico Veneziano', in *L'Arte* XV, 1912, pp. 81ff.) and to Uccello himself (Longhi, 'Fatti di Masolino e di Masaccio', in *La Critica d'Arte* XXV–VI, 1940, p. 179; Poggetto, in the version of this catalogue prepared for the Metropolitan Museum in New York, p. 144). Previously both Longhi ('Ricerche su Giovanni di Francesco', in *Pinacoteca* I, 1928, pp. 40–44) and Berenson (*Italian Painters of the Renaissance*, 1932, p. 342) had preferred an attribution to Giovanni di Francesco. Apart from the Prato Master, the unidentified artist has been called the 'Master of the Karlsruhe Adoration' (Pudelko, 'Der Meister der Anbetung in Karlsrühe', *Das Siebente Jahrzehnt: Festschrift zum 70 Geburtstag von Adolf Goldschmidt*, 1935, p. 125 n.), and the 'Quarata Master' (Salmi, 'Paolo Uccello, Domenico Veneziano, Piero della Francesca e gli affreschi del Duomo di Prato', in *Bollettino d'Arte*

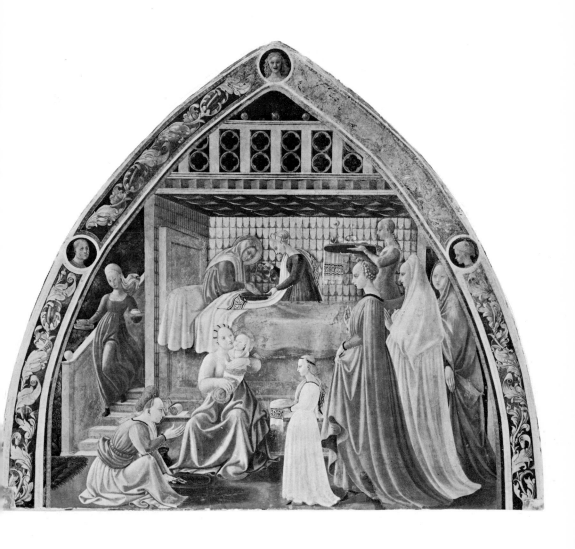

Detail, 34 ▷

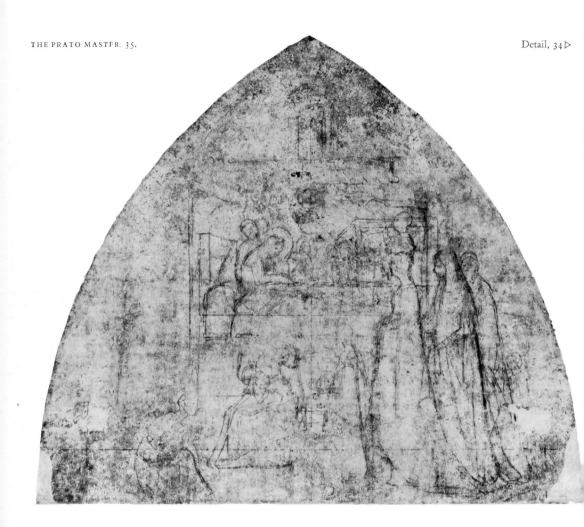

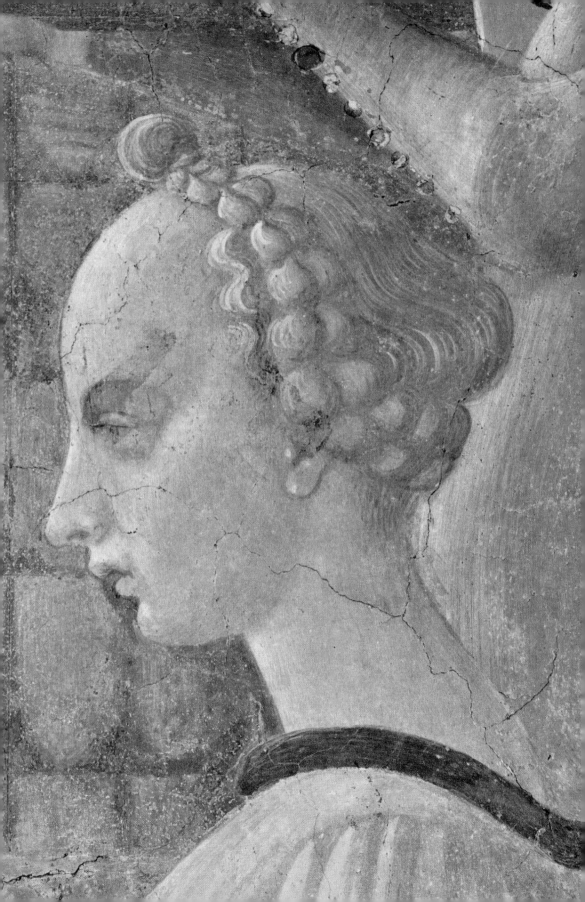

XXVII, 1934–5, pp. 1–16). The attribution to Domenico Veneziano is no longer supported, although Pudelko (*op. cit.*, p. 126) suggests that the Birth of the Virgin is derived from a lost fresco by Domenico Veneziano in S. Egidio in Florence, executed between 1439 and 1445. But because the Prato frescoes are particularly fine, a number of critics defend the attribution to Uccello himself. The design of these frescoes and the arrangement of space within them are, however, incompatible with the practice of Uccello, as is the *sinopia* which differs in style and handling from the *sinopie* of Uccello. D.D.R.

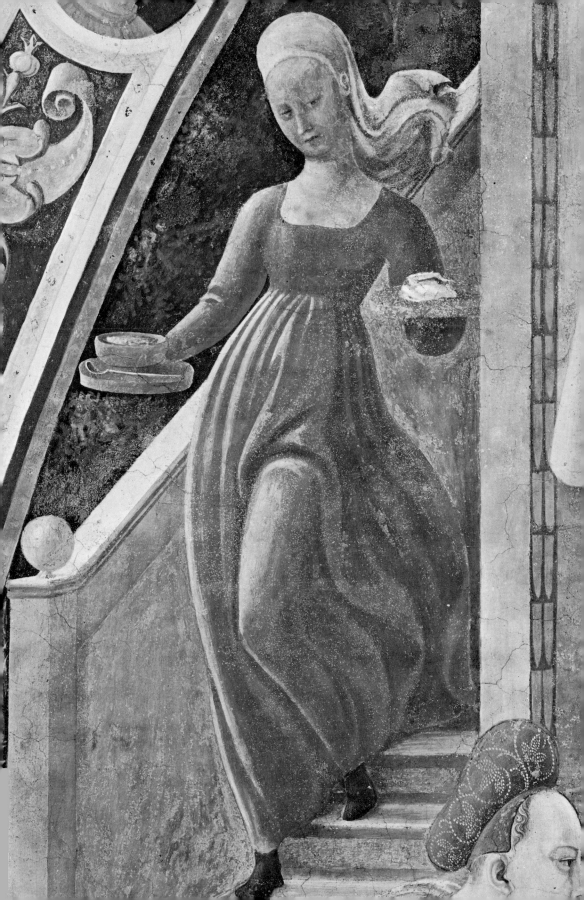

PAOLO UCCELLO (PAOLO DI DONO)
1397–1475

Born in Florence, Uccello was working as an assistant in the workshop of Ghiberti in 1407 and again in 1412. He joined the Compagnia di San Luca in 1414, and went to Venice in 1425. There he worked as a mosaicist in St Mark's until 1430, and returned to Florence deeply influenced by the International Gothic style. In 1436 he was commissioned to paint the memorial to Sir John Hawkwood in the Cathedral of Florence. In its employment of perspective it looks forward to Uccello's Rout of San Romano (National Gallery, London; Louvre, Paris; Uffizi, Florence). His greatest works are the two Chiostro Verde frescoes which illustrate the Drunkenness of Noah and The Flood. Perhaps influenced by the relief-style of Donatello, they are more powerful and less ornamental than the later paintings. These are few, and include a predella, The Profanation of the Host, commissioned in 1465 by the Confraternity of Corpus Domini in Urbino, and a Hunting Scene now in the Ashmolean, Oxford. Uccello returned to Florence in 1468, and died there on December 10, 1475.

36

THE NATIVITY

Sinopia, 5ft 2¼in x 7ft 2⅝in (158 x 220cm)
Soprintendenza alle Gallerie, Florence (from the church of San Martino alla Scala)

The fresco was removed by Dino Dini because of rapid deterioration during the twenty years following its discovery. At the time, no importance was attached to the *sinopia* which was left in place and arbitrarily covered with whitewash. In October 1958. it was detached using the *strappo* method and transferred to a masonite support.

U. Procacci, *Sinopie e Affreschi* (1961), p. 233.

In 1934, Paatz attributed the fresco of the Adoration of the Shepherds in the church of S. Martino alla Scala to Paolo Uccello. It was detached in August 1952 and beneath the *intonaco* this remarkable *sinopia* was found. It is a unique document, which shows Uccello's concern for perspective in the planning of his fresco. Most critics agree that the work dates from around 1446. The surface is divided by a series of lines, parallel to the line of the horizon, intersected by three lines converging on three distance points, one at the centre and the others at the extremities of the horizon. This construction is incised on the surface of the *intonaco*. It is anomalous in that the distance points distribute the pictorial space in two different directions. Parronchi (in *Paragone*, 1957, no. 89, pp. 14 f.) has explained this anomaly as an attempt to solve the problem of binocular vision which was discussed at the time.

UGO PROCACCI

fresco not exhibited [photo: Mansell collection] ▷

MASTER OF THE CHIOSTRO DEGLI ARANCI
active c. 1435–40

Ten of the twelve frescoes illustrating scenes from the life of St Benedict in the Chiostro degli Aranci in the Badia are the work of a distinctive artist. Active in Florence between 1435 and 1440, and influenced by such painters as Fra Angelico and Uccello, he nonetheless retains foreign elements suggesting either a Flemish or a Spanish origin. Payments were made from the Badia to a Portuguese artist called 'Giovanni di Consalvo (portoghese)' between 1436 and 1439, and he can probably be identified with the painter of these frescoes. Meiss (in the *Burlington Magazine* CIII, 1961, pp. 57ff.) attributes to the same artist a predella panel in the Berenson collection at Settignano.

The Dialogues of St Gregory preserve a number of legends surrounding the life of St Benedict. The two miracles represented here are among them. In the first, a labourer tells the saint that the blade of his scythe has fallen into the lake, and the saint promptly recovers it. The second refers to the attempt of a jealous priest to poison the saint by offering adulterated bread to the monastery. Miraculously aware of the plot, St Benedict orders a raven to take the bread away.

37, 38
THE MIRACLE OF THE SCYTHE
Fresco, 7ft 1¾in x 10ft ½in (218 x 306cm)
Sinopia, 7ft 1in x 9ft 11¼in (216 x 303cm)

39, 40
THE MIRACLE OF THE RAVEN
Fresco, 7ft 1¾in x 10ft ½in (218 x 306cm)
Sinopia, 7ft 1in x 9ft 11¼in (216 x 303cm)

Chiostro degli Aranci, Badia, Florence

The frescoes were restored during the last century, and again forty years ago. Their condition continued to deteriorate, and more recent attention improved the situation only temporarily. In 1956, they had to be detached from the wall, and the operation was undertaken by Leonetto Tintori, using the *strappo* method. He tried to remove what remained of previous restorations from the surface of the fresco, but could not eliminate the brown tone, which comes from coats of linseed oil applied in the past. Both frescoes and *sinopie* were transferred to masonite supports.

These two frescoes are the sixth and eighth of the ten scenes painted by the Aranci Master in a cycle devoted to the legend of the founder of the Benedictine Order. They represent minor deeds of St Benedict, but the painter has known how to transform them into solemn and important events. The painter has exploited the story of the lost scythe by representing a large, still lake—a form that, like others, indicates his recollections of the style of non-Italian masters such as Conrad Witz.

In the handsome refectory the monks sit quietly while their abbot, deep in the space, reaches across the table to address the raven with a gesture that is telling, though it lacks perspective or anatomical consistency. The monks at the right are so varied in feature and expression that they strike us as portraits. All but one of the corresponding monks at the left are hidden by a

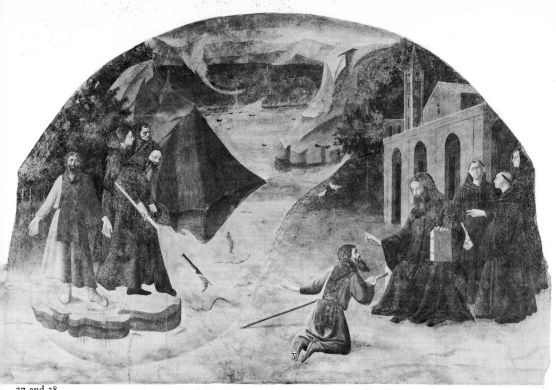

37 and 38.

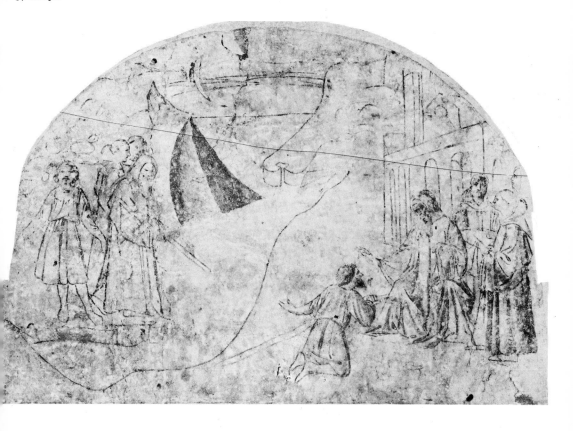

△ The Chiostro degli Aranci
in the Badia, Florence.

wall. By this device, which transforms into asymmetry a composition that
contains implications of symmetry, the abbot gains prominence and he is
put into more immediate relation with the spectator. When, furthermore,
the painter decided to make more vivid the depth of the interior by marking
its nearer limit, he hung a cloth over the pole at the right, leaving the left
open. (The cloth, an after-thought, was added in charcoal to the *sinopia*, as
Procacci has observed.) The painter located the vanishing point for the
composition—visible in the *sinopia*—directly below the head of St Bene-
dict and near his active hand. In this way the new science of focus perspec-
tive, introduced only a decade earlier, was immediately employed in the
service of the story. MILLARD MEISS

U. Baldini, in *I Mostra di Affreschi
Staccati* (Exhib. cat., Forte di
Belvedere, Florence 1957), nos.
91, 93, pp. 68 ff.
L. Berti, in *II Mostra di Affreschi
Staccati* (Exhib. cat., Forte di
Belvedere, Florence 1958, nos.
74, 75, 78, 79, pp. 41 ff. (with
bibliography).
M. Chiarini in *Arte Antica e
Moderna*, 13–16 (1961), pp. 134
ff.; in *Proporzioni* IV (1963), pp.
1 ff.
U. Procacci, *Sinopie e Affreschi*
(1961), pp. 27 f., 228 f.

Documents found by Poggi establish that Giovanni di Consalvo was paid
between September 1436 and February 1439 for colours 'for painting'.
Other payments 'to the artist who is painting the cloister', make no refer-
ence to his name. Apart from documentary evidence, the style of the frescoes
confirms a dating around 1435–40. They suggest the influence of Fra
Angelico and especially that of Filippo Lippi. The lost scenes from the life
of St Benedict painted by Uccello in the Chiostro degli Angeli could have
served, as Salmi suggests, as prototypes for the present cycle. Finally, they
perhaps show a debt to Domenico Veneziano, who had begun work by
1439 on his famous S. Egidio cycle. The identification of the artist with
Giovanni di Consalvo has been strengthened by the discovery of further
documentary references which indicate that in 1435 a certain Giovanni di
Portogallo was, with Zanobi Strozzi, a follower of Fra Angelico. This helps
to prove his contemporary standing and establishes the connection with
Fra Angelico seen in the Badia cycle from the first. In fact, Giovanni di
Consalvo may have collaborated with Fra Angelico, to judge from simi-
larities between the Chiostro degli Aranci frescoes and the predella panel of
St Nicholas saving a Ship at Sea in the Pinacoteca Vaticana, which formed
part of Angelico's Perugia altarpiece. LUCIANO BERTI

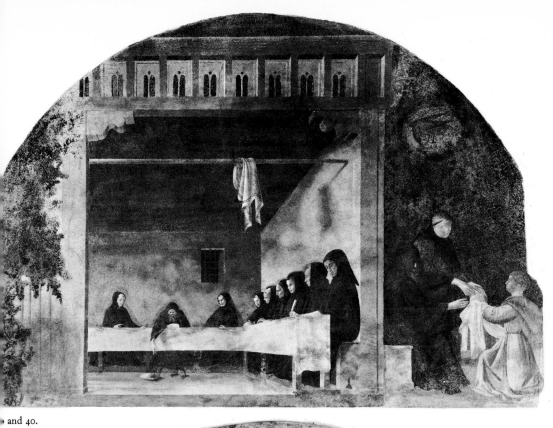

and 40.

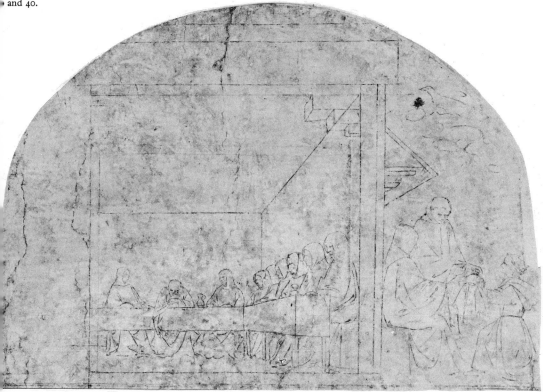

ANDREA DEL CASTAGNO
1423–57

On the upper section of the refectory wall, the Scenes from the Passion were in a state of continuing deterioration caused by dampness. To preserve them from further damage, both the frescoes and the *sinopie* were removed in 1953 by Leonetto Tintori, and transferred to masonite. The *sinopia* for the Resurrection is the only one in the whole cycle to contain figures which correspond exactly to the fresco. Variations are minimal, because the design was applied directly from a punched drawing with charcoal (see Introduction). The degree of finish varies considerably in the drawing of this *sinopia*. The angel is drawn and shaded with a meticulous attention to detail, while the three soldiers who guard the tomb are indicated in outline only. Finally, the figure of the ascending Christ in the centre of the picture is the least complete of all the preparatory drawings.

M. Horster, in *Wallraf-Richartz Jahrbuch*, XV (1953), pp. 124 ff., and passim.
E. Borsook, *The Mural Painters of Tuscany* (1960), pp. 26, 151 f. (with bibliography).
U. Procacci, *Sinopie e Affreschi* (1961), pp. 67 f.
M. Salmi, *Andrea del Castagno* (1961), pp. 15 ff., 47.
L. Vertova, *I Cenacoli Fiorentini* (1965), pp. 31 ff., and passim.

Castagno was born in S. Martino a Corella near Florence. He probably received his training in Florence, and at the age of seventeen was commissioned to paint the hanging corpses of men condemned for revolting against the Medici. In 1442 he worked with Francesco da Faenza on frescoes in the Venetian church of S. Zaccaria, but had returned to Florence by 1444, when he designed a stained-glass window for the Duomo. His well-known frescoes in the convent of S. Apollonia were probably painted before 1450. The influence of Donatello is apparent in Castagno's frescoes of Famous Men and Women, painted for the Villa Carducci at Legnaia, now in the former convent of S. Apollonia. It is most overt in his last known work, an equestrian portrait of the condottiere Niccolò da Tolentino in the Duomo (1456). Castagno's commission bound him to the form of Uccello's Hawkwood, although his version is more dramatic and reveals the influence of Donatello's Gattamelata. He died in 1457, during an epidemic of the plague in Florence, and was buried in Sta. Maria de' Servi.

41

THE RESURRECTION
Sinopia, 13ft 1⅞in x 5ft 10⅞in (401 x 180cm)
Refectory of Sant'Apollonia, Florence

The Resurrection is one of three Scenes from the Passion painted by Andrea del Castagno between 1445 and 1450 on the north wall of the refectory of S. Apollonia. They appear above his fresco of the Last Supper, and were rediscovered in 1890 beneath a layer of whitewash. The *sinopie* were found in 1953, and were published by Salmi.

UMBERTO BALDINI

Detail, 41.

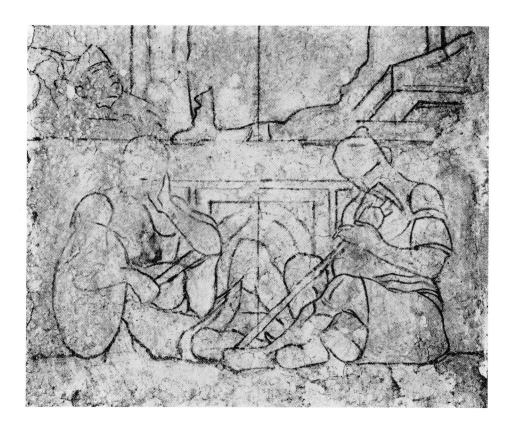

ANDREA
DEL
CASTAGNO

Sinopia, 41.

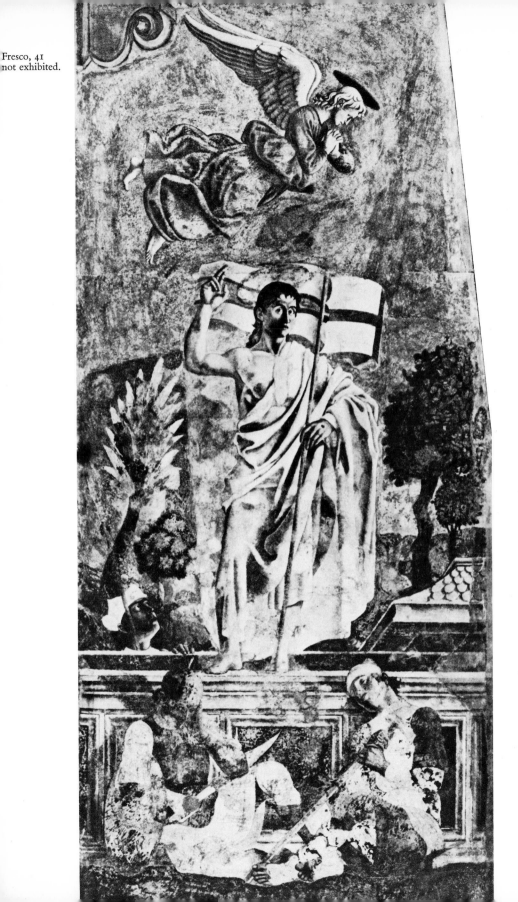

42, 43

THE TRINITY and ST JEROME WITH SAINTS PAULA AND EUSTOCHIUM
Fresco, 9ft 10in x 5ft 10½in (300 x 179cm)
Sinopia, 9ft 8⅞in x 5ft 10⅛in (297 x 178cm)
Church of Santissima Annunziata, Florence

The two chapels in the Santissima Annunziata containing the present fresco and a fresco of St Julian by the same artist appear to have been completed by Michelozzo in 1450. The frescoes therefore date from after 1451. The St Jerome was commissioned by Girolamo Corboli, the patron of the newly constructed chapel. It is mentioned by Vasari in the first edition of the Lives (1550) but by the time of the second edition (1568) was no longer visible, and was recovered only in 1899.

The lower part of the fresco was seriously damaged by the flood, and on April 18, 1967, it was removed from the wall by Alfio Del Serra, Leonetto Tintori and Giuseppe Rosi. The operation was a difficult one, because the *intonaco* had first to be dried from the other side of the wall, which faces on to the Chiostro dei Morti. This was covered with marble slabs and tombstones, which had to be taken down. The thickness of the wall was then reduced to allow the heat to penetrate, and after a month and a half the plaster was dry enough for the fresco to be removed by the *strappo* method.

M. Horster, *Wallraf-Richartz Jahrbuch*, XVII (1955), pp. 105 ff. and passim.
M. Salmi, *Andrea del Castagno* (1961), pp. 30 f., 50 (with bibliography).
M. Meiss, in *Art News*, 66 (1967), no. 4, pp. 26, 81.
U. Baldini, in *La Nazione*, Florence, Aug. 20, 1967.

Contemplating the Trinity, St Jerome beats his breast in penitence. Alongside him, gazing upward also, are two female saints, one old, the other younger. These saints, hitherto identified simply as two holy women or as the Magdalen and St Mary of Egypt, very probably represent two disciples of Jerome, Paula, who followed him to the Holy Land and became abbess of a convent he had founded in Bethlehem, and her daughter Eustochium, who succeeded her in this office.

The *sinopia* differs greatly from the fresco in design and in mood—so much that it is perhaps possible to ask whether Castagno himself made it. The modelling, which still preserves some of the strokes in charcoal that preceded the *sinopia*, is soft and silken, unlike any other extant *sinopia* by Castagno. The women do not turn their backs, as in the fresco, and the outlines are fluent, without the staccato interruptions of the painting. The fresco heightens the pitch of emotion also by agitated drapery and by the addition of a lion whose rolling eye and gaping mouth echo those of the saint.

Instead of the haggard old man in the fresco, his toothless mouth open, his bony body exposed almost to the midriff, there is a lithe, agile saint looking toward God with hope. His body is dynamic, one hand extended to balance his movement as in the figures by Domenico Veneziano or the early Baptist by Domenico's pupil, Piero della Francesca. The saint in the drawing shows in fact a novel phase of Castagno's art when he was closely studying Domenico.

After Castagno—for it was most probably he—had made this elaborate *sinopia* he decided to alter the design and he proceeded to draw a cartoon of equal size on paper. Though this cartoon has not survived, the round spots produced by pressing colour through it are visible along many of the outlines of the fresco.

Even after two full-scale drawings and after executing the composition in true fresco the master did not stop. He felt dissatisfied with part of the Trinity, which had been only schematically indicated in the *sinopia*. Wishing to transform symbols into full corporeal and perspective reality Castagno, like some other early Renaissance painters, occasionally got into trouble. He painted the lower part of Christ's body in drastic and, as it proved, quite awkward foreshortening. This he decided to conceal. Over the loin-cloth and the legs he painted seraphim. Since he made this addition *a secco* the paint as usual has peeled, so that today we can again see, and indeed sympathize with, the sources of Castagno's discontent.　　MILLARD MEISS

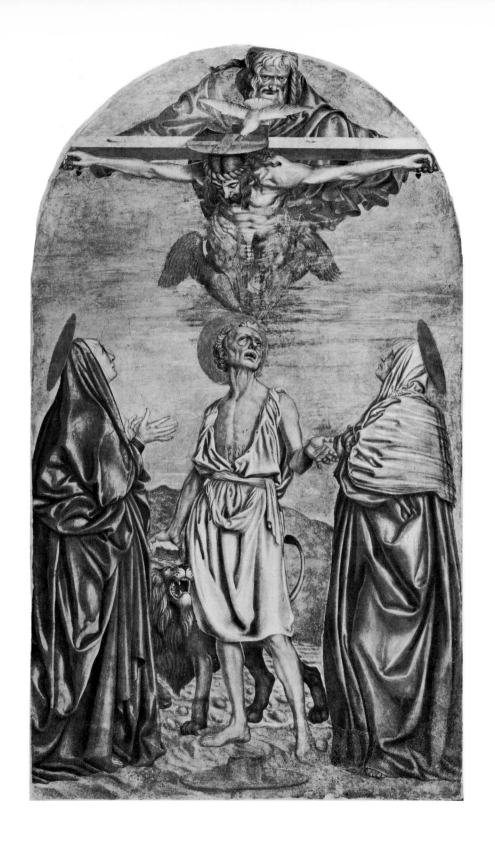

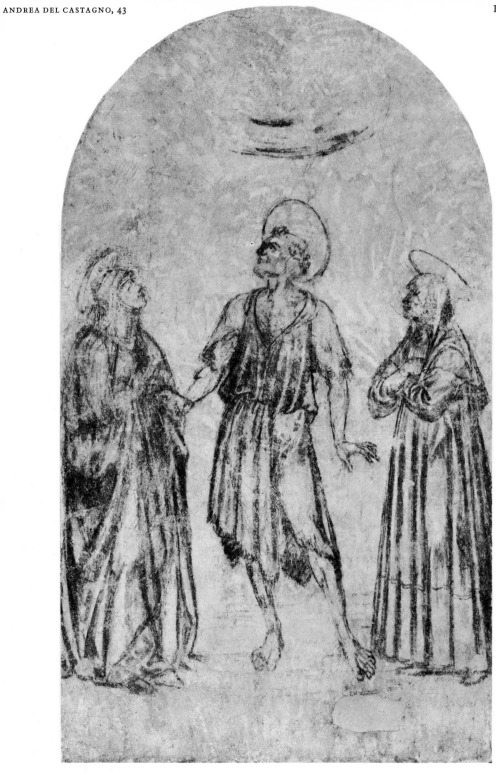

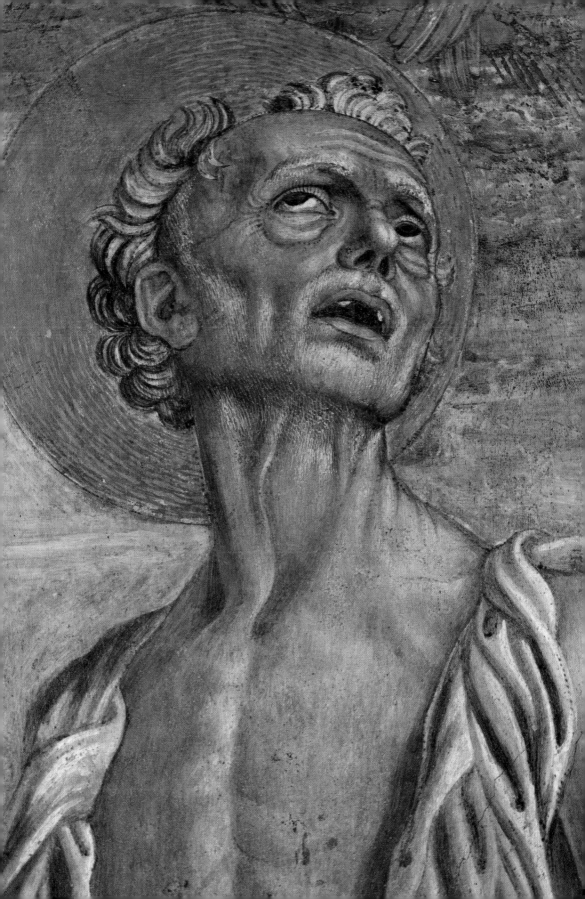

44

ST JEROME
Fresco, 14ft 5⅝in x 7ft 8½in (441 x 235cm)
Church of San Domenico, Pistoia

The fragment was partially uncovered in 1932 when it was discovered behind the whitewash in a closed recess to the immediate right of the entrance to the church. It was removed from the wall in 1958 by Alfio Del Serra, using the *strappo* method, and transferred to a masonite support. The original composition must have been a large one, with the Madonna and Child in the centre of the arcade and four saints, one standing and one kneeling on each side. The existing fragment is less than two-fifths of the complete fresco. It was painted over a Trecento fresco, of which parts were discovered when the St Jerome was removed (see no. 15).

U. Procacci, in *Rivista d'Arte*, series II, IV (1932), pp. 474 f.
S. Ortolani, *Il Pollaiuolo* (1948), pp. 111, 222 (with bibliography).
U. Baldini in *II Mostra di Affreschi Staccati* (Exhib. cat., Forte di Belvedere, Florence 1958), no. 13, pp. 7 f.

This fragment of a much larger fresco was discovered and published by Procacci in 1932. He suggested its derivation from a work by Antonio Pollaiuolo, pointing out at the same time affinities with the late Castagno, Botticelli's St Augustine in the Ognissanti, the head of St Jerome in the Palazzo Pitti attributed to Piero Pollaiuolo, and the altarpiece in Sta. Maria at Argiano for which the names of both Perugino and Verrocchio have recently been proposed. The attribution to Antonio Pollaiuolo was upheld by Berenson, Hind and Ortolani. Others described it as a ruin which could not be judged critically. In fact, before its restoration in 1958 it was difficult to see and was still partly covered by whitewash. Subsequent cleaning makes it clear that both the delicate colours and suppleness of line are closer to Verrocchio than they are to Pollaiuolo. The display of the cleaned fresco in 1958 at the Forte di Belvedere in Florence aroused considerable interest and prompted fresh attributions, among which may be noted those of Brandi and Martini to Bartolommeo della Gatta. However, two unusual features in the technical procedure followed by the artist suggest that he was not Florentine. We are not dealing with a true fresco, but with a *mezzo fresco* executed almost *a secco*. This can be seen from the flaking off of the colours which failed to penetrate into the *intonaco*, and from the incised lines common in painting *a secco* (see Introduction) which have caused the plaster to crumble. Secondly, the work was executed entirely from a cartoon. This enables us to place it within the ambience of Domenico Veneziano, whom we know to have had some connexion with Pistoia. The clear light and the monumentality which recalls Piero della Francesca, the architecture which belongs more to Alberti than to Brunelleschi and the very high quality of the fresco, could be reconciled, albeit hypothetically, with an attribution to Domenico Veneziano.

UMBERTO BALDINI

PIERO DELLA FRANCESCA (PIERO DEI FRANCESCHI)
c. 1420–1492

Piero della Francesca was born in Borgo San Sepolcro (or Sansepolcro) in Umbria, some time between 1410 and 1420. In 1439 he worked with Domenico Veneziano in Florence, on the lost S. Egidio frescoes, but by 1442 was back in his native town. On January 11, 1445, the Compagnia della Misericordia in Borgo commissioned an altarpiece which was to be delivered within three years. It was not finished until 1462, however, and is now in the Pinacoteca at Borgo. Before 1450, Piero della Francesca is supposed to have worked in Ferrara, and his fresco of Sigismondo Malatesta before St Sigismund in the church of S. Francesco in Rimini is signed and dated 1451. Perhaps his finest work, the Legend of the True Cross in S. Francesco at Arezzo was begun some time after 1452 and was complete by 1466. Meanwhile, 1459–60, he worked in the Vatican, where nothing survives, and tradition links him in the 1460s with the building of the Ducal Palace at Urbino. One of the greatest painters of the fifteenth century, Piero della Francesca is represented in the National Gallery, London, by altarpieces of the Baptism of Christ and the Nativity. Between 1482 and his death in 1492, he wrote two treatises, 'De perspectiva pingendi' and 'De quinque corporibus regularibus'.

45
ST JULIAN (?)

Fresco, 4ft 6in x 3ft 5⅜in (137 x 105cm)
Pinacoteca, Borgo San Sepolcro

Leonetto Tintori retrieved this fragment in 1957 by demolishing the wall behind it. The thickness of the *intonaco* was then pared down to approximately one centimetre, and attached to a support of compressed wood. Evidence of the *spolvero* can still be seen in the locks of hair, in the drawing of the eyes and mouth and in some parts of the clothing.

M. Salmi, *Bollettino d'Arte*, XL (1955), pp. 230 ff.
L. Berti in *I Mostra di Affreschi Staccati* (Exhib. cat., Forte di Belvedere, Florence 1957), no. 85, pp. 66 ff.

The Saint represented in this fragment has been convincingly identified by Salmi as St Julian. It was discovered accidentally in December 1954, beneath a coat of whitewash, in the apse of the former church of S. Agostino, and was later moved to the museum in San Sepolcro. The attribution to Piero della Francesca was proposed by Papini and Salmi, and is generally accepted. There is some uncertainty about the date, however, which is usually considered to be around 1460. On the other hand, Longhi argues that this fragment must be contemporary with Piero's first frescoes at Arezzo, around 1455. The young saint, wearing a red cloak over a pleated white tunic, presents a convincing parallel to the prophet on the right of the altar wall of the choir in S. Francesco at Arezzo.

PAOLO DAL POGGETTO

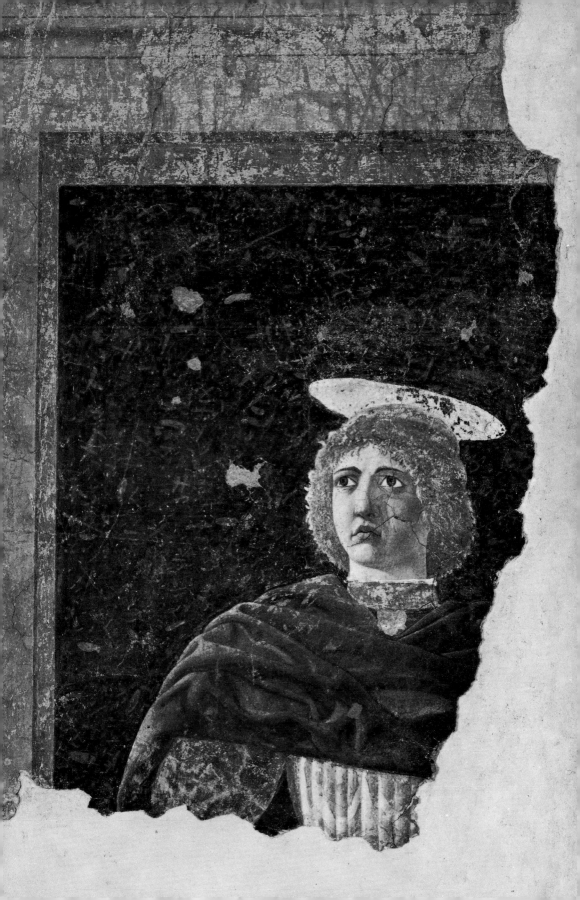

BENOZZO GOZZOLI (BENOZZO DI LESE)
1420–97

In 1444 Gozzoli worked as an assistant to the sculptor Ghiberti on the third bronze door for the Baptistery in Florence. He is perhaps better known as a follower of Fra Angelico, with whom he appears to have worked in Orvieto and Rome before 1450. Between 1450 and 1452 he painted a series of frescoes for the church of San Francesco, Montefalco, which show Gozzoli's debt to Fra Angelico, and particularly to the Roman frescoes with which he may have assisted in the chapel of Pope Nicholas V. His decoration of the Medici-Riccardi chapel (1459) is one of the most important Florentine manifestations of its time, as well as being a high point in Gozzoli's personal achievement. From 1463 to 1467 he worked in San Gimignano, where among other commissions he carried out a cycle of frescoes illustrating the life of St Augustine. By 1468 he had moved to Pisa, where he worked until 1484 upon a vast series of twenty-five frescoes illustrating events from the Old Testament. Heavy with detail, to the point of confusion, these nonetheless won the admiration of his contemporaries; Vasari quotes the flattering epigram attached to them. Gozzoli was granted a tomb in the Camposanto in 1478.

46

TABERNACLE

a Joachim's Expulsion from the Temple and the Madonna (*front*)
Fresco, 15ft 7¾in x 8ft 1⅝in x ⅝in (477 x 248 x 1.5cm)
b The Meeting at the Golden Gate and the Nativity (*back*)
Fresco, 15ft 6⅝in x 7ft 11¾in x ⅝in (474 x 243 x 1.5cm)
c Christ, the Four Evangelists and the Four Church Fathers (*under-arch, front*)
Fresco, 5ft 8½in x 8ft 1¼in x 3ft 11¼in (174 x 247 x 120 cm)
d The Birth of the Virgin (*left side*)
Fresco, 9ft 1½in x 5ft 9¼in x 2⅜in (278 x 176 x 6cm)
e Joachim among the Shepherds (*right side*)
Fresco, 8ft 9⅞in x 5ft 8½in x 2⅜in (269 x 114 x 6cm)
f Fragment with a Church
Fresco, 9ft 10½in x 4ft 2¾in x 2⅜in (301 x 129 x 6cm)
g Fragment with a Palace
Fresco, 9ft 10½in x 4ft 3⅛in x 2⅜in (301x130 x 6cm)
h The Annunciation (*top, front*)
Fresco, 10ft 8in x 10ft 4in x 7in (325 x 315 x 19cm)
i The Archangels Michael and Raphael (*top, back*)
Fresco, 10ft 8in x 10ft 4in x 7in (325 x 315 x 19cm)
ʲ Fragment with a Niche
Fresco, 12ft 9⅛in x 5ft 8⅞in x 7in (389 x 175 x 19cm)

k Fragment with a Niche
 Fresco, 12ft 6⅜in x 5ft 8⅞in x 7in (382 x 175 x 19cm)
l, m, n, o Niches with Conch Shells
 Fresco, each, 9ft 11¼in x 17¾in x 6¾in (303 x 45 x 17cm)

47

THE MEETING AT THE GOLDEN GATE
Sinopia (for 46b), 6ft 2¾in x 7ft 8½in (190 x 235cm)

48

TWO EVANGELISTS AND TWO FATHERS OF THE CHURCH
Sinopia (for 46c), 10ft 6¾in x 4ft 4in (332 x 132cm)

Chapel of the Visitation, Castelfiorentino

Dampness accounts for the disappearance of the lower sections and for losses in the parts nearest the roof of the tabernacle. To preserve what was left and to prevent further deterioration, the removal of the surviving frescoes was carried out in 1965 by Giuseppe Rosi, using the *strappo* method. The masonite panels on which the frescoes had been mounted were then assembled to reconstruct the shrine. Some of the *sinopie* were recovered, although most of them were destroyed by moisture.

E. Contaldi, *Benozzo Gozzoli* (1928), pp. 226 ff.
M. Lagaisse, *Benozzo Gozzoli* (1934), pp. 51 f. (with bibliography).

Benozzo Gozzoli designed a number of shrines for relatively unimportant places in the Val d'Elsa, among them the Tabernacolo dei Giustiziati at Certaldo and the Tabernacolo della Madonna della Tosse near Castelnuovo. The one exhibited here comes from the outskirts of Castelfiorentino, but its modest provenance should not lead us to underrate its importance as a work of art. Unfortunately most of the lower section was destroyed by flood waters from the nearby river Elsa. Originally the shrine contained two rows of frescoes, surrounded by fictive architecture. Of this, the niches survive, flanked by half pilasters capped by Corinthian capitals. Part of the central composition remains. Set into a deep rounded arch which spans the front of the tabernacle, it followed the form of an altarpiece. A Madonna enthroned with four Saints once occupied the lower space, and in the lunette above it, still well preserved, is the Expulsion of Joachim from the Temple. Outside the arch, in the spandrels, parts of an Annunciation are intact. The lower portion on the inside of the arch has disappeared, but fragments remain of a Presentation in the Temple (upper left) and what was perhaps the Visitation (upper right). A mandorla containing the blessing Christ occupies the centre of the vault, with two pairs of figures to each side. The pairs comprise an Evangelist and a Father of the Church. Next to the mandorla on the left are St Ambrose and St John, with St Augustine and St Luke below. On the right are St Matthew and St Gregory, with St Mark and St Jerome below. The paintings on the back are recognisable as a Nativity (below), the Meeting of Joachim and Anna at the Golden Gate (above), and the Archangels Michael and Raphael (pediment). In the upper section on the right is a damaged but handsome view of a city, and above, Joachim and the Shepherds. On the upper left is the Birth of the Virgin.
The lighting and colours are characteristic of Gozzoli. His art is tranquil and optimistic, infused with human dignity, and depicting the carefully culti-vated Tuscan landscape. Nor is it substantially diluted by the inevitable assistants. It is this more worldly approach that distinguishes Gozzoli from his master, Fra Angelico, whose influence is nonetheless clear in the drawing of the two *sinopie* shown here. Gozzoli was one of the finest draughtsmen

of the Quattrocento, as well as a master of fresco. In this case, he used the *sinopia* only to plan the distribution of figures in the space available, working out the details on the fresco itself. The dating of the shrine is uncertain. It was considered at first to predate Gozzoli's frescoes in the Medici-Riccardi chapel of 1459. Others agree with Cavalcaselle in considering it contemporary with his San Gimignano frescoes around 1464–5. Finally, and more convincingly (Contaldi, van Marle, Berenson and Bargellini), the Tabernacle of the Visitation has been compared with Gozzoli's work in the Camposanto in Pisa, and therefore dated after 1468.

PAOLO DAL POGGETTO

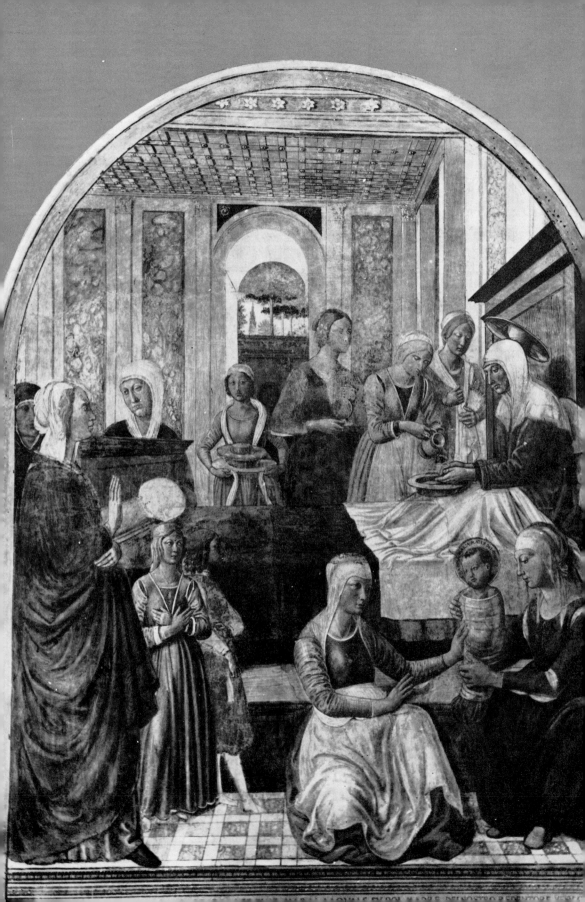

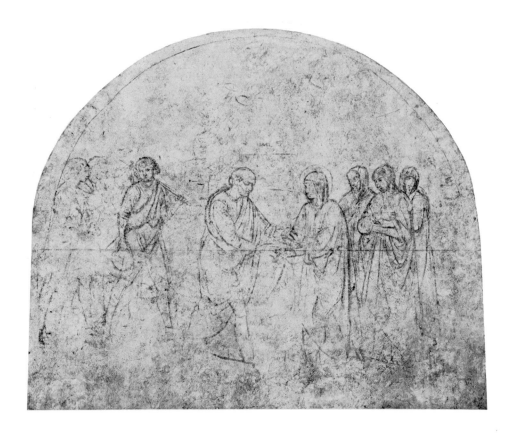

MINO DA FIESOLE
1430–84

Mino da Fiesole was a sculptor, from Poppi in the Casentino. He trained in Florence, probably in the studio of Desiderio da Settignano, and worked both in Florence and in Rome, which he visited in 1454, 1463 and c. 1473–80. He carried out a number of tombs; examples include the monument of Giovanni, Bishop of Fiesole, who died in 1466 (Fiesole, Cathedral) and the tomb of Count Ugo in the Badia, Florence, begun in 1469 and completed after Mino's return from Rome in 1481. In 1473 he carved two reliefs for Antonio Rossellino's pulpit in Prato Cathedral, and in 1481 a tabernacle for the church of S. Ambrogio, Florence. In Rome, his work has been confused with that of Mino del Reame. He was, however, associated with Giovanni Dalmata on the tomb of Pope Paul III in St Peter's (Grotte Vaticane) and worked, often in association with Andrea Bregno, on a number of funerary monuments. Popular as a portraitist he was among the first Renaissance sculptors to produce well-characterised busts of his contemporaries.

49

MURAL DRAWINGS
9ft 5¾in x 9ft 9in (289 x 297cm)
Soprintendenza alle Gallerie, Florence (from 7 Via Pietrapiana)

The drawings were found in 1905 beneath the whitewash on the walls of a corridor on the second floor. They remained there, unknown to scholars, until 1958 when they were removed *a stacco* by Dino Dini and mounted on panels of pine-wood and tempered masonite.

U. Baldini, in *II Mostra di Affreschi Staccati* (Exhib. cat., Forte di Belvedere, Florence 1958), nos. 9–12, pp. 6–7 (with bibliography).
U. Procacci, *Sinopie e Affreschi* (1961), no. 13, pp. 28, 47.

These drawings are not *sinopie* as such but simple sketches found on the walls of the house in which Mino da Fiesole lived. This is one of several such fragments containing elegant profiles, studies for figures, decorative motifs and even arithmetic. There is also a date: 'a di 8 maggio'. They were attributed to Mino da Fiesole by Dorini, who published documents to show that the house in which they were found was bought by Mino da Fiesole in 1464. Although Mino maintained his workshop in the church of S. Firenze, he lived in the Via Pietrapiana until 1480, and the latter year provides a terminal date for these drawings.

UMBERTO BALDINI

SCHOOL OF PERUGINO (PIETRO DI CRISTOFORO VANUCCI)
c. 1450–1523

Perugino was born at Città della Pieve around 1450. His training as a painter may have begun in Perugia, but he subsequently worked in the shop of Verrocchio in Florence. The first work which can be confidently attributed to him is a figure of St Sebastian, the only remaining fragment of a series of frescoes at Cerqueto near Perugia, signed and dated 1478. In 1478 he went to Rome, where most of his works were destroyed, including the altar-wall of the Sistine Chapel which made way for Michelangelo's Last Judgement. Christ presenting the Keys to St Peter (1481–2) survives, however, and testifies to the clarity and simplicity of his compositions. He returned to Florence with a commission for work in the Palazzo della Signoria. Between 1493 and 1496, he worked on a fresco of the Crucifixion in the convent of Sta. Maria Maddalena dei Pazzi in Florence creating an illusory loggia across the entire surface of the wall. Around 1500, Raphael became his pupil, and Perugino retired to the less critical milieu of Umbria as the assistant overtook the master. Ironically, one of his last undertakings was the completion of frescoes begun by Raphael in the church of S. Severo, Perugia, 1521.

50, 51
THE CRUCIFIED CHRIST APPEARS TO ST BERNARD
Fresco, 8ft ⅞in x 4ft 7⅞in (246 x 142cm)
Sinopia, 8ft 5¼in x 4ft 9⅛in (257 x 145cm)
Cenacolo del Perugino, Florence

This well-preserved fresco reflects the influence of Perugino's style around 1500. It is a work of high quality in which the type of landscape, the placid composition, and the clear colours all suggest Perugino's immediate circle. On the other hand, the slope of the ground and the full figure of St Bernard (compared with its source, the comparable figure in Perugino's Crucifixion of 1493–6 in the same church) suggest that the artist is likely to have been Florentine. The *sinopia* is also strongly Florentine in style. It shows an interesting variation in the position of the city, which was originally closer to the foreground of the picture.

PAOLO DAL POGGETTO

The fresco was seriously damaged by the flood in 1966, and had to be dried from the other side of the wall before restorations could be carried out. They were supervised by Giuseppe Rosi and the fresco was successfully removed *a strappo* in 1967. Slight variations in colour reveal the limits of each day's work on the fresco, especially where the retouching *a secco* has fallen away from the divisions. It is particularly noticeable in the upper part of the sky where the arm of the cross was deliberately used to disguise the join.

W. and E. Paatz, *Die Kirchen von Florenz* IV, (1952), pp. 100 f.

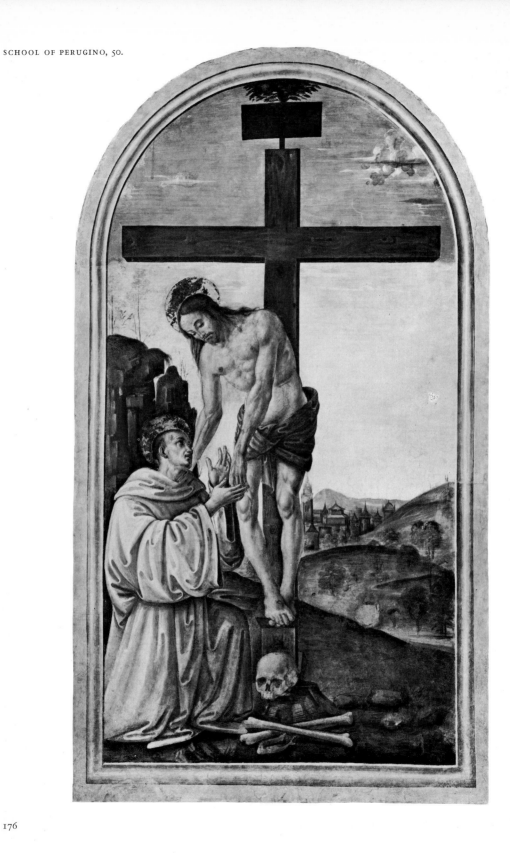

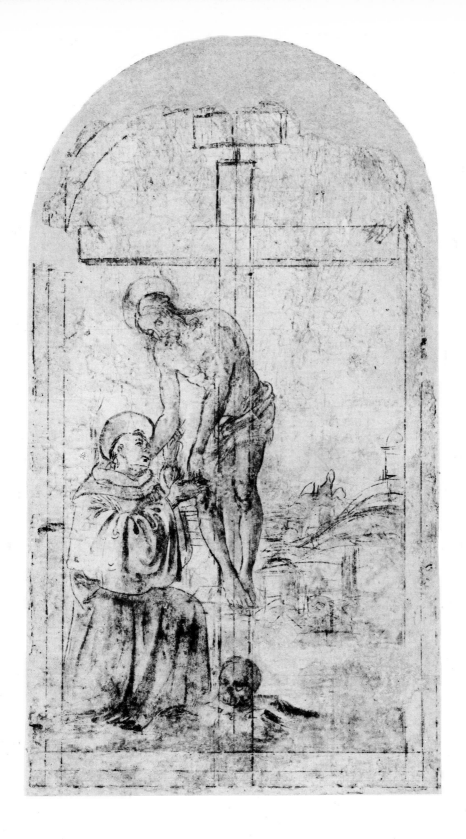

FRANCIABIGIO (FRANCESCO DI CRISTOFANO)
1482–1525

Franciabigio was the son of a Milanese weaver who lived in Florence. According to Vasari he became a pupil of Albertinelli, and later shared a workshop with Andrea del Sarto. The two artists appear to have influenced one another considerably, and a number of Franciabigio's commissions were undertaken in association with Andrea del Sarto. They both worked in the entrance court of SS. Annunziata in Florence, where Franciabigio painted the Marriage of the Virgin in 1513. This still bears the marks of the hammer with which he attempted to deface it after it was prematurely unveiled by the monks of SS. Annunziata. While Andrea del Sarto was in France, between 1518 and 1519, Franciabigio took over from him in the Chiostro allo Scalzo. He painted the Meeting of the Infants Christ and St John, and the Blessing of Zacharias, before Sarto returned to Florence to complete the cycle of frescoes. In 1521, Franciabigio contributed the Triumph of Cicero to the decorations of the Medici villa at Poggio a Caiano.

52

THE ANNUNCIATION
Fresco, 6ft 3⅛in x 8ft 8⅜in (191 x 265cm)
Convent of Santa Maria dei Candeli, Florence

The Annunciation is one of a series of frescoes, which include the three sections of the Last Supper (no. 54), painted in lunettes in the old refectory of the former convent of Sta. Maria dei Candeli. The frescoes are not mentioned by Vasari or by other early commentators, and attention was directed to them in 1866 by Cavalcaselle, when they were attributed to Franciabigio and a group of followers which included Sogliani, on the strength of a monogram FA BO. This appeared in the fresco of the Last Supper on the table leg to the right of Judas, but was partly erased in the recent floods, so that only the F and B remain legible. In spite of the monogram, the attribution to Franciabigio has been doubted, especially in the case of the Last Supper (see note on no. 54). However, both Freedberg (1961) and Sricchia (1963) firmly uphold his responsibility for the Annunciation, the Last Supper and the Nativity, although their dating of the frescoes varies. Freedberg considers them to be early works, painted around 1511, while Sricchia supports 1514, the date which appears in an eighteenth century inscription below one of the lunettes. The later dating is confirmed by the rather plain, square room, by the imposing figure of the angel with his distinctive gesture, and by the form of the dove, which have analogies in the Last Supper painted by Franciabigio in 1514 in the Convento della Calza in Florence. The sweetened folds of the Virgin's drapery and the soft chiaroscuro betray the hand of an assistant. PAOLO DAL POGGETTO

ECCE·ANCILLA·DOMINI

53

THE NATIVITY

Fresco, 2ft 5½in x 3ft ¼in (75 x 92cm)

Convent of Santa Maria dei Candeli, Florence

This fresco was painted in monochrome below the lunette containing the Annunciation (no. 52). Franciabigio apparently entrusted it to one of his assistants, and only the figure of St Joseph recalls his simpler and more monumental style. The composition, the landscape, and the types of the Virgin and the angels reveal a stronger influence of Albertinelli than Franciabigio displays, even in his earliest works. In spite of its inferiority to the securely attributed works of Franciabigio, the Nativity retains a certain archaising charm.

PAOLO DAL POGGETTO

54

THE LAST SUPPER
Fresco, each lunette 8ft 5⅝in x 9ft 2¼in (258 x 280cm)
overall 8ft 5⅝in x 23ft 4¾in (258 x 840cm)
Convent of Santa Maria dei Candeli, Florence

The frescoes in the Refectory of Sta. Maria dei Candeli were badly damaged by salts and deposits of oil when the flood waters rose in November 1966 to a height of more than half a metre from their base. They had to be dried out artificially, and were the first frescoes to be removed after the flood. The operation was carried out *a strappo* on December 10, 1966, by Dino Dini. The Last Supper frescoes were heavily repainted, and cleaning has revealed fictive architectural decorations between the three lunettes. Later covered, these show that originally the artist constructed the scene within a painted proscenium imposed upon the actual architecture of the wall.

S. J. Freedberg, *Painting of the High Renaissance in Rome and Florence* (1961), pp. 223 ff.
F. Sricchia Santoro in *Paragone* (1963), no. 163, p. 11.

Of the frescoes from Sta. Maria dei Candeli by or ascribed to Franciabigio in this exhibition, the three lunettes containing the Last Supper are the most impressive and the most problematical. In 1965 Luisa Vertova (*I Cenacoli Fiorentini*, pp. 59, 61 ff., 76, 105) reattributed them to Sogliani. Her arguments were based upon a group of drawings in the Uffizi (nos. 17066F, 17067F, 17068F) which seem to be studies for this fresco. The case was a strong one, supported by the style of the composition which is not entirely convincing as the work of Franciabigio. On the other hand, it was contradicted by the authentic monogram on the leg of the table to the right of Judas. This was not, as Vertova suggests, painted in the eighteenth century to replace a hypothetical GASO (Giovanni Antonio Sogliani). The attribution to Franciabigio must therefore stand, though he appears to have been assisted in the Last Supper by an unidentified follower whose shading was heavier and whose drawing was less forceful. Despite the deterioration of the colour, the quality of the fresco is consistently high. It displays a truth to domestic detail in the poorly furnished table, in the grey afternoon light, and in the two vases of roses and lilies which provide the only decoration of these modest surroundings. The gentle expressions contrast strikingly with the more animated style of Franciabigio. For a discussion of its dating, see the note to no. 52.

PAOLO DAL POGGETTO

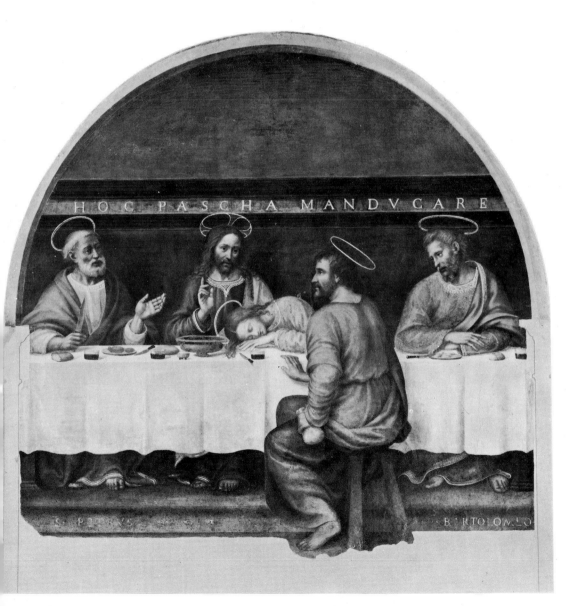

FRA BARTOLOMMEO (BACCIO DELLA PORTA)
c. 1472–1517

Fra Bartolommeo was born in Florence and was apprenticed to Cosimo Rosselli around 1484. He destroyed much of his earliest work when he became an admirer of Savonarola, whose death is supposed to have prompted his own ordination in 1501 as a Dominican friar in the convent of S. Marco. When Filippino Lippi died in 1504, Fra Bartolommeo took over his commission to paint an altarpiece for the Sala del Consiglio in the Palazzo della Signoria. Thereafter he worked, mostly on alterpieces, sometimes in partnership with Albertinelli. Although visits to Venice in 1508 and Rome in 1514 influenced his style, he retained the monumentality and simplicity of composition which were his own contribution to the Florentine High Renaissance, and which in turn influenced the style of Raphael.

55
THE MEETING OF ST FRANCIS AND ST DOMINIC
Fresco, 3ft 6½in x 6ft 2⅜in (108 x 189cm)
Convent of Sta. Maria Maddalena, Pian di Mugnone, Florence

The fresco was removed in 1960 by Dino Dini, using the *strappo* method, and was attached to a masonite support.

H. von der Gabelentz, *Fra Bartolommeo und die Florentiner Renaissance* I (1922), p. 170 (with bibliography).

This lunette is rarely mentioned in the critical writings on Fra Bartolommeo, partly because of its physical condition, which since the time of Gruyer (1866) has been described as very poor. Although there are considerable losses of pigment, its transfer has revealed its luminosity and splendour. It was painted above a doorway, in 1516–17, towards the end of Fra Bartolommeo's career. This can be established from the style of the painting, and from our biographical knowledge of the painter's life. Fra Bartolommeo spent his last years in the convent of Pian di Mugnone, where he painted the Annunciation (1515), the Noli me Tangere (1516), and this Meeting of St Francis and St Dominic. Stylistically, the lunette is close to his Risen Christ in the Palazzo Pitti, and to the Assumption in the Museo di Capodimonte in Naples, both painted in 1516. It goes back to a motif which he employed in the background of the Marriage of St Catherine of 1511 in the Louvre, and which is developed in a fine drawing now in the Musée Wicar at Lille. In its final form in this lunette, it is treated with the monumentality and spontaneity of his later style.

PAOLO DAL POGGETTO

ANDREA DEL SARTO (ANDREA D'AGNOLO DI FRANCESCO)
1486–1530

Andrea del Sarto was born in Florence on July 14, 1486. He was the son of a tailor ('sarto') and, according to Vasari, trained first as a goldsmith. He was probably a pupil of Raffaellino del Garbo, and enrolled in 1508 in the guild of Medici e Speziali. Between 1509 and 1510, he painted the first five of his frescoes in the entrance court of SS. Annunziata in Florence. They illustrate scenes from the life of St Philip Benizzi. His rapid development is illustrated by two subsequent frescoes in the forecourt of SS. Annunziata; an Adoration of the Magi in 1511, and a Birth of the Virgin in 1514. From about 1511 he shared a workshop with the sculptor Jacopo Sansovino. At this time he began work on the frescoes in the Chiostro allo Scalzo (see below). He had completed less than half of these when he left for France in 1518, on the invitation of Francis I. He returned to Florence a year later, however, to paint in the Medici villa at Poggio a Caiano, and to complete his Scalzo cycle. Among Andrea del Sarto's well-known panel paintings, the Madonna of the Harpies (Uffizi) predates his French visit, and the Madonna in the Wallace collection can probably be connected with it, and dated 1517–18 (Knapp and Shearman). The Pitti Pietà was painted in 1524 at Luco in the Mugello, where Sarto and his family took refuge from an outbreak of the plague in Florence. During the 1520s, his work began to show more mannerist tendencies, and it was his development of this, along with his dramatic use of colour in oil-painting which recommended him to the younger generation of Florentine mannerists. Rosso and Pontormo were among his pupils. He died during a plague in Florence, attended by a priest but neglected, according to Vasari, by his wife.

SCENES FROM THE LIFE OF ST JOHN THE BAPTIST AND TWO ALLEGORICAL FIGURES OF VIRTUES

56
THE VISITATION (1524)
Fresco, 9ft 6⅝in x 8ft 8¾in (291 x 266cm)

57
JUSTICE (1515)
Fresco, 6ft 3⅛in x 3ft 10in (191 x 117cm)

58
THE PREACHING OF ST JOHN (1515)
Fresco, 6ft 3⅝in x 6ft 10¼in (192 x 209cm)

59
THE BAPTISM OF THE MULTITUDES (1517)
Fresco, 6ft 3⅝in x 6ft 8¾ (192 x 205cm)

△ Chiostro allo Scalzo.

60

THE ARREST OF ST JOHN (1517)
Fresco, 6ft 3⅛in x 10ft 2⅞in (191 x 312cm)

61

THE DANCE OF SALOME (1521–2)
Fresco, 6ft 3⅛in x 10ft 2in (191 x 310cm)

62

THE DECAPITATION OF ST JOHN (1523)
Fresco, 6ft 3⅝in x 6ft 7½in (192 x 202cm)

63

THE FEAST OF HEROD (1523)
Fresco, 6ft 3⅝in x 7ft 2¼in (192 x 219cm)

64

HOPE (1523)
Fresco, 6ft 3⅝in x 3ft 4½in (192 x 103cm)

Cloister of the Compagnia di S. Giovanni Battista allo Scalzo, Florence

The Chiostro allo Scalzo was built on land acquired by the Compagnia allo Scalzo in 1487. There are no documents relating to the commissioning of the frescoes, the earliest of which, the Baptism of Christ (not here exhibited), beside the entrance at the north end, is variously assigned to 1509–10 and 1511. The adjacent figure of Charity (not exhibited) seems

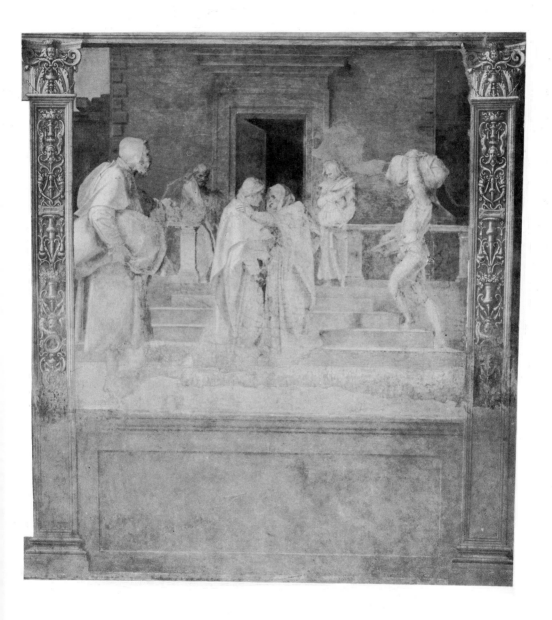

The removal of the entire series of frescoes from the Chiostro allo Scalzo took place between February 1963 and July 1968. It was effected by Leonetto Tintori, using the *strappo* method. The whole cycle had suffered from rising damp and from moisture penetrating through the roof. The lower bands of decoration had been repainted in the past, and extensive blistering of the paint began to threaten the original surface of the frescoes. After their removal, they were fastened to masonite supports.

J. Shearman, *Mitteilungen des Kunsthistorischen Institutes in Florenz* 9 (1960), pp. 207 ff.; and *Andrea del Sarto* (1965), I, pp. 52 ff., II p. 294 ff.
S. J. Freedberg, *Andrea del Sarto* (1963), I, pp. 29 f., II, pp. 9 f. and passim (with bibliography).
H. Wölfflin, *Classic Art* (London 1952), pp. 160–170.

to date from 1513. There follow, to the right of the entrance on the same wall, the figure of Justice (no. 57) and the Preaching of the Baptist (no. 58), which date from 1515. Sarto continued the decoration of the cloister in an anti-clockwise direction on the west wall, beginning with the Baptism of the Multitudes and the Arrest of the Baptist (1517), (nos. 59 and 60). Work was interrupted in 1518–19, when Sarto was in France, and in this interval two frescoes (not exhibited) were painted on the east wall by Franciabigio. Thereafter, Sarto resumed work in the cloister with the Dance of Salome (no. 61), which dates from 1521–2, and the Decapitation of the Baptist (no. 62), which dates from 1523. The Feast of Herod (no. 63), the first of the frescoes on the south wall, was completed by May 1523, and the figure of Hope next to it (no. 64), was finished by August of the same year. The fresco of the Visitation (no. 56) occurs at the south end of the east wall of the cloister, and was finished in the winter of 1524. The narrative scenes here exhibited therefore comprise the whole decoration of the west wall of the cloister, two scenes which abut on them at the north and south ends, and a single fresco from the opposite (east) wall. Stylistically there is one major break in the series, between the Arrest of the Baptist and the Dance of Salome. When the sculptor Jacopo Sansovino returned to Florence from Rome in 1511, coincidentally with the commencement of Sarto's frescoes, he established a joint workshop with Sarto, and there is a firm tradition that he was responsible for preparing models for figures in the frescoes. There is, however, no general agreement on the extent of Sansovino's intervention in the scenes. It is observed by Shearman, with reference to the frescoes here exhibited, that 'in the later frescoes there is a stronger effect of open space and less emphasis upon dense and assertive plasticity. The illusion of voids now balances that of solids. . . . The impression of a style of greater economy in general terms is a true one, and is seen especially in a more reserved use of gesture . . . [the Dance of Salome] demonstrates the growth of this supremely human painter to an entirely new stature as a dramatist.' In one of the candelabra to the left of the Visitation Baldini has discovered the signature of Francesco Morandini (il Poppi) and the date 1568. Poppi must therefore have intervened in the decoration of the cloister, presumably in areas which had been left unfinished. The cloister (p. 187) owes its present form in large part to a restoration of 1722; its original form is reconstructed by Shearman. Its frescoes, the first in which an attempt is made to combine, in monochrome, painting, fictive sculpture and fictive architecture, are some of the great masterpieces of Florentine High Renaissance art.

JOHN POPE-HENNESSY

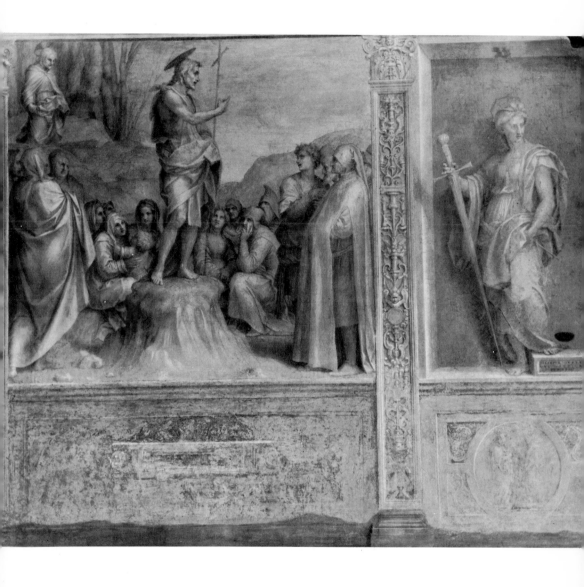

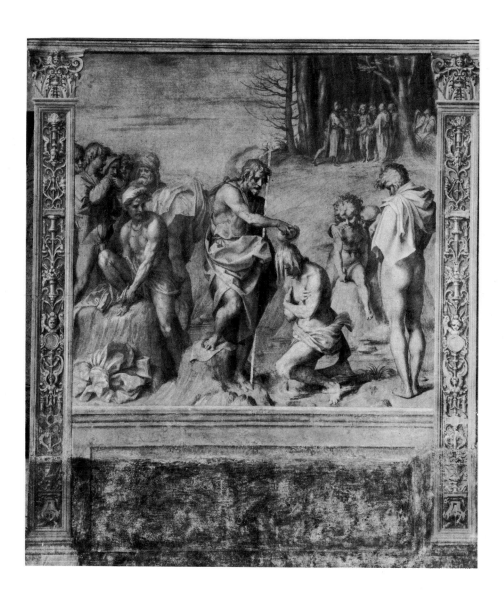

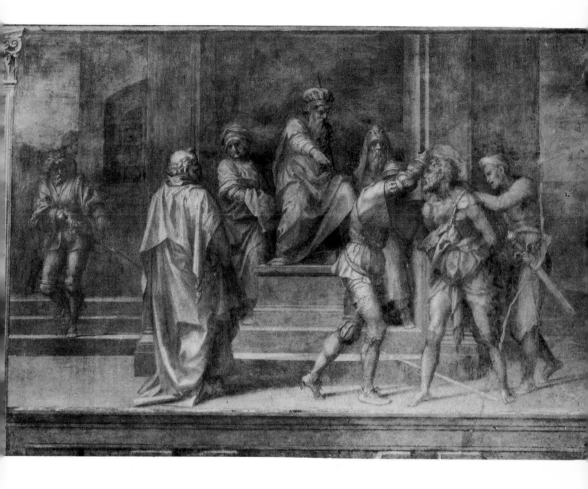

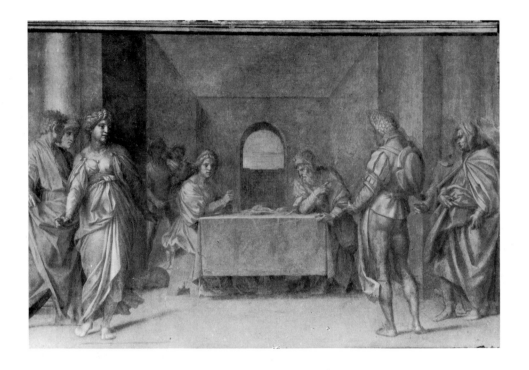

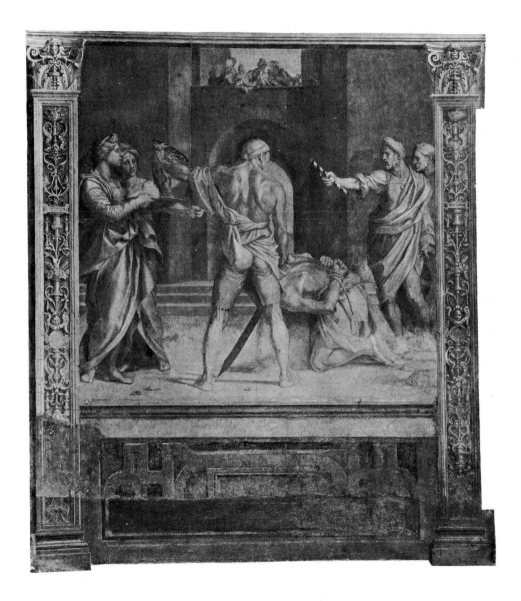

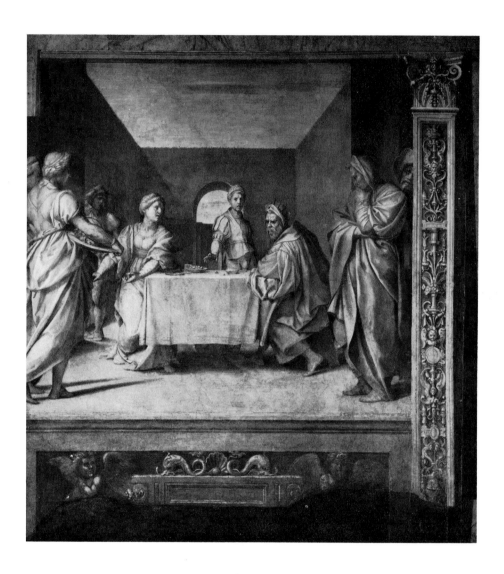

64.

PONTORMO (JACOPO CARRUCCI)
1494-1557

Jacopo Carrucci took the name Pontormo from the small village near Empoli where he was born. The son of a painter, he was apprenticed, according to Vasari, first to Leonardo da Vinci and then to Albertinelli and Piero di Cosimo. Soon after 1512 he worked in the studio of Andrea del Sarto, where he met Giovanni Battista Rosso (1494–1540) with whom he was to become one of the founders of Florentine mannerism. His altarpiece of 1518 in the church of S. Michele Visdomini in Florence shows both his derivation from Andrea del Sarto and that restless agitation which characterises his mannerist style. In 1521 Pontormo painted a fresco for the Medici villa at Poggio a Caiano, and from 1522–5 worked on the Passion cycle in the Certosa near Florence. Incorporating angular and linear features from Dürer's graphic work, these frescoes convey a deep sense of religious fervour. During this period, Bronzino began to work as Pontormo's assistant, and continued to do so in the church of Santa Felicita in Florence. Pontormo's Deposition (1525) is probably his finest work. The frescoes which he painted between 1546 and 1556 in the church of San Lorenzo are known today only from drawings, and although a diary which Pontormo kept in 1555–6 helps to break the silence, the last years of his life remain obscured by self-absorption and withdrawal.

65

HOSPITAL SCENE
Fresco, 3ft 4⅛in x 5ft 4⅛in (102 x 163cm)
Accademia, Florence

The fresco was subjected to an early transfer, and on that occasion was attached to a gesso support which prejudiced its survival. It was removed from this in 1956 by Leonetto Tintori and Alfio Del Serra using the *strappo* method, and was attached to sheets of masonite. The dark tone imposed upon the colours is the remains of a particularly heavy layer of repainting which could only be partially removed from the surface of the fresco.

F. M. Clapp, *Jacopo Carrucci da Pontormo* (1916), p. 115.
L. Berti, *Pontormo* (1964), esp. p. viii, (with bibliography).
J. C. Rearick, *The Drawings of Pontormo* (1964), I, p. 100.
K. W. Forster, *Pontormo* (1966), pp. 20, 127.

This small fresco came from a hall of the Accademia which incorporates the women's ward in the former hospital of St Matthew. Long regarded as an early painting by Andrea del Sarto, it was recognised by Gamba and Berenson as a work of Pontormo. Clapp dates it around 1513. Stylistically, however, it appears to belong in the year 1514, and Freedberg has pointed out the possible connexion of such details as the basin and the cast-off slippers with the Nativity of the Virgin by Andrea del Sarto in SS. Annunziata (1514). It is an interesting work not only because it predates the predella in Dublin and Pontormo's famous Borgherini panels, but also for the fascination of its own subject matter. It shows the interior of a Renaissance hospital with a remarkable degree of realism. Three sharply contrasting colours are used by the artist, and the small, puppet-like figures are painted in green earth colour (*terra verde*).

LUCIANO BERTI

66

MADONNA AND CHILD WITH SAINTS AGNES, LUCY, ZACHARY AND MICHAEL
Fresco, 7ft 3⅜in x 6ft 4¾in (222 x 195cm)
Church of Santissima Annunziata, Florence

When the fresco was moved in 1823, the entire wall on which it was painted was cut out. It was reinforced to prevent it from collapsing or cracking, and to judge from the present condition of the *intonaco* and of the *sinopia* below, the operation was remarkably successful. In the Cappella dei Pittori it closed off the main door of the chapel. Lateral additions were made and it was surrounded by green hangings. It had to be removed *a strappo* after its exposure to dampness during the flood, and was transferred to a polyester support. Under the *intonaco* an older *sinopia* was found (see no. 67). Restoration of the fresco has revealed several passages of original colour beneath later repainting. The Madonna's cloak had, for instance, been completely repainted in a different colour. The artist clearly used a cartoon for this fresco; lines incised on the fresh plaster can be seen on the faces, limbs and clothes of all the figures.

S. Freedberg, *Painting of the High Renaissance in Rome and Florence* (1961), pp. 504 ff. and passim.
L. Berti, *Pontormo* (1964), p. vi and passim (with bibliography).
J. C. Rearick, *The Drawings of Pontormo* (1964), pp. 102 ff. and passim.
K. W. Forster, *Pontormo* (1966), pp. 20 f., 128.
M. Meiss, *Art News*, 66 (1967), no. 4 pp. 26, 81.

Pontormo painted this fresco in the church of S. Ruffillo (S. Raffaello del Vescovo), formerly in the Piazza dell' Olio in Florence. When this church was demolished in 1823, the fresco was transferred to the Cappella dei Pittori in SS. Annunziata. A lunette with God the Father surrounded by seraphim disappeared at this time. Assigned by Clapp to the year 1513, it was probably commissioned from Pontormo after his success with a fresco of the arms of Pope Leo X in SS. Annunziata (1513–14), when he left the studio of Andrea del Sarto. Cox accepts a dating in 1514, and the combination of Fra Bartolommeo's monumentality with the diversity and energy of Andrea del Sarto is noted by Freedberg. The young Pontormo succeeded in compressing his composition into a tightly reduced space, with a symmetry that creates a continuous rhythm of interchanging lines and volumes. The mood is intimate rather than classical. The St Lucy looks out of the picture as she raises the salver containing the eyes of which her martyrdom has deprived her. The Saint kneeling next to her in an ecstasy of suffering appears to foreshadow Bernini. The Madonna gazes intently at the Archangel, who holds up the scales and returns her glance, while the Child reacts in a sullen way to the kneeling St Zachary who presses in on him too closely. Preparatory drawings for this fresco exist in Dresden and in Florence (Uffizi).

LUCIANO BERTI

67

MADONNA AND CHILD WITH SAINTS
Sinopia, 6ft 9½in x 6ft ⅞in (207 x 185cm)
Church of Santissima Annunziata, Florence

The *sinopia* was removed using the *strappo* method, and was mounted on a plastic support.

This *sinopia* was found beneath Pontormo's Madonna and Child with Saints (no. 66). It is the work of a Florentine artist, active towards the end of the fifteenth century, influenced by Filippino Lippi and Raffaellino del Garbo. For some reason the *sinopia* was not overpainted, but in its unfinished state, served as a substitute for a fresco; this fact explains why the haloes were later painted in yellow. Eventually the execution of the fresco was entrusted to Pontormo. Cartoons were by that time in common use among the more up-to-date painters, so a new *sinopia* drawing was unnecessary. Pontormo simply laid his *intonaco* on top of the old one, which is consequently preserved intact. The names of the saints illustrated are carefully inscribed at the base of the *sinopia*. They are the same as those who appear in Pontormo's fresco, perhaps on the insistence of the patrons, who may have been responsible both for the first and second commissions.

UMBERTO BALDINI

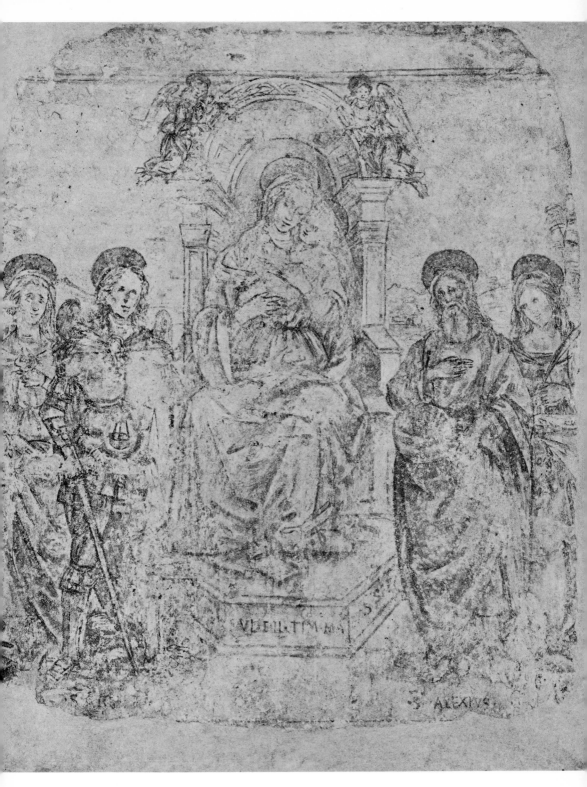

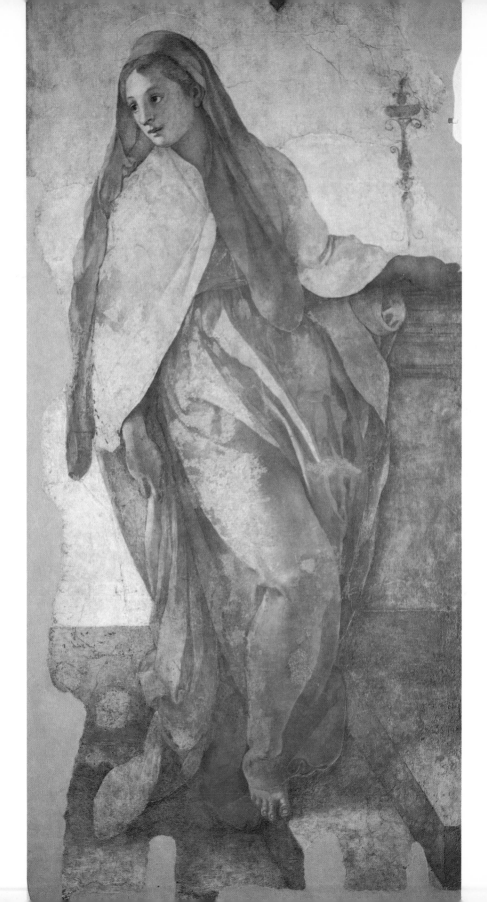

PONTORMO

(biographical notes on page 198)

68a

THE ANNUNCIATORY ANGEL

68b

THE VIRGIN ANNUNCIATE

Fresco, each 12ft ⅞in x 5ft 6⅛in (368 x 168cm)
Capponi Chapel, Santa Felicita, Florence

The fresco comes from the Cappella Capponi, whose paintings constitute some of Pontormo's greatest works. Dedicated to the Virgin Annunciate, the chapel belonged originally to the Barbadori family, and then passed to the Paganelli; it was acquired by Ludovico Capponi in 1525. He commissioned Pontormo to redecorate it completely. Assisted by Bronzino, Pontormo painted God the Father and four Patriarchs on the roof (only the drawings for these survive), the four Evangelists in tondi on the walls, and a brilliantly original Deposition on the altar. The Annunciation can be dated about 1527-8. Two preparatory drawings for it exist in the Uffizi (nos. 448F and 6653F; see Introduction). Commentators have often stressed the high quality of the Annunciation and the unique character of its style, which combines a proto-baroque Angel with a figure of the Virgin of the utmost delicacy.

LUCIANO BERTI

The fresco suffered for a long time from dampness and from the damage caused by previous restorations. These had not only altered its appearance, but also tended to lift the original pigment wherever the repainting was particularly heavy. The removal of the fresco was carried out in 1967 by Leonetto Tintori using the *strappo* method, and it was fastened to a support of polyester resin mixed with fibreglass. The results of cleaning were excellent. The original brightness of the colours has been recovered and inaccurate restorations of the missing portions have been removed.

L. Berti, *Pontormo* (1964), pp. cx, cxii and passim (with bibliography).
J. C. Rearick, *Pontormo* (1964), I, pp. 263 f. and passim.
K.W. Forster, *Pontormo* (1966), pp. 59 f., 142.

◁ Detail, 68b.

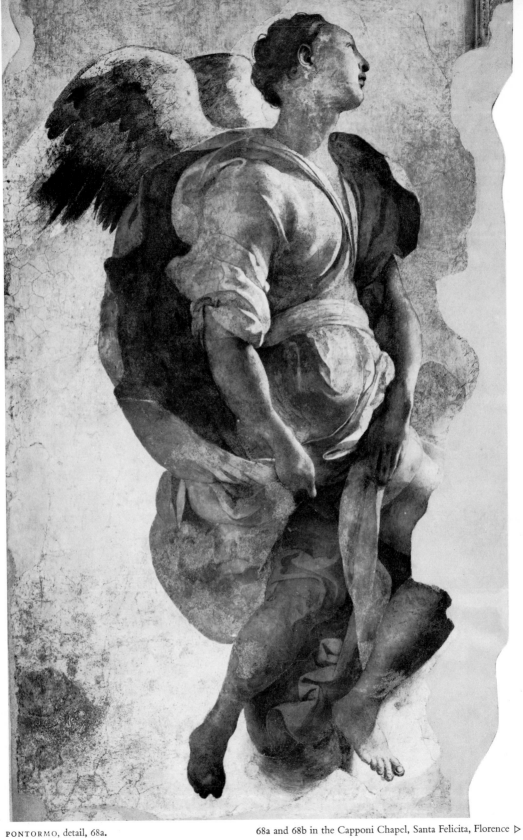

PONTORMO, detail, 68a. 68a and 68b in the Capponi Chapel, Santa Felicita, Florence ▷

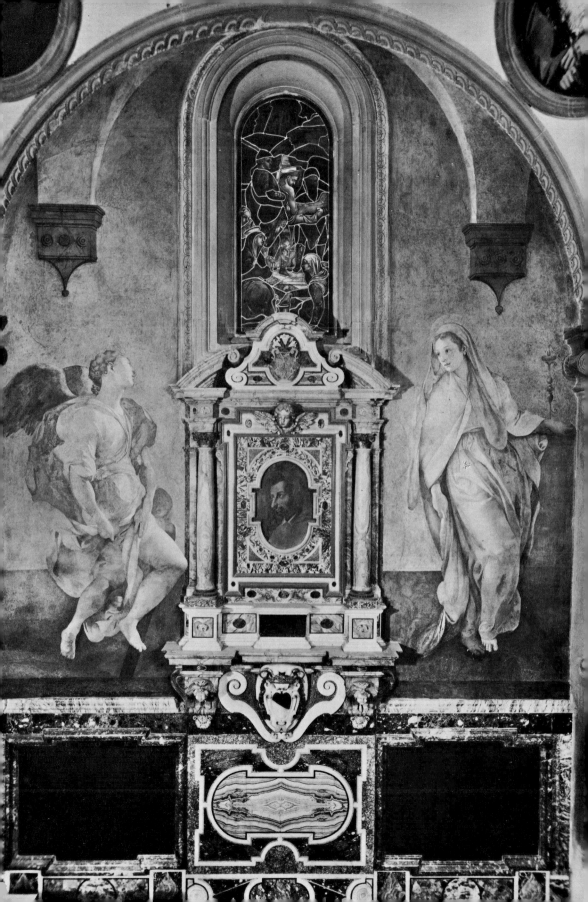

ALESSANDRO ALLORI (ALESSANDRO DI CRISTOFANO DI LORENZO ALLORI *or* ALESSANDRO BRONZINO-ALLORI)
1535–1607

Born in Florence, Alessandro Allori was adopted by his uncle Agnolo Allori (Bronzino) and grew up as a painter under his influence. At the age of seventeen he is supposed to have designed and executed an altarpiece showing the Crucifixion which won the approval of the Medici and was installed in the chapel of one of their villas. Two years later, in 1554, he went to Rome, where the work of Michelangelo appears to have been his major interest. It is consciously reflected on his return to Florence in his first major undertaking, the decoration of the Montaguti chapel in the church of SS. Anunziata (1560). He rapidly became one of the most prolific Florentine mannerists, benefitting from the Medici patronage of Bronzino but also popular in his own right. His works were commissioned by a large number of Florentine churches, among them Sta. Maria del Carmine where he painted a Last Supper in the refectory (1582), and Sta. Maria Novella, in which he decorated the vault of the Cappella Gaddi (1592). His Sacrifice of Isaac painted for the church of S. Niccolò is now in the Uffizi. He was equally prolific as a secular artist, contributing to the Studiolo in the Palazzo Vecchio (1570) and following Andrea del Sarto, Franciabigio and Pontormo as one of the decorators of the Medici villa at Poggio a Caiano (1585). His later painting is characterised by large muscular forms and a heavy, almost sculptural, drapery style. He died in Florence on September 22, 1607.

69

THE PROPHET JONAH
Fresco, 8ft x 8ft 1⅜in (244 x 248cm)
Museum of the church of Ognissanti, Florence

The frescoes were removed originally with the sections of the wall on which they were painted, and supported by a combination of cane lattice-work and wooden reinforcements. They suffered the full force of the inundation in 1966, and their supports were seriously weakened. The colour was less threatened than the *intonaco* and the *arriccio*, which showed signs of pulling away from the cane lattice-work. A second detachment was therefore carried out by Leonetto Tintori.

W. and E. Paatz, *Die Kirchen von Florenz*, IV (1952), p. 437.

This is one of a group of frescoes traditionally ascribed to Vasari, comprising seven prophets, the Creation of Eve and the Fall, which were removed from their original site at some point in the nineteenth century and placed in the refectory of the Ognissanti. In 1952, Paatz tentatively identified them with the frescoes stated to have been painted by Alessandro Allori and his school in the chapel of the old hospital of Sta. Maria Nuova. Their restoration since the flood has confirmed this attribution. The prophet Jonah is an autograph work by Allori. The grandiose scale of the figure and the studied *contrapposto* of the arms and legs reveal a greater devotion to Michelangelo than any works by Vasari. The light tonality, rose, grey and azure, and the serpentine locks of fair hair are typical of Allori. Stylistically, however, it does not belong to the years 1575–6 to which it is assigned by Paatz on the basis of documents published by Bagnesi (none of which refers directly to these frescoes). As Simona Lecchini Giovannoni has suggested, Allori must have painted the frescoes at least a decade earlier, around 1560.

PAOLO DAL POGGETTO

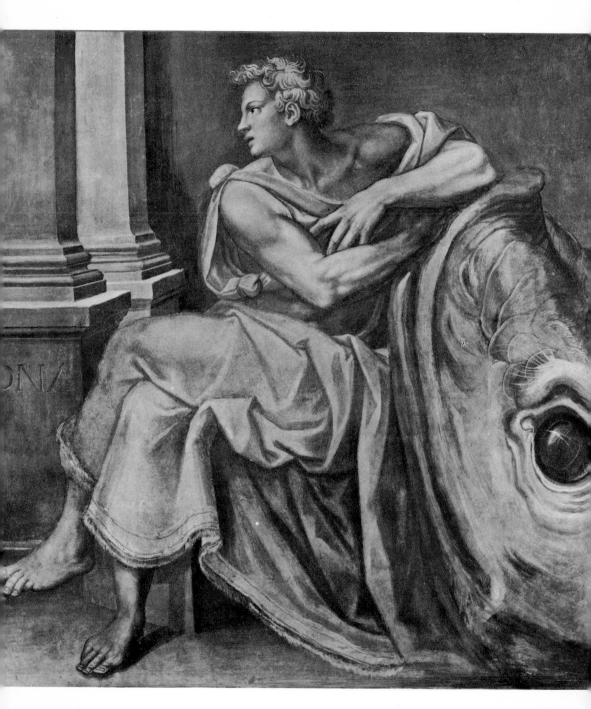

70

THE TRINITY
Fresco, 11ft 3¾in x 6ft 4¾in (345 x 195cm)
Church of Santissima Annunziata, Florence

The lower part of the fresco was badly damaged during the flood. Oil was cleaned from the surface, and it was treated with nystatin to prevent further outbreaks of mildew. An attempt to dry out the wall by tunnelling through the basement of the chapel did not succeed in checking the influx of salts which threatened large areas of pigment. Five months after the flood the fresco had to be removed, and a combination of adhesives was used to fasten canvas to the surface. Alfio Del Serra carried this operation out. When it was off the wall, the *intonaco* was removed and the fresco was then attached to a support of polyester interspaced with asbestos. On the *arriccio* there are traces of a mutilated and insignificant *sinopia* drawing.

A. Emiliani, *Il Bronzino* (1960), p. 90 (with bibliography).

The date 1571 appears on the lower left of the fresco, and apart from some doubts raised at the beginning of this century, scholars have accepted it. However, the problem of attribution was not settled until after the recent restoration. The fresco was generally regarded as the last dated work by Agnolo Bronzino, who died in 1572. Bronzino's initials, AN. BR., appear on the top of the right pedestal. The corresponding initials on the left side, IA. PV., are those of Jacopo Pontormo. For this reason it was argued that Pontormo made the drawing and even began the fresco which was later completed by Bronzino. By 1571, however, Pontormo had been dead for fifteen years, and the fresco certainly did not appear to have been left unfinished for such a long period of time. Documents published in 1907 by Geisenheimer make it quite clear that in 1567 the fresco was allocated to 'Messer Agniolo Bronzino e Lessandro Allori, suo allievo.' Payment for the fresco was made to Allori alone, presumably because he executed it. It may, however, have been based upon a design by Bronzino. Allori's is the only name cited in the documents which record the progress of the work from March 26 to September 20, 1571. Even so, Geisenheimer's discoveries did not explain the two sets of initials on the fresco. The solution was provided by restoration. Under the painted marble of the pedestals, faint traces of two portrait heads were found. They represented Pontormo and Bronzino, and the initials served to identify them. But when were they painted and by whom? The answer can be found by looking again at the documents and by following the technical clues given by the fresco. In 1567 the commission went to Bronzino and Allori. On March 26, 1571, the *arriccio* was prepared and paid for, but Bronzino is no longer mentioned. Allori began to paint on September 13, 1571, when the scaffolding was in place and the first consignment of lime was paid for. He received his final payment on September 20, 1571. The documents indicate seven days' work, and this is confirmed by the fresco, on which seven distinct *giornate* (see Introduction) can be detected. In 1572, Bronzino died in the house of Alessandro Allori. His eulogy before the Accademia del Disegno was entrusted to Allori and his body was carried to the chapel in which Pontormo was buried. Appropriately, their commemorative portraits were then painted on the pedestals of the Trinity fresco. The dry *intonaco* was scored, the pinkish-violet colour painted in imitation of marble was covered with a green ground, and the two heads were painted on to it. Allori's special relationship to Bronzino makes him the most likely candidate for this intervention. But the later painting, a *secco*, proved less durable, and when in time it disintegrated, the pedestals were again

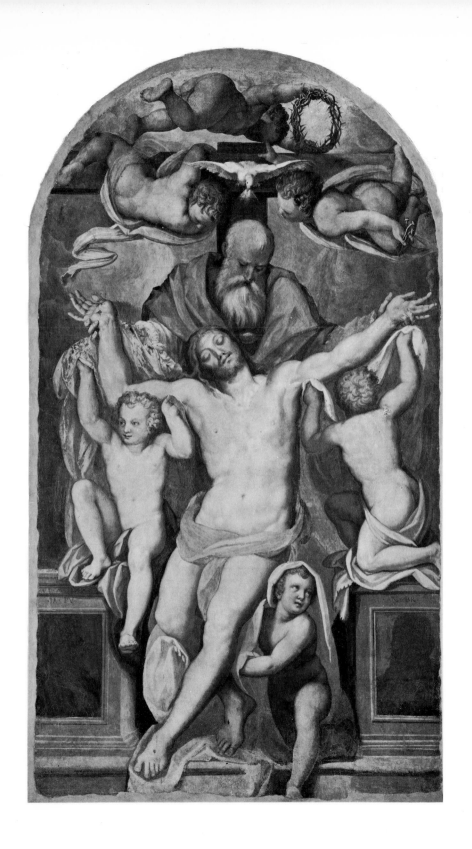

covered with a layer of violet paint. This was removed during restoration, when the faded green background on which the portraits were painted was disclosed. The green is darker where it was protected from the light by pigment, so that although the actual portraits have disappeared, the silhouettes of Pontormo and Bronzino remain. (Comparable portraits appear in Allori's Last Supper, painted in Sta. Maria del Carmine.)

UMBERTO BALDINI

Glossary

Affresco (in English usage, 'fresco'). Painting in pigments mixed with water, on freshly laid plaster. The lime of the wet plaster supplies a binding medium, and as both dry they become completely integrated. Known as 'true' fresco, this technique was most popular from the late thirteenth to the mid-sixteenth centuries.

Arriccio. The preliminary plaster layer spread on the masonry. On this layer the *sinopia* is executed. The *arriccio* was left rough so that the final top layer (see *Intonaco*) might more easily adhere.

Cartone (in English usage, 'cartoon'). The artist's final preparatory drawing of his composition, enlarged to the size of the wall area to be painted. The cartoon was laid against the wall over the final freshly laid plaster on which the painting was to be done. Its outlines were incised on the plaster through the heavy paper with a stylus. The resulting incised lines guided the artist in painting. This procedure was frequently used in the sixteenth century. See also *Spolvero*.

Giornata. The amount of fresco painting executed in one day. The artist decided in advance the amount of wall surface he could paint in a day and laid on top of the *arriccio* or rough plaster only the amount of fresh *intonaco* or fine plaster needed for his day's work. Work was thus divided into *giornate* (or daily work units). The joinings are discernible from a close examination of the painted surface, revealing the order in which the sections were done because each successive day's work slightly overlaps the preceding.

Intonaco. This is the final, smooth plaster layer on which the finished painting was to be done. It was made from lime and sand and laid on in sections, according to the amount of work an artist planned to execute each day.

Martellinatura (or *Punzecchiatura*). A method of making the *intonaco* on which the fresco was to be painted adhere to a layer of plaster that was already there, and not one that the artist had laid himself at the beginning of his work. It was the practice to chip a too even surface with the pointed end of a hammer (or *martello*), denting it (*punzecchiatura*) and giving it the roughness necessary to make the *intonaco* stick. This chipping was also used when an artist had to make a new fresco, with new *intonaco*, on top of another fresco.

Mezzo fresco. Painting on partially dry plaster. The pigment penetrates the plaster less deeply than with the 'true' fresco method. *Mezzo fresco* was a popular procedure in the sixteenth century, when it was considered the only correct method of mural painting.

Pontata. The division of work units according to the gradual lowering of the scaffolding on which the artist worked. The plaster was laid in horizontal bands, each a few feet high. Such divisions are found exclusively in frescoes painted on walls of great height.

Quadrettatura. An intermediate step in which a small drawing is divided into equal squares and enlarged in proportion to the full-scale size of the cartoon to be transferred to the wall.

Secco (literally 'dry'). Painting done on plaster that has already dried and cannot therefore absorb the pigments and unite with them. To make his colours adhere to the dry *intonaco* the artist had to roughen it slightly and add a binder to the pigments. The method is occasionally referred to as 'false' fresco.

Sinopia. A large drawing on a wall made in preparation for painting a mural, which served as a guide to the artist for the general lines of his composition. It was done on the rough coat of plaster or *arriccio*, first in charcoal, then gone over sometimes in diluted ochre, and finally retraced in a red earth pigment called *sinopia*, because it came originally from Sinope, a town on the Black Sea. Its use was especially popular from the mid-thirteenth to the mid-fourteenth centuries, at the end of the sixteenth century, and during the early seventeenth century.

Spolvero (dusting or pouncing). A second method (see *Cartone*) of transferring the artist's drawing on to the final plaster layer. After drawings as large as the frescoes themselves were made on paper, their outlines were pricked, and the whole paper was cut into pieces the size of each day's work. After the day's section of *intonaco* was laid, the corresponding drawing was place over it and 'dusted' with a cloth bag filled with charcoal powder, which passed through the tiny punctured holes, leaving an outline of the design on the fresh *intonaco*. This method was most popular in the second half of the fifteenth century.

Stacco. The process of detaching a fresco painting from the wall by removing the pigment layer and a layer of *intonaco*. Usually an animal glue is applied to the painted surface and then two layers of cloth (calico and canvas) are applied, left to dry, and later stripped off the wall, pulling the fresco with them. It is taken to a laboratory where the excess plaster is scraped away and another cloth is attached to its back. Finally, the cloths on the face of the fresco are carefully removed. The fresco is then ready to be mounted on a new support.

Strappo. The process by which a fresco painting is detached when the plaster on which it is painted has greatly deteriorated. *Strappo* is the process of taking off only the paint-layer without removing excessive amounts of plaster. It is effected by the use of a glue considerably stronger than that used in the *stacco* technique. The procedure which follows is identical with that in the *stacco* operation. It should be noted, however, that after certain frescoes are removed by means of *strappo*, a coloured imprint may still be seen on the plaster remaining on the wall. This is evidence of the depth to which the paint penetrated the plaster. These traces of colour are often removed by a second *strappo* operation on the same wall.

Tempera. The medium added to paint in order to bind the colour and surface to be painted. The binding medium may be made from various substances, but in practice the term refers specifically to the addition of egg to pigments. It was sometimes used to complete a composition already painted in fresco. Because the paint and the dry wall surface do not become thoroughly united, as they do in true fresco, mural paintings done with tempera tend to deteriorate rapidly.

Artists

Catalogue number 69–70	Allori, Alessandro
26–29	Angelico, Fra
55	Bartolommeo, Fra
13	Bonaccorso di Cino
41–43	Castagno, Andrea del
23, 24	Francesco d'Antonio
52–54	Franciabigio
3	Florentine School, 13th century
25	Florentine School, early 15th century
44	Florentine School, mid-15th century
67	Florentine School, late 15th century
7–9	Gaddi, Taddeo
4	Giotto
46–48	Gozzoli, Benozzo
2	Lapo da Firenze
5, 6	Lorenzetti, Ambrogio
5, 6	Lorenzetti, Pietro
18	Lorenzo di Bicci
19–22	Masolino da Panicale
37–40	Master of the Chiostro degli Aranci
14	Master of the Fogg Pietà
49	Mino da Fiesole
12	Nardo di Cione
10, 11	Orcagna
30–32	Parri Spinelli
50–51	Perugino, school of
45	Piero della Francesca
1	Pistoiese School, 13th century
15	Pistoiese School, 14th century
65, 66, 68	Pontormo
34, 35	Prato Master
56–64	Sarto, Andrea del
33	Schiavo, Paolo
16	Spinello Aretino
17	Starnina, Gherardo
36	Uccello, Paolo

Places

Catalogue number 30	*Arezzo*	Church of San Domenico
16		Church of San Lorenzo
31, 32		Palazzo Comunale
45	*Borgo San Sepolcro*	Pinacoteca (from the church of Sant 'Agostino)
46–48	*Castelfiorentino*	Chapel of the Visitation
27	*Cortona*	Church of San Domenico
19–22	*Empoli*	Church of Sant 'Agostino
25	*Fiesole*	Castel di Poggio
26		Church of San Domenico
4, 8, 9, 12	*Florence*	Badia
37–40		Badia, Chiostro degli Aranci
3		Baptistery
50, 51		Cenacolo del Perugino
14		Church of Sant 'Ambrogio
42, 43, 66, 67, 70		Church of Santi Annunziata
33		Church of Santissimi Apostoli
68		Church of Santa Felicita
7		Church of San Francesco di Paola
13		Church of San Lorenzo
17		Church of Santa Maria del Carmine
23, 24		Church of San Niccolò
56–64		Cloister of the Compagnia di San Giovanni Battista allo Scalzo
52–54		Convent of Santa Maria dei Candeli
55		Convent of Santa Maria Maddalena, Pian di Mugnone
65		Gallery of the Accademia
10, 11		Museum of Santa Croce
28, 29		Museum of San Marco
69		Museum of the church of Ognissanti
41		Refectory of Sant'Apollonia
36		Soprintendenza alle Gallerie (from the church of San Martino alla Scala)
18		Soprintendenza alle Gallerie (from the Via Aretina)
49		Soprintendenza alle Gallerie (from 7 Via Pietrapiana)
5, 6	*Montesiepi*	Oratory of San Galgano
2	*Pistoia*	Cathedral
1, 15, 44		Church of San Domenico
34, 35	*Prato*	Cathedral